Victoria and Albert Museum
Thomas Goode & Company Limited

Minton 1798-1910

Exhibition August–October 1976

Elizabeth Aslin and Paul Atterbury

Endpapers: a selection of Minton encaustic,
majolica, printed and painted tiles, c. 1850–1910

Printed in England for Her Majesty's Stationery Office
by McCorquodale Printers Ltd., London

ISBN 0 901486 96 5

Foreword

When in 1974 the idea was mooted of a retrospective Minton Exhibition at the Victoria and Albert Museum, it was received with enthusiasm as being of particular relevance to the Museum and of especial significance in itself. Minton was the great innovating firm in the English pottery industry of the middle and second half of the nineteenth century, and this pre-eminence was accorded the flattery of imitation in potteries all over the world, while Minton encaustic floor-tiles and majolica tile-work for walls enjoyed an enormous vogue. The Museum itself was a beneficiary of this mode of decoration, which could formerly be seen on the walls and ceiling of the 'Keramic Gallery' (now the Silver Galleries), and may still be seen on the staircase between Rooms 11 and 70A. Minton tiles also adorn the Old Grill Room and Refreshment Room, recently re-opened, which house part of the present Exhibition.

Much of the material of this Exhibition is drawn from the Museum's own collections, but a vital part of it is formed by the loans from the Minton Museum in Stoke-on-Trent and the Minton archives, at present housed in the University College of North Wales, Bangor. For these we are grateful to Mr Richard Bailey and the Directors of Royal Doulton Tableware Limited. Royal Doulton also generously provided the services of Mr Paul Atterbury, who prepared the entries in the Catalogue with the help and advice of Miss Elizabeth Aslin.

An essential element in this Exhibition has been the collaboration of Messrs Thomas Goode & Company, of South Audley Street, who have been able to display in their premises, as a complement to the Exhibition in the Museum, an unrivalled series of the *pâte-sur-pâte* wares for which Minton was famous. Goode's, connected as they were with Minton by ties of trade and personal friendship, were able to acquire examples of the finest and most ambitious Minton productions, such as those made for the International Exhibitions of 1878 and 1889; and a visit to South Audley Street is conceived as an essential ingredient in this Exhibition. Messrs Goode's have contributed generously to the production of the present Catalogue and for this and for much other help the Museum is greatly indebted to their Directors, and particularly to Mr P. Rayner and Mr B. Jakins.

Roy Strong
Director

Acknowledgements

We should first of all like to thank all those who have lent items from their collections for this exhibition. We are particularly honoured that Her Majesty The Queen should have agreed to lend pieces from the Royal Collections. The lenders, I. Bennett, W. Chappel, Gay Antiques Ltd, G. A. Godden, F. Halliwell, D. Harrison, R. Hildyard, H. V. Levy, Mrs I. Lockett, J. M. Scott, Mr and Mrs Smythe, W. Solon, and M. Whiteway have been most generous with their time, knowledge, and not least with their collections themselves. In addition, we owe special thanks to A. Mountford, G. Elliott, Mrs Halfpenny and the staff of the City Museum and Art Gallery, Stoke-on-Trent, and to the staff of Royal Doulton Tableware Limited, in particular to W. M. Fisher, Miss A. Linscott and Mrs J. Brown. We are also grateful to the Hon. H. Gibson, whose enthusiasm and interest was instrumental in launching this exhibition. Many people have helped to make the production of the exhibition easier by their support, advice and knowledge and we are indebted to D. Battie, Mrs L. Bonython, G. de Bellaigue, Miss H. Bury, J. Cox, R. G. Haggar, M. Haslam, G. Hawkins, P. Myers, Mr and Mrs Novak, T. A. Lockett, Mme Tamara Préaud, E. A. Sibbick. In addition, we owe particular thanks to B. Jakins and the staff of Thomas Goode and Co. Ltd for making the Goode Collection and company records so readily available. A. Giles-Jones, the Archivist of the University College of North Wales, Bangor, has been especially generous with his time and knowledge, and with the Minton archives that are at present in his care. The preparation of this catalogue and exhibition has involved much hard work on the part of our colleagues in the Museum, and we are particularly grateful to Miss J. Hawkins whose dedication and interest often far exceeded the bounds of duty; in addition, we should like to thank R. J. Charleston, D. Coachworth, T. Clifford, I. Heal, J. V. G. Mallett, Mrs B. Morris, J. Physick, C. Wainwright and finally Miss S. Elliott for typing the manuscript with such patience, speed and accuracy. All the photographs in the catalogue are Crown Copyright Victoria and Albert Museum and were taken with great care and patience by Messrs Large and Williams of Leach and Co. Ltd, who were able to achieve excellent results in often unpromising locations.

Elizabeth Aslin
Paul Atterbury

Contents

page nos

3 Foreword
4 Acknowledgements
7 Historical Introduction
10 Biographies of Artists and Designers
14 Bibliography
15 List of Exhibitions
16 Minton Marks

 Catalogue
19 Notes on the Catalogue

21 Section A Tablewares c. 1798–1830
25 Section B Biscuit and enamel-painted figures c. 1826–45
29 Section C Ornamental porcelains c. 1815–45
33 Section D Stonewares c. 1830–45, Summerly Art Manufactures 1846–52 and wares designed by A. W. N. Pugin c. 1845–52
38 Section E Parian wares c. 1846–90
43 Section F Majolica wares c. 1850–80
48 Section G Renaissance influenced wares c. 1855–80
54 Section H Tablewares c. 1830–1910
63 Section I Ornamental porcelains c. 1850–80
67 Section J The Kensington Art Pottery Studio and its influence c. 1870–90
71 Section K *Pâte-sur-pâte* wares c. 1858–1910 and the work of Louis Marc Solon
77 Section L Oriental influenced wares c. 1860–90
83 Section M Ornamental porcelains c. 1880–1910
86 Section N Secessionist wares c. 1902–10
91 Section O Tiles and architectural work c. 1840–1910
93 Section P The Grill Room and Refreshment Room
98 Section TG The Thomas Goode Collection of Minton *pâte-sur-pâte*, on display at 19 South Audley Street, London W1

111 List of Lenders

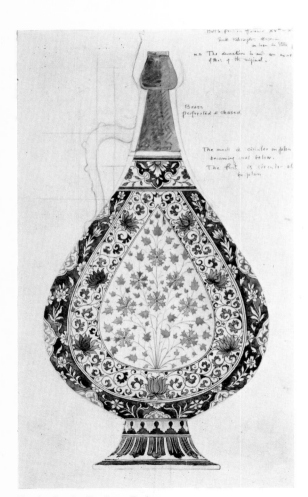

Persian bottle. Catalogue L16

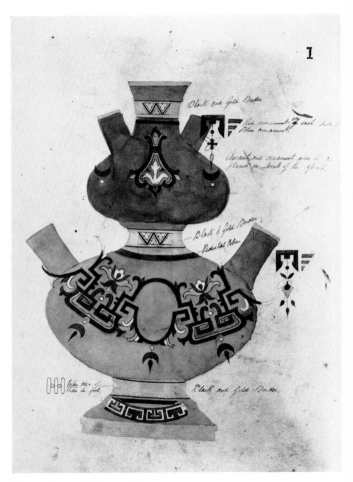

Cloisonné vase. Catalogue L6

Historical Introduction

After working for some years as an engraver in Caughley, London and Stoke, Thomas Minton, in partnership with William Pownall and Joseph Poulson, built a small pottery in Stoke in 1793 on land bought from John Ward Hassals. Production did not start until 1796 and for the first few years concentrated on blue-printed earthenwares of the type then being made by many companies in Staffordshire and Shropshire. These early Minton wares were unmarked, and many were supplied to other manufacturers, including Wedgwood. In about 1798 Minton began to produce a type of bone china, prompted partly by his visits to Cornwall during the summers of 1798 and 1799 to arrange for regular supplies of china clay and china stone to be shipped to Staffordshire. Out of these visits grew the Hendra Company, in which Minton was the main partner, a company that played a significant role in the development of porcelain manufacture in Staffordshire. With the introduction of bone china, Minton's company prospered and its output and sales increased dramatically. Surviving stock ledgers of the period 1810–17 show a wide range of wares in production, including printed and painted earthenwares, cream-coloured wares, printed and painted bone china, stonewares and Egyptian black. In 1817 Thomas Minton took his two sons into partnership, and the pattern of successful, if unadventurous progress continued until 1836, when, on Thomas's death, his son

Herbert took control, the other son having left the company by this time to enter the Church. The company then moved into a period of considerable expansion, aided by partnerships, first with John Boyle, and subsequently with Michael Daintry Hollins and Colin Minton Campbell, Herbert's nephew. Herbert Minton was an outstanding Victorian *entrepreneur*. He revolutionised methods of production, introduced new ranges including encaustic and printed tiles, parian and majolica, and, by attracting artists and designers from Derby and elsewhere he was soon able to match the commercial output and reputation of other longer-established firms. Through his friendship with such men as A. W. N. Pugin and Sir Henry Cole, he was also able to establish for Minton an international artistic reputation that was second to none. In 1849 Léon Arnoux joined the company as Art Director, the first of a long line of European artists and designers to come to the Potteries, and under his guidance the company grew to a position of pre-eminence among Victorian manufacturers. A skilled chemist and ceramic technician as well as a designer and painter, Arnoux soon made his mark with the majolica glazes introduced at the Great Exhibition of 1851, gaining the first of many awards that were presented to the company at the great international exhibitions of the second half of the nineteenth century. Herbert Minton died in 1858 and was succeeded by Colin Minton Campbell, who

continued to lead the company with the same dynamism and imagination as his predecessor, with the result that Minton dominated the English and many overseas ceramic markets. Tablewares, tiles, huge majolica garden ornaments and delicately painted porcelains were produced side by side with parian figures, Renaissance and orientally inspired wares and the freely painted plaques and vases decorated at the South Kensington Art Pottery Studio, the culmination of a long and close relationship between Mintons and the South Kensington Museum and Schools. On another level, the Minton Patent Oven developed by Arnoux carried the name into the porcelain works of the world, both great and small. Design throughout this period tended to rely on revivalism, and in particular reveals a considerable debt to the eighteenth century Sèvres factory; however, while earlier styles were a source of inspiration, they were often interpreted with such verve and daring that they became something quite new. During the last part of the nineteenth century the range of Minton products increased further. Acid-etched and richly gilded tablewares for the Royal Houses of Europe, and the *Art Nouveau*-inspired Secessionist wares were added to a list already augmented by the time-consuming, expensive but splendid *pâte-sur-pâte* decorated pieces. Louis Marc Solon came to Stoke in 1870, bringing with him from France the *pâte-sur-pâte* technique, which he developed into what is probably Minton's best-known contribution to Victorian ceramics.

In more recent years the company has maintained its reputation as a leading manufacturer of tablewares, and in 1968 became a member of the Royal Doulton Tableware Group.

Drawings by W. Wise; see Section O for related tiles

Drawings and designs from the Minton archives are shown on pages 6, 8 and 9

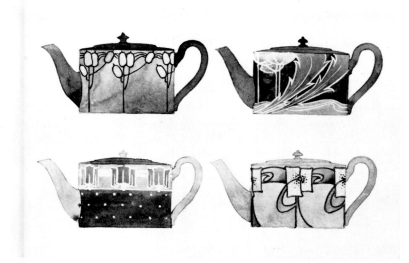

Secessionist teapots; see Section N

Drawing by C. Dresser; see Section O for related tile

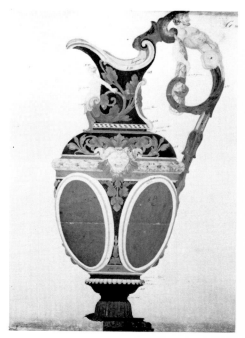

Jeannest ewer. Catalogue P7

The Grace from the *Anacreon* series. Catalogue H64

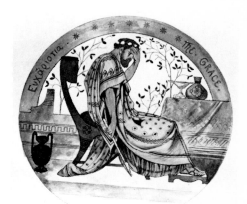

Biographies of Artists and Designers

Allen, Thomas
c. 1831–1915
Painter, designer
Born in Stoke, employed by Mintons from
c. 1845, trained at Stoke School of Art, won
National Scholarship to School of Design,
Marlborough House, in 1852, returned to
Stoke 1854. Painted figures and flowers on
porcelain largely in the Sèvres style, also
decorated majolica and tiles. Moved to
Wedgwood 1875

Arnoux, Joseph François Léon
1816–1902
Designer, chemist, Art Director 1849–92
Born St Gaudens, Toulouse, into a large,
well-established pottery family. Came to
England mid 1840s and started working for
Mintons as designer, Art Director 1849,
responsible for many technical and design
innovations including majolica, oriental
glazing, St Porchaire earthenwares.
Attracted distinguished French and English
designers and sculptors to Stoke, and
developed the Minton Patent Oven. Juror
at International Exhibitions, Companion of
the Legion of Honour 1878. Continued to
advise Mintons until his death

Bancroft, Joseph
c. 1796–c. 1860
Painter
Worked at Derby, moving to Stoke in
c. 1830. Specialised in flower and feather
painting on porcelain

Bell, John R A
1811–1895
Sculptor, modeller
Important sculptor trained at Royal
Academy Schools, exhibited R A 1833–77.
Modelled many figures and groups for
production in parian from c. 1847–c. 1855,
many for Summerly's Art Manufactures

Birks, Alboine
1861–1941
Pâte-sur-pâte decorator
Pupil of Solon, working c. 1873–1937

Birks, Lawrence
Pâte-sur-pâte decorator
Cousin of Alboine Birks, pupil of Solon,
working c. 1874–95

Boullemier, Antonin
1840–1900
Painter
Born at Metz, trained as a porcelain
painter, worked at Sèvres until 1870.
Employed by Mintons 1872 until death.
Exhibited R A 1881–82. Specialised in
delicate figure painting, notably cupids, on
earthenware and porcelain

Boullemier, Henri P.
Painter
Boullemier, Lucien
1876–1949
Painter
Sons of Antonin, working in same style and
specialising in Sèvres copies

Bourne, Samuel
c. 1789–c. 1865
Painter, Chief Designer c. 1828–63
Born Norton, Staffordshire, trained as a painter with Wood & Caldwell, Burslem. Specialised in romantic landscapes and topographical views. Son of the same name born 1822 was a flower painter

Carrier de Belleuse, Albert E.
1824–1887
Sculptor, modeller
Well-known French sculptor, employed as designer by Sèvres, working at Minton c. 1850–55, and later in freelance capacity after returning to France. Figure modeller in parian, porcelain and majolica. Also designed ironwork for Coalbrookdale

Cole, Sir Henry
1802–1882
Designer
Author, director of Summerly's Art Manufactures, designer of Society of Arts Prize tea service 1846, friend of Herbert Minton, member of Executive Committee of 1851 Exhibition, Secretary of Department of Science and Art 1853–73, director of first Museum of Ornamental Art (now the Victoria & Albert Museum)

Coleman, William Stephen
1829–1904
Designer, painter, Art Director 1871–73
Trained as naturalist, worked as designer and painter for Copeland, moved to Minton 1869, at first in freelance capacity. Director of Minton's Art Pottery Studio, Kensington Gore, London 1871–73. Specialised in naturalist subjects of Japanese and English inspiration, and in nude children and cherubs. After 1873 worked as freelance designer, painter and illustrator

Comolera, Paul
Modeller
French modeller, working 1873–c. 1880, specialising in life-size majolica models of birds and animals

Dean, J. Edward
d. 1935
Painter
Working from c. 1882 into twentieth century, specialising in animals, fish, birds, and Sèvres-type porcelains

Dresser, Dr Christopher
1834–1904
Designer
Botanist, designer and writer on design, working in many materials for many companies. Mintons produced shapes and decoration designed by him from c. 1865. Sold designs to the Kensington Art Pottery Studio. Mintons also used his published designs

Dudley, M.
Painter
Working from late nineteenth century, specialising in floral painting and Sèvres-type decoration

Foster, Herbert Wilson
1848–1929
Painter
Trained at Hanley School of Art and South Kensington, employed at Mintons 1872–93, specialising in portraits, figures, animals and birds on earthenware and porcelain

Goode, William J.
1831–1892
Designer, painter
Member of family and firm of Thomas Goode & Co, travelled widely, painted on earthenware and porcelain in style of W. S. Coleman, designed ornamental wares, invented process of etching on porcelain. Large private collection of eighteenth century Sèvres used as models by Mintons

Gregory, Albert
Painter
Floral painter working from c. 1890, later at Derby

Henk, Christian
1821–1905
Painter
German painter employed at Mintons from c. 1848 until his death, specialising in Watteau-style landscapes and figures

Henk, John
1846–1914
Modeller
Son of Christian, apprenticed to Mintons 1859 and employed until his death, became Chief Staff modeller specialising in majolica figures

Hollins, H.
Pâte-sur-pâte decorator
Trained by Solon, working c. 1872–80

Jahn, Louis M.
d. 1911
Painter, Art Director 1895–1900
Born Thuringia, worked in Vienna then came to England, employed by Mintons c. 1862–72, specialising in Sèvres-type painting. Art Director for Brownfields 1872–95, then returned to Mintons. Curator of Hanley Museum, 1900 until death

Jeannest, Emile
1813–1857, designer
French sculptor and silver designer, worked for Mintons c. 1846–52 designing figures, tablewares, ornaments and majolica. Later worked for Elkingtons

Joseph, Samuel
1800–1850
Sculptor
Modelled parian figures for Summerly's Art Manufactures

Kirkby, Thomas
1824–1891
Painter
Born Trentham, where he lived most of his life, joined Mintons 1841 and worked there until 1887, specialising in Watteau-type landscapes, cupid figures and majolica decoration

Latham, John
Painter
Working c. 1840–65, specialising in floral painting, moved later to Coalport

Lawton, Stephen
Painter
Working c. 1850–60, specialising in Limoges enamels

Leroy, Désiré
1804–1908
Painter
French painter working for Mintons c. 1874–90, probably after training at Sèvres, specialising in floral and bird subjects often painted in white enamels on coloured grounds. Moved to Derby in 1890

Lessore, Emile
1805–1876
Painter
French artist trained at Sèvres, worked for Mintons c. 1858–62 before moving to Wedgwood, where he established his reputation as an 'impressionist' decorator. Specialised in majolica painting, based often on Old Masters and developed a Barbizon-inspired way of painting

Linnell, John
1792–1882
Painter
Decorated for Summerly's Art Manufactures

Lockett, Benjamin
Painter
Working c. 1850–60, specialising in Limoges enamels

Longmore, Thomas
Modeller
Working c. 1865–1887

Marks, Henry Stacy R A
1829–1898
Designer, painter
Painter trained in the Royal Academy Schools and at Paris, working for Mintons from c. 1871, specialising in plaques and tile designs, many semi-humorous or in medieval costume. Many items bearing his name painted by students of the Art Studio

Mellor, T.
Pâte-sur-pâte decorator
Trained by Solon, working c. 1872–85, specialising in polychrome classical ornamentation. Later produced inferior copies of Solon wares under his own name

Moody, Francis Wollaston
1824–1886
Designer, painter
Instructor in Decorative Art, South Kensington Schools, involved in the design of the tiling schemes in the Victoria and Albert Museum, painted majolica wares

Mussill, William
d. 1906
Painter
Born Bohemia, studied in Paris, worked at Sèvres, moved to England and worked for Mintons c. 1872 to his death, specialising in bird, fish and flower painting in a thick *barbotine* technique on red earthenware and porcelain

Pratt, Henry L.
1805–1873
Painter
Trained at Derby, worked for Mintons 1830–40, specialising in landscapes and topographical views, left to become an illustrator, then returned to Stoke c. 1861 and worked again for Mintons in the same style as a freelance painter

Protat, Hughues
Sculptor, modeller
French sculptor employed by Mintons c. 1845–58, modelling instructor at Stoke School of Design 1850–64, moved to Wedgwood in 1858, but continued to work in a freelance capacity. Specialised in parian figures, ornamental wares in porcelain and majolica

Pugin, Augustus Welby Northmore
1812–1852
Designer
Architect, designer, writer, friend of Herbert Minton. Designed encaustic and printed tiles from c. 1842, also designed tableware, tiles, garden seats from 1849 to his death

Rhead, George Wooliscroft
d. 1920
Painter
Author and painter, exhibited R A 1882–96, working at Mintons in the 1870s. His brother, Frederick was a *pâte-sur-pâte* decorator, trained by Solon, and working c. 1872–77

Rice, Silas
Designer, painter
Working c. 1845–60, later at Wedgwood

Rischgitz, Edouard
1828–1909
Painter
French painter employed at Mintons c. 1864–70, painting landscapes and figures on porcelain and earthenware in style of Lessore

Sanders, H.
Pâte-sur-pâte decorator
Working c. 1872–76, later at Moore Brothers

Simeon, Victor
Designer, modeller
French-born, working c. 1850–60, known for his eccentric behaviour

Simpson, John
1811–1884
Painter
Born Derby, trained there as porcelain painter, moved to Stoke c. 1837 and worked for Mintons until c. 1847 as painter of figures, landscapes, portrait plaques. In 1847 took charge of porcelain painting classes at Marlborough House, and became a miniature painter, patronised by Queen Victoria and exhibiting R A 1847–71

Smith, John Moyr
Designer, painter
Designer, author, illustrator, editor of periodical *Decoration*, worked for Mintons c. 1872–89, designing printed tiles and some tableware

Solon, Léon Victor
1872–1957
Designer, Art Director 1909
Son of Louis Marc Solon, trained at Hanley School of Art and South Kensington, worked for Mintons from 1896, specialising in slip-trailed Art Nouveau decoration. Joint designer Secessionist Ware. Moved to USA 1909

Solon, Louis Marc Emmanuel
1835–1913
Pâte sur pâte decorator
Born Montauban, trained Paris as illustrator, worked at Sèvres, where he learnt the *pâte sur pâte* process, and then for the Paris designer and patron, E. Rousseau. Came to England in 1870, and worked for Mintons 1870–1904, specialising in *pâte-sur-pâte*, continued working in a freelance capacity until his death. Formed a large personal collection and a major ceramic library, wrote extensively on ceramic subjects

Steel, Thomas
1771–1850
Painter
Important flower and fruit painter, worked at Derby and Rockingham before moving to Minton in c. 1832, where he stayed until his death

Stevens, Alfred
1817–1875
Designer
Painter, sculptor and designer, studied in

Italy, appointed Assistant Master at School of Design, Somerset House in 1845. Worked for Mintons c. 1859–62, the last of a series of involvements with commercial manufacturers

Toft, Charles
1832–1909
Designer, modeller, decorator
Born and trained in Stoke, modelled figures and busts for Mintons and Worcester in the 1850s, best known for the copies of St Porchaire inlaid earthenwares made during the 1860s and 1870s. Taught at Birmingham School of Art, and designed metalware for Elkingtons. Later chief modeller for Wedgwood, started own pottery in 1889

Townshend, Henry James
1810–1890
Designer, modeller
Well-known painter exhibited R A 1839–66, designed tablewares and figures for Summerly's Art Manufacturers

Wadsworth, John William
1879–1955
Designer, Art Director 1909–14, 1935–55
Joint designer Secessionist Ware

Wise, William
Designer, painter
Working c. 1870–85, specialising in designs for printed tiles and painted majolica, exhibited R A 1876

Bibliography

Published material with relevant illustrations or text references is listed below in alphabetical order under author. Journals and exhibition catalogues are listed separately at the end. Each document is numbered, and these numbers are used to identify the source for illustrations or text references in the catalogue entries. Thus, *Ill: No. 6, pl. 35* means Godden, G. A., *Victorian Porcelain*, pl. 35.

1 Aslin, E.,
The Aesthetic Movement,
London, 1969
2 Bemrose, G.,
19th Century English Pottery & Porcelain,
London, 1952
3 Cole, Sir Henry, KGB,
Fifty Years of Public Work, 2 vols.,
London, 1884
4 Delange, C.,
Recueil de toutes les pièces de la faience française dite Henri II,
Paris, 1861
5 Godden, G. A.,
Minton Pottery & Porcelain of the First Period, 1793–1850,
London, 1968
6 Godden, G. A.,
Victorian Porcelain,
London, 1961
7 Godden, G. A.,
Illustrated Encyclopaedia of British Pottery & Porcelain,
London, 1966
8 Godden, G. A.,
Illustrated Guide to British Porcelain,
London, 1974
9 Godden, G. A.,
Illustrated Guide to British Pottery,
London, 1974
10 Hillier, B.,
Pottery & Porcelain 1700–1914,
London, 1968
11 Honey, W. B.,
English Pottery & Porcelain,
London, 1933
12 Jewitt, L.,
The Ceramic Art of Great Britain, 2 vols.,
London, 1878
13 Jewitt, L. and Godden, G. A.,
The Ceramic Art of Great Britain, rev. ed.
London, 1968
14 Mankowitz, W. and Haggar, R. G.,
Concise Encyclopedia of English Pottery & Porcelain,
London, 1957
15 Rhead, G. W. and F. A.,
Staffordshire Pots and Potters,
London, 1906
16 Shinn, C. and D.,
Victorian Parian China,
London, 1971
17 Wakefield, H.,
Victorian Pottery,
London, 1962

Journals
18 *Art Journal*,
London, 1849–1912

19 *Art Union*,
London, 1839–48
20 *Journal of Design and Manufacture*,
London, 1849–51

Exhibition catalogues
21 *Victorian & Edwardian Decorative Arts :
The Handley-Read Collection*,
Royal Academy, London, 1972
22 *The Aesthetic Movement and the Cult of
Japan*,
Fine Art Society, London, 1972
23 *Gothick 1720–1840*,
Brighton Art Gallery and Museum, 1975
24 *Victorian & Edwardian Decorative Arts*,
Victoria & Albert Museum, London, 1952

Further Reading
Barnard, J.,
Victorian Ceramic Tiles,
London, 1972
Blacker, J. F.,
Nineteenth Century Ceramic Art,
London, 1911
Fortnum, C. D. E.,
*A Descriptive Catalogue of the Maiolica,
Hispano-Moresco, Persian, Damascus, and
Rhodian Wares in the South Kensington
Museum*,
London, 1873
Giles Jones, A.,
Catalogue of the Minton Manuscripts, 2 vols.,
University College of North Wales, Bangor,
1973–75
Godden, G. A.
British Pottery & Porcelain 1780–1850,
London, 1963
de Guillebon, R. de P.,
Paris Porcelain 1770–1850,
London, 1972
Haslem, J.,
The Old Derby China Factory,
London, 1876

Troude, A.,
*Choix de Modèles de la Manufacture
Nationale de Porcelaine de Sèvres*,
Paris, 1897
Waring, J. B.,
*Masterpieces of Industrial Art & Sculpture
at the International Exhibition, 1862*
3 vols., London, 1863

Exhibitions

Exhibitions in which pieces now on display
have previously appeared are listed below,
with the shortened form of the title as it
appears in the catalogue entries.

Great Exhibition of the Industry of All
Nations 1851
London 1851
Universal Exhibition 1855
Paris 1855
International Exhibition 1862
London 1862
Universal Exhibition 1867
Paris 1867
International Exhibition 1871
London 1871
Universal Exhibition 1873
Vienna 1873
International Exhibition 1874
London 1874
Philadelphia Centennial Exhibition 1876
Philadelphia 1876
Universal Exhibition 1878
Paris 1878
Universal Exhibition 1889
Paris 1889
Victorian & Edwardian Decorative Arts,
Victoria and Albert Museum, London 1952
V & E
The Aesthetic Movement and the Cult of
Japan, Fine Art Society, London 1972
Fine Art
Gothick 1720–1840, Brighton Art Gallery
and Museum, 1975
Brighton

Minton Factory Marks

The marks found most frequently are illustrated and numbered below. These numbers are used in the catalogue to identify the various styles of mark, while the method of application is explained in full in each entry, for example:
Marks: No. 1, painted in blue.
Unusual marks are detailed fully in the entry where they occur, as are all additional pieces of information such as date, inscription, painter's signature or monogram.
Also illustrated (page 18) is the table of yearly marks, used fairly generally from 1842 to 1942 to indicate date of manufacture. Whenever they occur, date marks are specified in the entry.
There are also references in the entries to the Design Registration Marks, the diamond shape device in use 1842 to 1883. Wherever possible the date of registration is given, which refers to the date of introduction of a design or shape, and not to the date of manufacture.

Mark No. 1
Sèvres-type, or double L mark
Occurs frequently on porcelain tablewares of the period c. 1798–16, often accompanied by the pattern number. Can also be found on some ornamental porcelains of the same period

Mark No. 2
Moulded cartouche mark
Occurs frequently on stonewares, earthenwares and parian tablewares of the period c. 1830–50. The mark usually incorporates the pattern number and M, or M & Co, and may be accompanied by a moulded Society of Arts mark

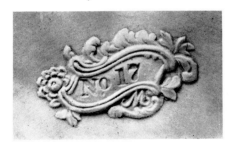

Mark No. 3

Printed cartouche mark

Occurs frequently with many variations on earthenwares, ironstones, blue-printed wares, felspar porcelains etc., and may incorporate M, M & Co, M & B (Minton & Boyle 1836–41) or M & H (Minton & Hollins 1845 on). These printed marks were used from c. 1825 to the end of the century

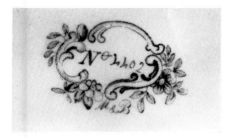

Mark No. 4

Moulded Summerly mark

Found on figures designed by John Bell for the Summerly Art Manufactures, c. 1846–52, incorporating Bell's name and the FS monogram

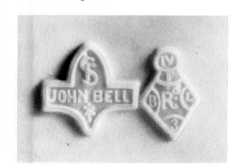

Mark No. 5

Ermine mark

Occurs frequently on ornamental porcelains and tablewares of the period c. 1845–65. Can also be found on parian figures. May be incised, or painted or printed in a variety of colours, and is often accompanied by other marks

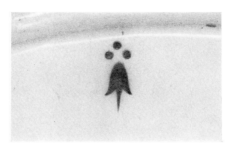

Mark No. 6

Printed circular crown and ermine mark

Occurs frequently on high quality ornamental porcelains and earthenwares of the period c. 1860–70, including many Exhibition pieces

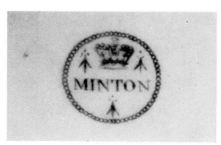

Mark No. 7

Impressed Minton mark

Occurs frequently on all categories of ware from c. 1862 to the present day, often accompanied by an impressed date mark. In 1873 the mark became MINTONS

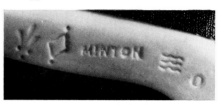

Mark No. 8

Printed 1878 Exhibition mark

Special mark used on pieces made for the 1878 Exhibition, usually in gold

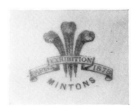

Mark No. 9

Printed Studio mark

Sometimes found on earthenwares decorated at Minton's Art Pottery Studio, South Kensington, 1871–74

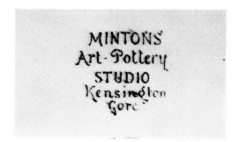

Mark No. 10

Printed globe mark

Found, with many variations, on all categories of ware from c. 1863 to the present day, in many colours. In 1873 the name was changed to MINTONS, in the early 1880s a crown was added above the globe and in 1891 England was added below the globe. The addition of wreaths and the words Made in England date from c. 1912. The globe mark was frequently incorporated in a printed retailer's mark, to indicate wares made to special order for Goode's, Mortlock's, Phillips and for many American and Canadian retailers

Mark No. 11

Printed Secessionist mark

Occurs frequently on moulded and slip-trailed Secessionist earthenwares of the period c. 1902–14

Yearly marks

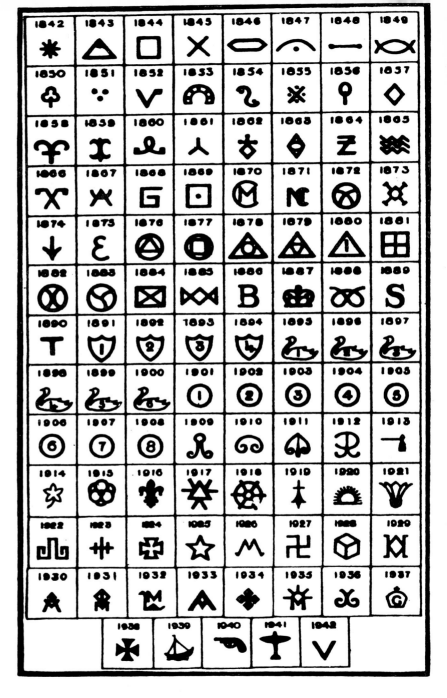

Catalogue

Notes on the Catalogue

All sizes are given in centimetres, and refer to the height unless otherwise stated.

In the descriptions of the pieces the words *Minton ornament design number* and *Minton figure design number* are frequently used. These refer to the numbers in the surviving design record books, which indicate that designs were entered in chronological order. The existence of a design in the records does not necessarily mean that the design was put into production, nor does it give any indication of quantity. There are some wares that do not appear to be in the design books, but are marked Minton, while other, unmarked pieces can only be identified by the designs. Many designs in record books were also produced in a variety of materials and styles.

The surviving design books are housed at present with the Minton archives in the Library of the University College of North Wales, Bangor, and may be viewed by appointment.

The names given to objects in this catalogue are taken, whenever possible, from the Minton design record books, and these are used as they occur, including mis-spellings and other eccentricities of the period.

Items owned by Royal Doulton Tableware Limited have been drawn from the Minton Museum in Stoke-on-Trent, one of the most important 19th century ceramic collections in the world.

Marks are identified in the catalogue entries by a number system which refers to the marks illustrated on page 16. Illustrations and text references in previously published material are identified also by a number system which refers to the bibliography, page 14, in which books are listed alphabetically under author.

The following abbreviations are used:

Ill: Illustrated

Ref: Reference

Ex: Exhibited

Dates are given whenever possible. These refer to the date of manufacture, and not to the date of introduction of the design.

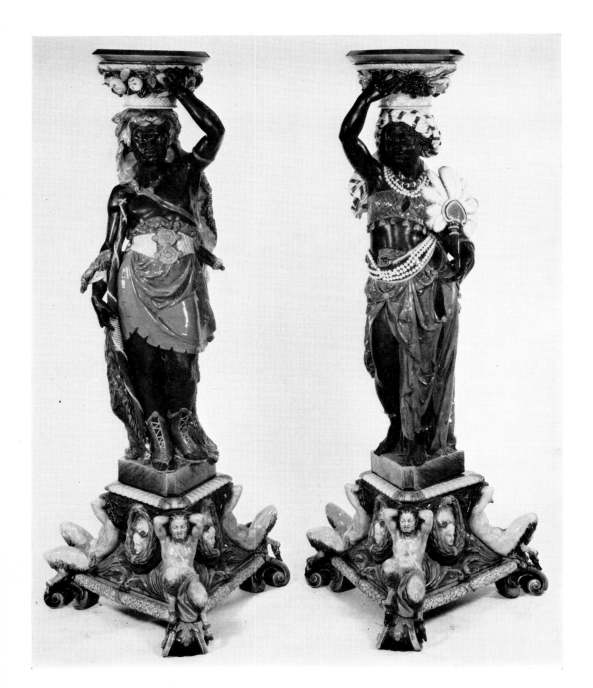

Catalogue F21 & 22

Section A

Early tablewares
c. 1798–1830

From 1793 to 1836, the period of Thomas Minton's control, production was concentrated on tableware of all types. At first, earthenware only was produced, mostly decorated with blue-printed patterns such as Broseley and Willow, but after 1798 cream-coloured wares and bone china were made in large quantities. The growth of the factory was quite dramatic in the years leading up to 1810; in that year the total stock, buildings, equipment and materials in hand were valued at £9,743 1s 2d.[1] Surviving stock ledgers show the wide range of wares being produced, which, apart from the usual tableware items, included asparagus trays, beehive honey pots, glass coolers, paint cups, toast racks, artichoke cups and tooth brush trays. An equally large range of patterns was entered in the pattern books, which had reached number 704 by 1811. These reflect the variety of styles and techniques that characterised china production in Staffordshire and elsewhere during this period and include bat-printing, Imari designs, chinoiseries, lustres, French-inspired floral patterns, neo-classical designs, and landscapes. Overglaze enamel decoration was frequently used, often enriched with gilding, and in many patterns an underglaze print delineated the outline of the design. Many Minton patterns are very similar to those produced by their rivals, for example Spode, Miles Mason, New Hall and Pinxton, and so can only be distinguished by the pattern numbers.

For reasons not fully understood, porcelain production ceased c. 1816, and was not resumed until 1824. During this period, earthenware and cream colour dominated once again. After the resumption of porcelain production styles again followed contemporary taste, reflecting the influence of France, especially Paris porcelain, the neo-rococo movement and the eighteenth century, and the wares of contemporary English manufacturers, in particular Derby, Rockingham, Davenport and the Welsh factories. Much early tableware was unmarked, especially the earthenware and cream colour, but bone china of the period c. 1798–1816 sometimes carries a painted Sèvres-type mark (No. 1) and the pattern number. After 1824 most bone china tableware was unmarked, except by pattern numbers.

(1) Minton mss 1228

A1. Cup and saucer

Bone china, the saucer dish-shaped with no footrim the cup with a ring handle, painted in enamels with a border of floral swags, Minton pattern number 18
Cup 5.6 cms, saucer 13.7 cms diam.
Marks: Painted pattern number
Date: c. 1789
Victoria & Albert Museum (3084 & a-1901)

A2. Cup and saucer

Bone china, the saucer dish-shaped with no footrim, the cup with a ring handle, painted with exotic flowers and foliage in brown and red and enriched with gilding, Minton pattern number 85
Cup 6 cms, saucer 13.7 cms diam.
Marks: No. 1 and pattern number painted in blue
Date: c. 1802
Royal Doulton Tableware Limited

A3. Cup and saucer

Bone china, the saucer dish-shaped with no footrim, the cup with a ring handle, painted with landscapes in black enamel and enriched with gilding, Minton pattern number 119
Cup 6 cms, saucer 13.8 cms
Marks: No. 1 and pattern number painted in blue
Date: c. 1800
City Museum & Art Gallery, Stoke (360 P 35)
Ill: No. 5, pl. 12

A4. Breakfast cup and saucer

Bone china, the saucer dish-shaped with no footrim, the cup with a ring handle, transfer-printed with oriental flowers and overpainted with enamels, enriched with gilding, Minton pattern number 236
Cup 6.8 cms, saucer 15.2 cms diam.

Marks: No. 1 and pattern number painted in blue
Date: c. 1802
City Museum & Art Gallery, Stoke (4047 & 4049)

A5. Cup and saucer

Bone china, the saucer dish-shaped with no footrim, the cup with a ring handle, painted in gold with a design of holly leaves and insects, Minton pattern number 465
Cup 6 cms, saucer 13.8 cms diam.
Marks: No. 1 and pattern number painted in blue
Date: c. 1808
Royal Doulton Tableware Limited

A6. Cup and saucer

Bone china, the saucer dish-shaped with no footrim, the cup with a ring handle, painted in red and blue enamel with an Imari pattern and enriched with gilding, Minton pattern number 545
Cup 6 cms, saucer 13.8 cms diam.
Marks: No. 1 and pattern number painted in blue
Date: c. 1808
City Museum & Art Gallery, Stoke (4048)
Ill: No. 2, pl. 48B

Plate 1. Catalogue A4

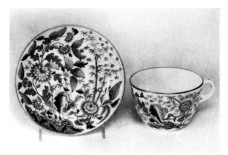

A7. Cup, coffee can and saucer

Bone china, the saucer dish-shaped with no footrim, the cup and can with ring handles, painted in gold with a design of arcades alternately filled with neo-classical vases and acanthus leaves in the style of contemporary Paris porcelain, Minton pattern number 238
Coffee can 6.4 cms, cup 6 cms, saucer 13.8 cms diam.
Marks: Pattern number painted in gold
Date: c. 1805
G. A. Godden

A8. Coffee can

Bone china, cylinder shape with ring handle, painted with cornflower sprays in green and purple enamel and enriched with gilding, Minton pattern number 31
6.1 cms
Marks: No. 1 and pattern number painted in blue
Date: c. 1800
Victoria & Albert Museum (c. 723-1921)

A9. Coffee can

Bone china, cylinder shape with ring handle painted in enamels with freely-drawn oriental figures in a landscape and enriched with gilding, Minton pattern number 105
6 cms
Date: c. 1800
City Museum & Art Gallery, Stoke (50 P 33)
This type of oriental design, derived from eighteenth century Chinese export porcelains, was produced by many factories during this period, the best-known being New Hall

A10. Coffee can

Bone china, cylinder shape with ring handle, bat-printed in sepia with sea-shell

motifs and enriched with gilding, Minton pattern number 723
6.1 cms
Marks: No. 1 and pattern number painted in blue
Date: c. 1808
City Museum & Art Gallery, Stoke
The bat-printed record book, still preserved in the printing shop at the Minton factory, includes these designs

A11. Mug
Bone china, cylinder shape with square handle, bat-printed in red with a scene of gothic ruins and the motto *A Gift from the Potteries*
5. 9 cms
Date: c. 1812
Royal Doulton Tablewares Limited
Although unmarked, this mug is of a well-known Minton shape. The bat-print record book includes this design

A12. Jug
Bone china, globe shape, painted on both sides in enamels in Pinxton style with landscape scenes enclosed in gilt roundels, the neck decorated with a gilt Greek key design, Minton pattern number 248
11.5 cms
Marks: Pattern number painted in gold
Date: c. 1805
G. A. Godden

A.13. Sauce boat
Bone china, oval shape, painted in enamels with a scene of oriental figures in a landscape and enriched with gilding, Minton pattern number 757
11 cms

Marks: Pattern number painted in blue
Date: c. 1808
City Museum & Art Gallery, Stoke (887 P 58)

A14. Teapot and cover
Bone china, straight-sided oval shape, painted with a band of floral and foliate forms in puce enamel and enriched with gilding, Minton pattern number 111
15.8 cms
Marks: M111 painted in red
Date: c. 1800
City Museum & Art Gallery, Stoke (879 P 58)

A15. Teapot and cover
Bone china, canoe shape, painted with a deep blue band decorated with gilt scrolls and enriched with gilding, Minton pattern number 909
15. 2 cms
Marks: No. 1 and pattern number painted in blue
Date: c. 1810
Royal Doulton Tableware Limited

Plate 2. Catalogue A12

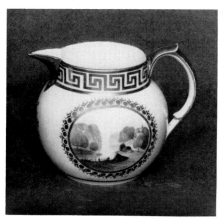

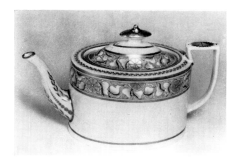

Plate 3. Catalogue A14

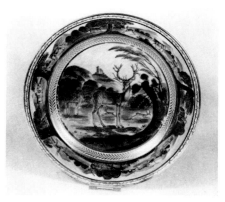

Plate 4. Catalogue A16

A16. Plate
Bone china, painted in enamels with a scene of a deer standing in a landscape, the rim painted with a frieze of domestic and wild animals, after T. Bewick, and enriched with gilding
22.3 cms diam.
Marks: No. 1 painted in blue
Date: c. 1805
Royal Doulton Tableware Limited
Ill: No. 5, pl. 32 and 33 for other pieces from the service
This plate, and the related items preserved in the Minton Museum, Stoke, probably come from a service made to special order as

there is no record of this design in the
pattern books. The gothic ruin painted in
the landscape appears to represent a folly
erected on Mow Cop, Cheshire, in 1754

A17. Saucer dish

Bone china, bat-printed in sepia with sea-
shell motifs and enriched with gilding,
Minton pattern number 723
20.2 cms
Marks: No. 1 and pattern number painted
in blue
Date: c. 1808
Victoria & Albert Museum (2733–1901)
See also catalogue A10 for similar bat-
printed decoration

A18. Plate

Bone china, painted in underglaze blue and
coloured enamels with a chinoiserie
landscape scene and enriched with gilding,
Minton pattern number 816
22.5 cms diam
Marks: No. 1 and pattern number painted
in blue
Date: c. 1810
Victoria & Albert Museum (2721–1901)
Ill: No. 11, pl xx(a); No. 14, pl. 68

A19. Bowl

Bone china, steep-walled circular shape with
pronounced footrim, painted inside and out
with exotic flowers and leaves in red on a
pale green ground in *famille verte* style,
enriched with gilding, Minton pattern
number 178
29 cms diam.
Marks: No. 1 and pattern number painted
in blue
Date: c. 1804
Royal Doulton Tablewares Limited

Plate 5. Catalogue A17

A20. Bowl

Bone china, steep-walled circular shape
with pronounced footrim, painted inside
and out in coloured enamels with floral
sprays reserved out of a dark blue ground
and enriched with gilding, Minton pattern
number 499
25.2 cms diam.
Marks: No. 1 and pattern number painted
in blue
Date: c. 1808
Victoria & Albert Museum (312–1869)
Ill: No. 5, pl. 63

A21. Caudle Cup and Stand

Bone china, trumpet-shaped cup on three
claw feet, the handle moulded as a leaf and
stem, the saucer steep-sided with a
pronounced footrim, the cup painted in
enamels with a continuous landscape,
both pieces with an emerald green ground
and enriched with gilding, Minton ornament
design number 55
Cup 9 cms
Date: c. 1828

G. A. Godden
Ill: No. 5, pl. 79
Based on Paris porcelain of circa 1815,
probably from models by Darte or Dagoty
et Honoré

A22. Veilleuse, or Night Lamp

Bone china, comprising a small teapot and
cover with pronounced knop, heavily gilded,
a cylindrical central drum with castellated
top, painted in coloured enamels with an
Italianate landscape scene and gilded, and
a circular base, also richly gilded, which
holds the night-light, Minton ornament
design number 40
22. 3 cms
Date: c. 1828
Victoria & Albert Museum (c. 601a-e-1935)
Ill: No. 5, col. pl. III; No. 8, pl. 378
Catalogued for many years as Swansea or
Nantgarw, this veilleuse is typical of the
high-quality wares produced by Minton
during the 1825–40 period. Very similar
Night Lamps also exist with a Derby mark

Section B

Biscuit and enamel-painted porcelain figures
c. 1826–45

In the Minton stock ledgers of 1810–13 there are intriguing references to 'figures' and 'chimney ornaments',[1] while the list of moulds drawn up in 1817 includes 12 moulds for figures. However, it is not possible at present to identify these early figures.

Minton figures in biscuit and enamel-painted porcelain really belong to the post-1824 period, and were probably not in production until c. 1826. Like the ornamental wares of the same period, Minton figures are known largely through the surviving design books, which show a sequence that starts with 1 and continues through the century, reaching 503 in c. 1888. The range of early figures reveals the same catholic uses of sources and influences as the ornamental porcelains.

The first Minton figures were modelled in low relief in Staffordshire style with undecorated backs. Modelling in the round was not introduced until c. 1828. From c. 1830 a variety of portrait busts and figures were produced, followed by figures based on eighteenth century continental models probably known through Derby copies, and upon sculptors such as Clodion and Canova. Theatre, literature, politics, religion, legend and history also provided many subjects. By the late 1830s Minton had achieved a very high quality of modelling and decoration, but unfortunately the artists who brought this about are largely unknown. Keys, Cocker and Whitaker are known to have modelled for Minton, but it is not possible to attribute figures to them.

Many figures were produced both in biscuit and with enamel painting and gilding, and in many cases the same moulds remained in use after the introduction of parian porcelain in c. 1846.

Few early figures are marked, and so attribution is dependent upon the design books.

(1) Minton Mss 1228, 1282

B1. Sancho Panza
Bone china, relief figure seated on a
donkey, brightly painted with enamels and
enriched with gilding, Minton figure design
number 7. The name *Sancha Panza* (sic) is
painted on the front of the oval base
11.8 cms
Date: c. 1827
H. V. Levy
Ill: No. 5, pl. 29
The earliest Minton figures are mainly
reliefs, their undecorated backs recessed
where modelling appears at the front.

B2. Don Quixote
Bone china, relief figure seated on a horse,
brightly painted with enamels and enriched
with gilding, Minton figure design number
8. The name *Don Quixotte* (sic) is painted
on the front of the oval base
13 cms
Date: c. 1827
H. V. Levy

Plate 6. Catalogue B2

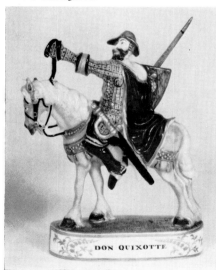

DON QUIXOTTE

B3. Good Night
Bone china figure of a little girl kneeling on
a cushion, taking off her shoes, brightly
painted with enamels and enriched with
gilding, Minton figure design number 12
8.7 cms
Date: c. 1830
H. V. Levy
Also issued in biscuit porcelain and parian,
this popular figure remained in production
for many years. Marked Derby examples
also exist, along with its companion, Infant
Samuel (Minton number 11), which is after
Reynolds

B4. Good Night
Biscuit porcelain figure of a little girl
kneeling on a cushion, taking off her shoes,
Minton figure design number 12
8.7 cms
Date: c. 1830
H. V. Levy

B5. Good Night
Parian figure of a little girl kneeling on a
cushion, taking off her shoes, Minton figure
design number 12
8.5 cms
Marks: No. 7 impressed
Date: c. 1855
H. V. Levy
This figure is listed second in the first
Minton parian catalogue, issued in 1852

**B6 & B7. King William IV and Queen
Adelaide**
Pair of biscuit porcelain busts on square
bases, Minton figure design numbers 14
and 15
11.2 cms
Date: c. 1830
H. V. Levy

Ill: No. 5, pl. 143
William IV reigned from 1830 to 1837

B8. Lord Brougham
Biscuit porcelain bust on a glazed square
base, Minton figure design number 16
11 cms
Date: c. 1832
H. V. Levy
Ill: No. 5, pl. 143
Lord Brougham was elevated to the
peerage in 1830, and was associated with
the Reform Bill of 1832. This bust has
also been found with a Rockingham mark,
and the style of the portrait is similar to
that frequently found on brown saltglazed
stoneware spirit flasks

B9. Lord Grey
Biscuit porcelain bust on square glazed base,
Minton figure design number 17. The
name *Earl Grey* is painted in gold on the
front of the base
17 cms
Date: c. 1832
G. A. Godden
Ill: No. 5, pl. 134
Earl Grey became Prime Minister in 1831.
His close association with the Reform Bill
(1832) made him a popular figure for
ceramic modellers; apart from busts such as
this he is depicted on a variety of brown
saltglaze stoneware spirit flasks

B10. Greyhound
Biscuit porcelain figure of a greyhound
seated on a cushion, its front paws crossed,
Minton figure design number 18
6.2 cms
Date: c. 1832
H. V. Levy

B11. Poodle

Bone china figure of a French poodle crouching on a cushion with its rear legs raised, after a Vincennes model, painted with enamels and enriched with gilding, Minton figure design number 19
7.4 cms
Date: c. 1832
H. V. Levy

B12. Mrs H. Moore

Biscuit porcelain figure seated in an armchair on a pierced scroll-work base, Minton figure design number 60
17 cms
Date: c. 1835
H. V. Levy
Ill: No. 5, pl. 135
Based on the portrait dated 1821 by H. W. Pickersgill (1782–1857) of Hannah Moore, the religious writer who died in 1833, this style of biscuit figure is commonly attributed to the Derby or Rockingham factories. It is a companion piece to the figure of Wilberforce, with whom Mrs Moore was associated

B13. Wilberforce

Biscuit porcelain figure reading a book, seated in an armchair on a pierced scroll-work base, with more books piled under the chair, Minton figure design number 63
19.5 cms
Date: c. 1835
H. V. Levy
Ill: No. 5, pl. 135
This figure of William Wilberforce, famous for his work in connection with the abolition of slavery and the founding of the Church Missionary Society, is a companion to that of Mrs H. Moore. Both figures were also produced at Derby, modelled by George Cocker (see J. Haslem, *The Old*

Derby China Factory, p. 159, and F. Brayshaw Gilhespy, *Crown Derby Porcelain*, pl. 171)

B14. Duke of Wellington

Biscuit porcelain standing figure on a circular base, Minton figure design number 78
28.5 cms
Date: c. 1838
H. V. Levy
Ill. No. 5, pl. 134

B15. Gleaner

Bone china figure of a seated girl, after a Meissen model, holding a sheaf of corn, on a scroll base, brightly painted with enamels and enriched with gilding, Minton figure design number 83
13.8 cms
Date: c. 1837
H. V. Levy

B16 & B17. Male standing with Basket and Female Companion

Pair of bone china figures standing on scroll bases which also support baskets, after Meissen models, the girl holding a bunch of flowers in her right hand, her wide hat on a cord round her neck, the man standing with one leg raised, holding a bunch of grapes in his left hand, both painted with enamels and enriched with gilding, Minton figure designs numbers 84 and 85
21.2 cms
Date: c. 1836
H. V. Levy
Ill: No. 5, pl. 141 (male only)

B18. Guitar Player and Harper

Bone china group, comprising male guitar player and female harp player seated side by side on a scroll base, brightly painted with

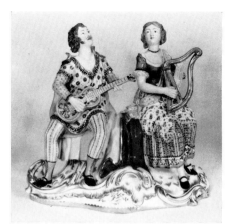

Plate 7. Catalogue B18

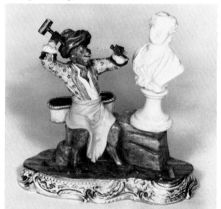

Plate 8. Catalogue B19

enamels and enriched with gilding, Minton figure design number 99
15 cms
Date: c. 1837
H. V. Levy
This figure, and catalogue B20, may be based on contemporary Paris porcelain models by Jacob Petit

B19. Burlesque Sculptor

Bone china figure of a flamboyant monkey

richly dressed, sculpting a bust on a plinth, the scroll base scattered with assorted tools, painted with enamel colours and enriched with gilding, Minton figure design number 117
17.8 cms
Date: c. 1837
F. Halliwell

B20. Arabia
Bone china figure of a girl wearing a turban and a cloak, holding with both hands a classical vase painted with flower sprays which is standing on a rock, on an irregular base, painted with enamels and enriched with gilding, Minton figure design number 137. The word *Arabia* is painted in gold on a panel set onto the base
32 cms
Date: c. 1838
H. V. Levy
Ill: No. 5, col. pl. XII

B21. Sense of Smelling
Biscuit porcelain figure of a seated girl smelling a bunch of flowers, her left arm leaning on a small side table, on a rectangular base, Minton figure design number 147
13.8 cms
Date: c. 1842
H. V. Levy
Ill: No. 8, pl. 388
Ref: No. 19, December 1846
One of a group of five Senses, based on Meissen models, of 1772–74. The lace work on this figure shows the quality of Minton figure modelling during this early period

B22 & B23. Admiral and Lady with Muff
Pair of bone china standing figures on scroll bases, after Meissen models, the admiral

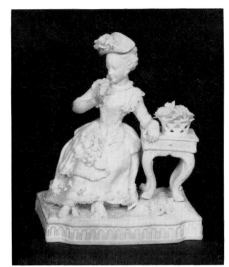
Plate 9. Catalogue B21

holding a telescope to his right eye, the lady reading a letter held in her right hand, brightly painted with enamels and enriched with gilding, Minton figure designs number 155 and 156
21.2 cms
Date: c. 1840
H. V. Levy
Despite their German ancestry these figures have been adapted to represent Nelson and Lady Hamilton, for the letter that the lady is holding is clearly inscribed: '1797 Dear Emma . . .'

B24 & B25. Extinguisher Figures
Pair of bone china hollow standing figures, the male raising his hat, the female holding a fan, brightly painted with enamels and enriched with gilding, Minton ornament design number 176
7.5 cms
Date: c. 1837
H. V. Levy

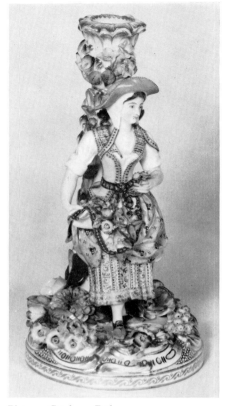
Plate 10. Catalogue B26

Ill: A similar male figure is shown as part of a bower candlestick in No. 5, pl. 147
These extinguisher figures were sold originally either as part of the bower candlesticks (design number 173), or on a tray

B26. Single Figure Candlestick
Bone china figure of a girl with flowers in her apron standing on a circular base, behind her a tree-trunk forming a candlestick, the base and tree-trunk encrusted with flowers, brightly painted

28

with enamels and enriched with gilding,
Minton ornament design number 192
22.3 cms
Date: c. 1837
Victoria & Albert Museum (c. 699-1935)
Ill: No. 5, pl. 146
There is a male companion to this figure;
both figures also occur in simpler shell
bases, with no floral encrustation, and on
plain circular ribbed bases

B27 & B28. Candlestick Figures
Pair of bone china figures, after Meissen
models, seated on elaborate rococo ormolu
candlesticks, the male with a basket of fruit
on his lap, the female holding a wreath of
flowers, brightly painted with enamels and
enriched with gilding
Candlesticks 27.6 cms, figures 10 cms
Date: c. 1838
H. V. Levy
Ill: Similar figures seated as part of bower
candlesticks, No. 5, col. pl. XI
These figures were also produced at Derby

Section C
Ornamental porcelains
c. 1815–45

Although ornamental wares were made
during the first period of porcelain
production, c. 1798–1816, they played no
significant part in Minton's output. After
1824, when the influence of Herbert Minton
was becoming more apparent, a large range
of ornamental porcelain was put into
production. Surviving design books show a
numerical sequence that started at 1 and
reached 255 by 1840. The sequence
continued throughout the century,
reaching about 3500 by 1900. These designs
reflect a great variety of styles and reveal
that the Minton factory was very much in
touch with contemporary British and
European taste in porcelain. Derby-type
flower encrustations were produced side by
side with copies of eighteenth century
Meissen, Sèvres and Chelsea wares, often
identified as such in the design books. It is
possible that some of this familiarity with
continental styles was based on eighteenth
century Derby copies rather than on the
originals themselves. Greek and Roman art,
the Renaissance, Mannerism, the Gothic
revival and Neo-classicism also proved a
rich source of ideas for the Minton modellers
and decorators, while many pieces also
reveal a considerable debt to contemporary
French porcelains, especially to the products
of Jacob Petit. This catholic use of sources
is important in relation to the later
development of the factory, for it shows that
the internationalism that characterised
Minton after 1850 was well-established long
before the coming of Léon Arnoux.

Styles of decoration also reflected
contemporary taste, and the skills of the
Derby-trained painters were much in
demand. The names of many of these
painters are well known, Steel, Bancroft,
Simpson, Wareham, Smith, Bourne, etc.,
but the development of factory, as opposed
to individual style makes attribution an
unprofitable activity.
Few of the early ornamental porcelains were
marked with any regularity until the
introduction of the ermine mark (No. 5) in
c. 1850, but examples are known with
Meissen-type crossed swords marks, rare
printed marks and dates. This anonymity
makes the attribution of Minton wares
difficult, and so a degree of familiarity with
the design books is essential.

C1. Vase

Bone china, crater shaped with two low-set handles, painted with Italianate landscapes in monochrome puce enamel and enriched with gilding

15 cms

Marks: No. 1 painted in blue

Date: c. 1815

Royal Doulton Tableware Limited

Ill: No. 5, pl. 56

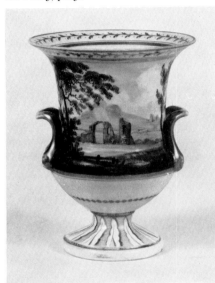

Plate 11. Catalogue C1

C2. Vase

Bone china, krater shaped with two low-set handles, painted in enamels with two panels of flower sprays reserved out of a dark blue ground, further decorated with gilt leaves and enriched overall with gilding, Minton pattern number 780

16.5 cms

Marks: No. 1 and pattern number painted in blue

Date: c. 1815

Victoria & Albert Museum (C.683-1935)

Ill: No. 5, col. pl. I; No. 8, pl. 373

This is the central vase of a garniture of three, all with identical decoration. It is unusual to find a numbered tableware pattern used on an ornamental piece

C3. Gothic Pedestal Ornament

Bone china, krater shaped vase with two low-set mask handles on a tall plinth decorated with gothic moulding, painted in enamels with a scene of an abbey reserved out of a green ground and enriched with jewelling and gilding, Minton ornament design number 4

25 cms

Date: c. 1830

G. A. Godden

Ill: No. 5, pl. 112; No. 23, pl. 37

Ex: Brighton, no. F41

This style of Gothic ornamentation probably comes from Paris porcelain, and shows the scale of Minton's dependence on French styles

C4. Wellington Vase

Bone china, classical shaped vase on a circular plinth, with a flared neck, moulded acanthus decoration and ram's head handles, painted in enamels with flower sprays on a dark blue ground, enriched with gilding, Minton ornament design number 11

38 cms

Possibly painted by Thomas Steel

Date: c. 1830

G. A. Godden

Ill: No. 5, col. pl. VI, pl. 114; No. 8, pl. 381; No. 13, pl. 67

The Wellington vase was made in three sizes and in a number of colours

C5. Globe Potpourri raised flowers

Bone china, globe shaped with crabstock handles, after a Meissen model, painted in enamels on the front with a Highland landscape inscribed *Glen Gyle* and on the verso with a floral spray, encrusted with modelled flowers around the painting and on the lid and enriched with gilding, Minton ornament design number 19

17 cms

Marks: Crossed swords painted in blue on both vase and cover

Date: c. 1830

G. A. Godden

Ill: No. 2, pl. 63A; No. 5, pl. 97

C6. Thermometer

Bone china, shaped as an arched frame for a brass thermometer, with moulded scroll work and bow-fronted base, painted in green and yellow enamels and enriched with gilding, Minton ornament design number 35

17.5 cms

Date: c. 1830

Victoria & Albert Museum (C.770-1935)

Ill: No. 5, pl. 106

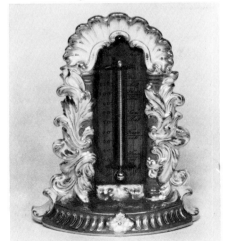

Plate 12. Catalogue C6

C7. Castle Ink

Bone china, modelled to represent the façade of a battlemented Gothic castle with two towers, the details of the door and windows and the plants growing up the walls painted in gold, dated 1724 in a panel above the door, Minton ornament design number 43

8 cms
Date: c. 1830
G. A. Godden
Ill: No. 5, pl. 89

This is one of a series of Minton inkwells and pastille burners in the form of buildings. Other examples include the Colyseum Ink or Pastile (sic), design number 33, and the Cottage Ink or Pastile, design number 49

C8. Dresden Scroll Vase with raised flowers

Bone china, ovoid shape on tall foot with two scroll handles, the pierced cover surmounted with a seated male figure richly painted in enamels, both pieces encrusted with modelled flowers and painted in enamels with flower sprays and enriched with gilding, Minton ornament design number 77

45 cms
Date: c. 1835
G. A. Godden
Ill: No. 5, pl. 117; No. 8, pl. 382; No. 7, col. pl. VIII

C9. Sèvres Eared Vase

Bone china, pear-shaped with two handles formed from the rococo moulded mouth, painted in enamels with Watteau figures in an irregular panel reserved out of an apple green ground, enriched with gilt foliage, Minton ornament design number 99

20.4 cms
Possibly painted by Christian Henk

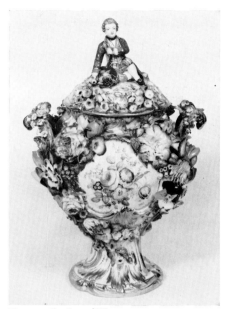

Plate 13. Catalogue C8

Marks: No. 5 printed in green
Date: c. 1850
Victoria & Albert Museum (C.685-1935)
Ill: Similar vase, No. 5, pl. 118
Copied from an eighteenth century Sèvres *vase à oreilles*, the design for this vase probably dates from the early 1830s

C10. Large Table Ornament

Bone china, spherical covered vase surmounted by gilded flames and supported by three standing gilded cherubs, themselves standing on a square plinth supported at the corners by gilded dolphins, the vase painted in enamels with bird and flower panels alternating with bands of deep blue, the plinth painted in enamels with Watteau figures reserved out of a deep blue and gilt *caillouté* ground, enriched overall with gilding, Minton ornament design number 159

66 cms
Date: c. 1837
G. A. Godden
Ill: No. 5, col. pl. VII, pl. 105

C11. Octagon Chelsea Vase

Bone china, flattened octagonal shape with a narrow neck, decorated with two elaborate rococo scroll handles, painted in enamels with a romantic scene of a man fishing before the ruins of Donegal Castle on the front, and on the verso and neck with flower sprays, all reserved out of a deep blue ground and enriched with gilding, Minton ornament design number 165

46 cms
Marks: *Donegal Castle* painted in red on the base
Date: c. 1837
G. A. Godden
Ill: No. 5, pl. 119; No. 8, col. pl. VII

This vase was made in four sizes, the largest 55 cms high. The design was probably based on the pair of Chelsea vases of c. 1762 known as the *Chesterfield Vase* and the *Foundling Vase*, illustrated by J. V. G. Mallet in the *Bulletin of the Victoria & Albert Museum*, January 1965, pp. 30-1

C12. New Tray

Bone china, irregular oval shape with two raised handles after a Sèvres *plateau Hebert*, richly painted in enamels with a seated Virgin and Child reserved out of a deep blue ground and enriched with gilding, Minton ornament design number 245

32 cms diam.
Probably painted by John Simpson, after Raphael
Marks: *Virgin and Child* painted on base
Date: c. 1840
G. A. Godden
Ill: No. 5, pl. 107

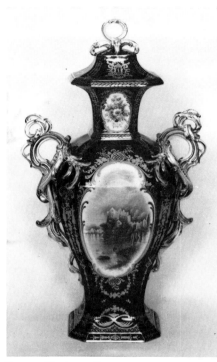

Plate 14. Catalogue C11

Plate 15. Catalogue C14

C13. Vase
Bone china, rococo Sèvres shape with two handles and flared neck, painted in enamels with a rustic landscape reserved out of a green, white and gold tartan ground and enriched with gilding, Minton ornament design number 210
25.5 cms
Date: c. 1835
G. A. Godden

C14. Tray
Bone china, octagonal shape, painted in enamels with a scene of children and girls playing with a swing in a rustic landscape and enriched with raised gilding
23.5 cms diam.
Painted by Samuel Bourne
Marks: Signed *S. Bourne*, rare printed mark, MINTON enclosed by scrolls forming two cursive Es
Date: c. 1830
G. A. Godden
Ill: No. 5, pl. 161
This is the only known piece signed by Bourne, who was at Minton from c. 1828 to c. 1863

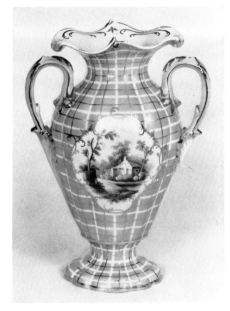

Plate 16. Catalogue C13

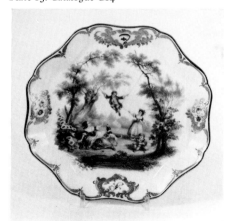

Section D

Stonewares c. 1830–45
Summerly Art Manufactures c. 1846–52
& Wares designed by A. W. N. Pugin c. 1848–52

Summerly's Art Manufactures

In 1845 the Society of Arts offered prizes for a tea service and beer jugs for common use. Sir Henry Cole, at that time at the forefront of the movement for improving public taste, designed a tea service (under the pseudonym Felix Summerly) and persuaded Herbert Minton both to make the service and to submit jugs of Minton design. Both entries won medals, and this success led Cole to believe that it would 'promote public taste' if well-known artists were employed to make designs for manufactured articles of everyday use. As a result Summerly's Art Manufactures was founded in 1847, an enterprise that lasted for about three years until Cole became fully involved in the preparations for the Great Exhibition of 1851. The introduction to the catalogue of the Art Manufactures stated: 'It is the purpose of this collection ... to revive the good old practice of connecting the best Art with familiar objects in daily use. In doing this Art-Manufactures will aim to produce in each article superior utility, which is not to be sacrificed to ornament: to select pure forms: to decorate each article with appropriate details relating to its use, and to obtain these details as directly as possible from Nature. These principles ... may possibly contain the germs of a style which England of the nineteenth century may call her own.' Many artists and manufacturers of note became involved with the scheme, including John Bell, William Dyce, J. C. Horsley, Daniel Maclise, W. Mulready, Richard Redgrave, Sir Richard Westmacott, the Coalbrookdale Co., Dixon & Sons, Jennens & Bettridge, Minton & Co., J. Rodgers & Sons and Wedgwood.

Many of the Summerly designs made by Minton remained in production long after the end of the initial scheme. The various parian figures were particularly popular and the Summerly cup and saucer became a Minton standard shape and was produced in quantity throughout the century. Summerly-designed parian figures usually carry a special moulded mark (No. 4).

D1. Jug

Earthenware, transfer-printed in red with portraits of William IV and Queen Adelaide contained within moulded reserves, regal symbols and flowers printed on the neck, the body of the jug decorated with a moulded pattern, Minton design number 13
18.5 cms
Date: 1830
G. A. Godden
Ill: No. 5, pl. 54
Produced for the coronation of William IV in 1830, this jug was also made in grey stoneware with applied white reliefs of William and Adelaide

D2. Jug

Grey stoneware, moulded in relief with foxes on one side and dogs on the other, the handle formed as a fox, Minton design number 17
20 cms
Marks: No. 2
Date: c. 1830
Royal Doulton Tableware Limited

D3. Jug

Grey stoneware, moulded in relief with a bust of Sir Walter Scott framed by a wreath of trophies, on the verso a book representing the Waverley Novels, Minton design number 91
18 cms
Marks: No. 2
Date: c. 1835
City Museum & Art Gallery, Stoke (22 P 73)

D4. Jug

Stoneware, ovoid shape, the neck stained blue with a continuous frieze of hops and foliage moulded in white relief, Minton design number 268
15 cms

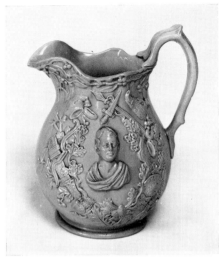

Plate 17. Catalogue D3

Marks: No. 2 incorporating *Society of Arts Prize Jug 1846*
Date: 1846
Royal Doulton Tableware Limited
Ill: No. 18, 1849, p. 300
This jug was made in a great variety of sizes, colours and materials after its success in the Society of Arts competition

D5. Font and Cover

Buff stoneware replica of a font and cover at St Mary Magdalene, Oxford, octagonal shape, both pieces decorated with moulded gothic tracery, saltglazed overall
29.5 cms
Marks: No. 2 incorporating *St Mary Mag. Oxford*
Date: c. 1840
R. Hildyard
A variety of fonts were produced, some based on actual models. Later examples in parian are more common, and were still being made in the 1890s

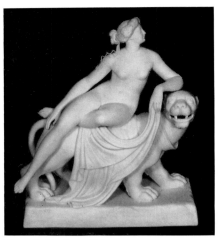

Plate 18. Catalogue D8

D6 & D7. Teapot and cover, cup and saucer

Cream-coloured earthenware, the teapot globular with a tall cylinder shaped neck, the handle and knop moulded as goat's heads on vine leaves, the spout as a lion's head, the saucer dish-shaped, the cup handle formed also from a goat's head and vine leaves
Teapot 15.8 cms, cup 6.3 cms, saucer 14.6 cms diam.
Designed by Henry Cole
Marks: Summerly mark printed in red, incorporating FS monogram and date 1846 surrounded by a garter inscribed *SOCIETY OF ARTS PRIZE PATTERN Minton & Co Staffordshire*
Date: 1846
Victoria & Albert Museum (2741 & a, 2743 & a-1901)
Ill: No. 3, vol. II, p. 178
Ex: V & E, Nos. A7 and A8

D8. Ariadne, or 'Voluptuousness'

Parian figure of a naked girl reclining on a

panther, on a rectangular base, Minton figure design number 163
37.2 cms
Reduced model by John Bell of the figure by Dannecker in Frankfurt, 1816
Marks: No. 5 and No. 7 impressed
Date: c. 1850
H. V. Levy
Ex: London 1851
Ref: No. 19, March 1847

D9. Una and the Lion
Parian figure of a naked girl riding on a lion, on a rectangular base, Minton figure design number 184
36.5 cms
Designed and modelled as a companion to Ariadne by John Bell
Marks: Nos. 4 and 7 and registration mark (for 19 August 1847)
Date: 1865
Victoria & Albert Museum (46-1865)
Ill: No. 6, pl. 70; No. 16, pl. 65
Ex: London 1851

D10. Dorothea
Parian figure of a girl seated on a rock, her right arm across her figure, her shoes and a bundle on the ground, Minton figure design number 189
35.5 cms
Designed and modelled by John Bell, a reduced model of the life-size figure made for Lord Lansdowne in 1844
Marks: No. 4 and registration mark (for 4 October 1847)
Victoria & Albert Museum (C.41-1969)
Ill: No. 16, pl. 86; No. 5, pl. 149; No. 3, vol. II, p. 183
Dorothea, from *Don Quixote*, was the most successful of John Bell's designs for the Summerly venture. It was a best-seller within two months of its introduction, and

continued to sell well for the following forty years. In the Summerly catalogue the figure was priced at £2 2s. Bell subsequently designed two further figures in the same style, *Clorinda* and *Miranda* (Minton figure designs number 203 and 245). *Clorinda*, also a Summerly commission, was intended to be the pair for *Dorothea*

D11. Kissing Children Paperweight
Parian porcelain, modelled as two children embracing, kneeling on a glazed circular base, Minton figure design number 188
9.5 cms
Modelled by John Bell, after a Sèvres group by Boizot
Marks: *MINTON & CO Modelled in 1847 Manufactured in 1865* painted in black on the base
Victoria & Albert Museum (42-1865)
In the Summerly catalogue, this paperweight is shown as en suite with The Bride's Inkstand. It was also produced mounted on the cover of a loving cup (Minton design number 358), and was made in gilt bronze

D12. The Waterloo Bust of the Duke of Wellington
Parian bust, showing the Duke as a young man, on a rectangular base, Minton figure design number 190
36 cms
Modelled by Samuel Joseph
Marks: Incised, *Saml. Joseph. Sculp. 1847*, No. 7 impressed and date code for 1865
Victoria & Albert Museum (49-1865)
Ref: No. 3, vol. II, p. 185

D13. The Belief
Parian figure of a kneeling child clasping a Bible, on an irregular base, Minton figure design number 199

22.8 cms
Designed and modelled by John Bell
Marks: *MINTON & CO Modelled in 1848 Manufactured in 1865* painted in black on the base
Victoria & Albert Museum (48-1865)
Ref: No. 3, vol. II, p. 185
This figure and its partner, The Lord's Prayer (Minton design number 198), were registered on 10 December 1847

D14. The Greek Slave
Parian figure of a naked girl, her wrists chained together, on a circular base, Minton figure design number 207
37.2 cms
A reduced model of the statue by the American sculptor, Hiram Powers
Marks: Nos. 5 and 7 impressed and date code for 1857
Victoria & Albert Museum (Circ.90-1968)
The original sculpture was exhibited in London in 1851, but it was well known in reproduction before that date. It was shown in the Birmingham Exhibition of 1849, and is included in the Summerly catalogue. Copeland also produced a Greek Slave in parian

D15. Distressed Mother
Parian figure of a girl seated on a rock, a bundle at her feet, holding her naked child to her right breast, on an irregular base, Minton figure design number 210
32.8 cms
Reduced model by I. Peppercorn of the memorial in Westminster Abbey to Elizabeth Warren (1816) by Sir Richard Westmacott RA
Marks: Nos. 5 and 7 impressed and late code for 1865
Victoria & Albert Museum (486-1865)
Ill: No. 20, vol I, 1849, p. 14

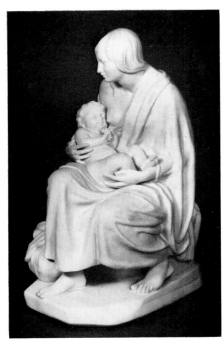

Plate 19. Catalogue D15

D16. Mug
Porcelain, cylinder shape, transfer-printed with Red Riding Hood and the wolf, overpainted with enamels
7.7 cms
From a design by T. Webster RA
Date: c. 1847
Victoria & Albert Museum (374-1854)

D17. Fascination Vase
Bone china, ovoid shape, the base formed by a curled snake, the body decorated with two moulded snails, the cover surmounted by a flying bird, deep blue ground, the modelling picked out in enamels and with gilding, Minton ornament design number 421
15.3 cms
Designed by John Bell

Date: c. 1847
Victoria & Albert Museum (377-1854)
Ill: No. 20, vol II 1849, p. 203
Ex: V & E, A3

D18. Vase
Bone china, transfer-printed with a continuous panel depicting the story of Reynard the Fox, overprinted with enamels and enriched with gilding
15.3 cms
Painted by John Linnell after a print by Everdingen
Marks: Inscribed in gold *Reynard's Submifsion* and *Reynard Summoned to Court*
Date: c. 1847
Victoria & Albert Museum (378-1854)
Ex: V & E, A10

D19. The Two Drivers or The Coach and Railway Jug
Earthenware, moulded in relief with plaques of a coachman and an engine-driver set against scenes illustrating travel in 1800 and 1849, the spout moulded as a mask, Minton design number 335
17.8 cms
Designed by Henry J. Townsend
Marks: No. 2
Date: c. 1850
Victoria & Albert Museum (540-1855)
Ill: No. 17, pl. 21; No. 20, vol. II, 1850, p. 132
Ex: V & E, A17

D20. The Hop Jug
Earthenware, modelled in relief with hops, hop-gatherers and figures emblematic of agriculture and decorated with majolica glazes
26.7 cms
Designed by Henry J. Townsend
Date: c. 1857

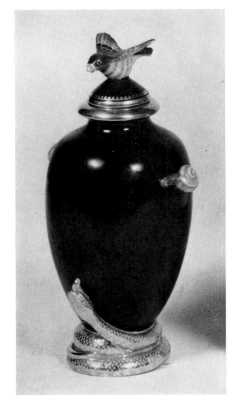

Plate 20. Catalogue D17

Victoria & Albert Museum (4521 & a-1858)
Ill: No. 17, pl. 20; No. 13, pl. 70
Ref: No. 3, vol. II, p. 180
Awarded the Gold Model of the Society of Arts 1848 for 'the Union of Superior Art & Manufacture'. The jug was originally designed to be produced in brown earthenware

D21. The 'Well Spring' Vase
Porcelain, ovoid shape with flared neck and two handles moulded as twisted tendrils, painted in enamels with water plants and

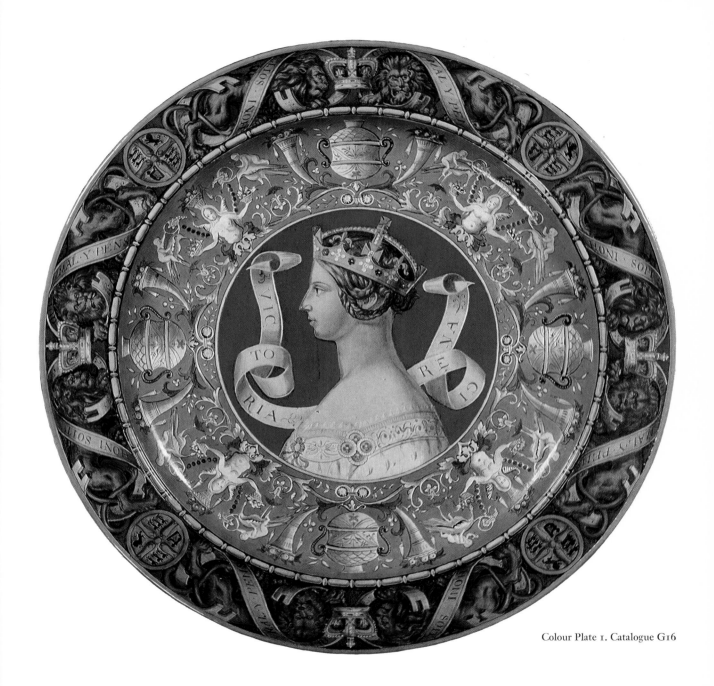

Colour Plate 1. Catalogue G16

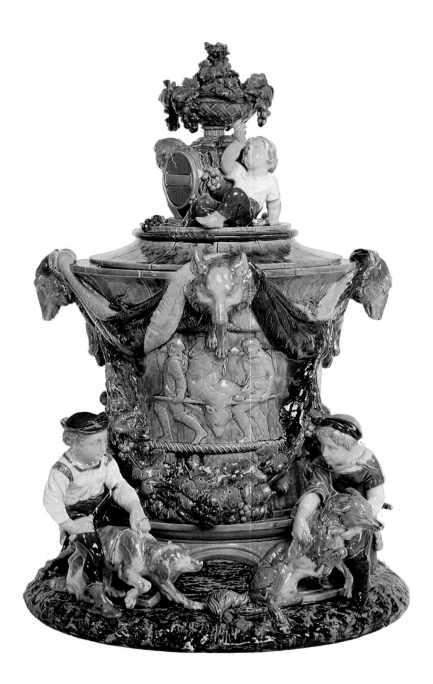

Colour Plate 2. Catalogue P2

reeds, Minton ornament design number 365
17.3 cms
Designed by Richard Redgrave RA
Marks: *MINTON & CO Modelled in 1847
Manufactured in 1865* painted in black on
the base
Victoria & Albert Museum (135-1865)
Originally designed by Redgrave for
Summerly as a glass water carafe, the vase
was adapted for production in white
porcelain and parian.
Ex: Society of Arts Exhibition, 1848

D22. The Bride's Inkstand
Tinted parian, modelled as a kneeling cupid
holding a torch in his right hand, his left
resting on a covered vase, mounted on an
oval green-tinted stand flanked by two lizards,
Minton ornament design number 356
34.5 cms wide
Designed and modelled by John Bell
Marks: No. 4 and registration mark
for 23 March 1847
Date: 1848
*By gracious permission of Her Majesty The
Queen*
Ill: No. 3, vol. II, p. 182
The inkstand was also made without
lizards (Minton design number 357)

D23. Pugin's Bread Plate
Earthenware, circular, decorated with ears
of wheat and foliate ornament in coloured
glazes and stained clays inlaid in the
encaustic style, the motto *Waste Not Want
Not* in Gothic letters around the rim,
Minton ornament design number 430
33.2 cms diam.
Designed by A. W. N. Pugin
Date: c. 1850
Victoria & Albert Museum (C.46-1972)
Ill: No. 20, vol. III, 1850, p. 97; No. 21,

Plate 21. Catalogue D24

p. 30
Ex: Birmingham 1849
This plate can be found in a variety of
encaustic colours and there is also a
majolica version

D24. Luncheon Tray, embossed
Earthenware, decorated with a Gothic
pattern in coloured glazes and stained clays
inlaid in the encaustic style, Minton
ornament design number 799
46.5 cms diam.
Marks: Impressed date code for 1859
Victoria & Albert Museum (7262-1861)

D25. Plate
Bone china, circular, printed in colours
with foliate ornament and an inscription in
Gothic lettering round the rim, *ubi amor ibi
fides*, using the Collins and Reynolds patent
process
25 cms diam.
Designed by A. W. N. Pugin
Date: 1851
Victoria & Albert Museum (459-1852)
Ill: No. 14, pl. 68

Ex: London 1851; V & E, C29
The patent for printing on ceramics by
lithography was taken out by Collins and
Reynolds on 14 March 1848, and Herbert
Minton subsequently bought an interest in
it. The method was first used on large tiles
designed by Pugin for the Smoking Room
in the Palace of Westminster. See also the
related design by Pugin, dated '50

D26. Flower Pot
Formed by four square earthenware tiles
mounted in a cast iron and gilt metal frame,
the tiles printed in colours by the Collins
and Reynolds process
30 cms
Designed by A. W. N. Pugin
Date: 1851
Victoria & Albert Museum (926-1852)
Ex: London 1851
See also the related design in an early
Minton tile catalogue

Section E

Parian wares

c. 1846-90

Although the invention of statuary porcelain is usually credited to Thomas Battam and the Copeland and Garratt factory, Minton were producing their own version of this highly vitrified form of biscuit porcelain by 1846. They called this Parian, after the Greek marble, and this name has subsequently been adopted as a generic term for this type of porcelain. The development of Minton parian was greatly helped by their involvement with Summerly's Art Manufactures, for whom many of the first pieces were produced (see Section D). Also, the existence of a range of figures that had been designed for production in biscuit or enamel-painted bone china meant that the moulds could easily be adapted for the manufacture of parian figures. The first Minton Parian Catalogue, published in 1852, includes both early figures re-used in parian, and new models specially designed for the material. The production of parian continued throughout the nineteenth century and the last figures designed for parian production date from c. 1888. In the 1850s a method of tinting parian was developed, and many pieces were subsequently made in a combination of colours. While parian is usually associated with figures, the material was also used extensively for ornaments and tablewares, and was frequently used in combination with glazed and enamel-painted bone china. Parian itself was sometimes glazed, and in this form was used for the *pâte-sur-pâte* decorated wares.

Many figures and ornaments produced in parian were scaled-down models of existing sculptures by both contemporary and historical artists, and in many cases the reduction was effected by Benjamin Cheverton's Reducing Machine, which was patented in January 1844.

E1. Herbert Minton
Parian figure standing on a circular base, his left arm resting on a Palissy dish supported on a tall plinth, vases, plates and a group of encaustic tiles piled at his feet, *Hbt MINTON* impressed on a plaque on the base
39.3 cms
Designed and modelled by Hughues Protat
Marks: Incised *Hughues Protat, April 24, 1860*; No. 7 impressed
Victoria & Albert Museum (7126-1860)
Ill: No. 6, pl. 79: No. 16, pl. 82
Although several examples of this figure are known to exist, it does not occur in the Minton figure design books. This particular example was given to the Museum by the artist

E2. Canova's Dancing Girl
Parian figure of a girl with one leg raised, her right hand to her mouth and a wreath on her left arm, on a circular base, Minton figure design number 182, *CANOVA* impressed on the base
38.5 cms
After Canova
Marks: No. 7 impressed
Date: c. 1855
H. V. Levy
Ill: For the partner to this figure see No. 16, pl. 71
There are a variety of Minton models based on sculptures by Antonio Canova (1757–1822). The original marble of this figure was completed in 1810. This figure and its partner, design number 195, were in production at least by May 1847

E3. Duke of Wellington
Parian bust on a circular plinth, the Duke modelled as an old man, Minton figure design number 272

24 cms
Designed and modelled by Charles Toft
Marks: Incised *C Toft fecit 1853*. On the verso painted in red in a scroll: *Presented to Mr J. L. Robinson as a token of respect. Dec. 25 53.*
City Museum & Art Gallery, Stoke (643 P 45)
Ill: No. 2, pl. 75
Presumably made shortly after the Duke's death in 1852, this bust is an unusual example of modelling by Charles Toft, associated with copies of the Saint-Porchaire inlaid earthenwares. It also suggests a date for Toft's involvement with Minton that is considerably earlier than generally accepted.

E4. Flight into Egypt
Parian figure of Mary carrying the infant Jesus, riding side-saddle on a donkey, on an irregular oval base, Minton figure design number 223
22.8 cms
Marks: Nos. 5 and 7 impressed
Date: c. 1850
H. V. Levy
Ex: London 1851; London 1862

E5. Princess Beatrice
Parian figure of a naked child reclining in a shell, on an oval base, Minton figure design number 364, impressed *PRINCESS BEATRICE* on the base
23 cms
Designed and modelled by Mary Thornycroft
Marks: *Mary Thornycroft Sculp.* impressed on the base ; No. 5 incised
Date: c. 1858
City Museum & Art Gallery, Stoke (401 P 50)
Ill: No. 18, 1860, p. 370

Plate 22. Catalogue E5

The original of this model, an alabaster by Mary Thornycroft, who produced a series of sculptures of the Royal children, is at Osborne House. Minton produced at least fifteen models of members of the Royal family over a thirty-year period, starting with Queen Victoria's accession in 1837. See also Prince Alfred with Pony, catalogue E6

E6. Prince Alfred with Pony
Parian figure of a boy wearing a kilt, his right arm resting on the neck of a Shetland pony with a shaggy mane and tail which stands behind him, on a rocky base, Minton figure design number 357, incised *HRH Prince Alfred* on the base, Reduced model of the original bronze by Baron Carlo Marochetti

41 cms
Marks: Incised round the base *Published by Minton & Co* and signed *C Marochetti*
Date: c. 1858
By gracious permission of Her Majesty The Queen
Ex: London 1862

E7. Perseus and Andromeda

Parian, Perseus wearing a lion skin and a helmet surmounted by a sphinx, carrying Andromeda away from the dragon which lies dead at their feet, coiled round the rocky base, Minton figure design number 425
50.8 cms
Marks: No. 7 impressed and date code for 1868
Royal Doulton Tableware Limited

E8. Clodion Venus

Parian bust on a circular plinth of a girl with her arms crossed across her breast, the porcelain tinted a bright terracotta pink, Minton figure design number 392
41.2 cms
After the bust of Modesty by Claude Michel (Clodion)
Marks: No. 7 incised and 1873
Victoria & Albert Museum (831–1873)
Ex: London 1862
Sculptures by Claude Michel, or Clodion (1738–1814), were frequently copied in parian by Minton, in some cases using examples in English public collections as models. Previously made in white parian in this version

E9 & E10. Fine Art and Science

Pair of polychrome tinted parian figures on circular bases, *Fine Art* studying a vase, *Science* measuring distance on a globe, Minton figure designs number 469 and 470
37.3 cms

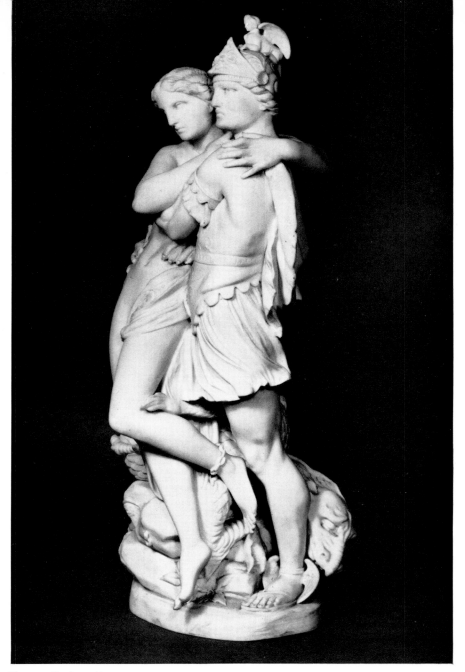

Plate 23. Catalogue E7

Plate 24. Catalogue E9 & E10

Designed by T. N. Maclean
Marks: No. 7 impressed and date code for
1874
H. V. Levy
Ill: No. 18, 1873, p. 343; No. 12, p. 184
Ex: Vienna, 1873
Designs for these figures and for two
others were bought from T. N. Maclean
on 8 November 1872. The technique of
mixing together different colours of tinted
parian was an important development, for
the same process was used in the manu-
facture of *pâte-sur-pâte*

E11. Colin Minton Campbell

Parian figure of Campbell standing on a
square base, his right hand holding a tazza
which rests on a model of a majolica stand.
Minton figure design number 501, *COLIN
MINTON CAMPBELL* impressed on the
front of the base
48.4 cms
A reduced model by T. Longmore of a
statue of Campbell by Sir Thomas Brook
RA which stands today outside the Minton
factory in Stoke

Plate 25. Catalogue E11

Marks: No. 7 impressed
Date: c. 1887
H. V. Levy

E12. Cellini Ewer and Stand
Parian, the ewer ovoid shape on a fluted circular base, the tall handle modelled as a winged monster, moulded in relief with cherubs, Renaissance arabesques and foliate scrolls in the style of Urbino maiolica, a mask below the spout, the stand moulded with a frieze of arabesques and foliate scrolls, both pieces enriched with gilding, Minton ornament design number 472
Ewer 32.5 cms, stand 26.3 cms diam.
Probably modelled by Emile Jeannest
Marks: No. 7 incised
Date: c. 1850
Victoria & Albert Museum (2791 & a-1901)
Ex: London 1851: V & E, E18
Despite its name, this ewer is not based on any specific Cellini object, but rather reflects the Victorian use of Cellini as synonymous with Renaissance. In style it is close to the Neo-Renaissance wares produced in France by Jacob Petit during the period 1835–45

E13. Victoria Flacon Holder
Glazed and tinted parian, quatrefoil shape with scrolled feet, flanked by four kneeling cherubs linked by foliate swags, fitted with a shaped metal stand for four circular glass bottles enriched with gilding, Minton ornament number 573
15.3 cms including bottles
Marks: No. 7 impressed and date code for 1868
Victoria & Albert Museum (C.694-1935)
Ex: Paris 1855
Called the Victoria as it was originally

modelled as part of a dressing table set which was Prince Albert's Christmas present to the Queen in 1853. This set is still preserved at Osborne House, Isle of Wight

E14. Clodion Vase with 2 Seated Fawns
Parian, tall classical shape with square base, after a Sèvres *vase Leriche aux syrènes*, decorated with moulding in relief and applied flowers, two modelled fauns seated on the shoulder of the vase, their arms around its neck, enriched with green enamel and gilding, Minton ornament design number 647
29.5 cms
Modelled by A. Carrier de Belleuse
Marks: Inscribed in red *Manufactured by Minton & Co Stoke upon Trent*
Date: c. 1856
Victoria & Albert Museum (3557-1857)
Ex: London 1862
This vase was also made without the seated fauns, design number 648

Plate 26. Catalogue E15

E15. Triton Vase, or Salt
Tinted and glazed parian, modelled as a kneeling triton on an oval base, supporting on his back with his two-pronged tail a shell, enriched with gilding, Minton ornament design number 1292
22 cms
Marks: No. 7 impressed and date code for 1868
Royal Doulton Tableware Limited
This vase was modelled on a bronze by M. Gautier shown in the 1862 Exhibition, in turn based on a Renaissance model

E16. Jug
Tinted parian, depressed ovoid shape moulded in relief with cherubs, a mask below the spout, the handle modelled as a mermaid, Minton ornament design number 1420
18.5 cms
Marks: No. 7 impressed
Date: c. 1880
Royal Doulton Tableware Limited
The jug may be compared with the majolica version, catalogue F14, to show how different materials and styles were used on the same object. The difference in size also indicates the relative shrinkage between parian and earthenware. The form is based on a wine ewer excavated at Pompeii

E17. Flower Vase Embossed
Tinted parian, ovoid shape with flared lip, decorated with arabesques, figures and birds moulded in relief in white, Minton ornament design number 534
25.5 cms
Marks: Impressed date code for 1854
Victoria & Albert Museum (536-1855)

Section F

Majolica wares
c. 1850–80

Among the many forms of Renaissance ceramics that interested Léon Arnoux was Italian maiolica. Although he did in fact produce on-glaze painted tin enamelled wares in the styles of Castel Durante, Deruta and Castelli, his main contribution was the development of a range of brightly coloured low-temperature glazes which had little directly to do with their Renaissance source. Introduced in c. 1849 and first exhibited in London in 1851, the boldly modelled wares with their rich colouring rapidly became the most characteristic earthenware of the Victorian period. Such was the commercial and artistic success of the ware that it became generally known as majolica, and was copied by a number of other manufacturers. In 1852 an experimental majolica workshop was established at Sèvres in an unsuccessful attempt to compete with Mintons.

Early Minton majolica wares fall into two categories, those based on the earthenwares of Bernard Palissy, and those whose decorative effect was based on modelled plant and animal forms. During the 1850s and 1860s Mintons frequently used the word Palissy to describe both copies of actual sixteenth century pieces and wares in a general Renaissance style. The use of animal and plant forms, often prompted by Victorian ideas of fitness for purpose, in fact continued a strong tradition of eighteenth century ceramic design; Wedgwood cabbage and pineapple wares and the moulded vegetable and animal forms of Chelsea porcelains would seem to be the source for much Victorian majolica. In some cases Mintons made use of actual eighteenth century moulds that they had acquired. Similarly, Arnoux made considerable use of effects such as marbling and agate that were well known in Staffordshire in the seventeenth and eighteenth centuries. The success of the majolica wares prompted Mintons to produce a large range that included tablewares, figures, ornaments, tiles, fountains and other garden decorations. Many pieces were also spectacularly large, as well as colourful and the greatest achievement in the material was the fountain surmounted by a group of St George and the Dragon that was shown at the International Exhibition of 1862, and which was 30 feet high and 40 feet in diameter. Majolica production continued throughout the nineteenth century, and so reflected the many diverse styles adopted by Victorian designers. A Carrier de Belleuse and Emile Jeannest were among sculptors who modelled pieces for decoration in majolica, while styles of painting ranged from the precise and academic approach of Kirkby to the free brushwork of Rischgitz and Lessore. Many ornaments and figures designed for production in porcelain and parian were also made in majolica. Minton majolica usually carries impressed marks and date codes, but unmarked pieces can be identified from the ornamental design books.

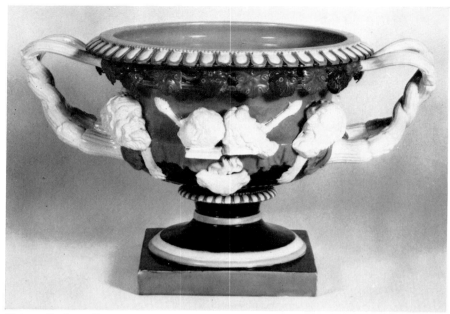

Plate 27. Catalogue F2

Plate 28. Catalogue F5

F1. Vase
Earthenware, bottle shape and moulded in relief with foliate swags and applied medallions containing allegorical busts, the ground strongly marbled on an agate body, the applied decoration painted with majolica colours
21.5 cms
Date: c. 1858
Victoria & Albert Museum (6932-1860)
The combination of an agate body with surface glaze marbling is unusual, and is the type of technical challenge that appealed to Léon Arnoux

F2. Warwick Vase
Earthenware, modelled as a replica of the Warwick vase on a square base, and richly painted with majolica glazes
31 cms

Date: c. 1855
F. Halliwell
This Victorian interpretation of the large Roman marble vase preserved at Warwick Castle occurs on an unnumbered page of the Minton ornament design book.

F3. Chestnut Dish and Spoon
Earthenware, the circular dish half covered by moulded chestnut leaves and nuts, the spoon modelled as a chestnut branch, richly painted with majolica glazes, Minton ornament design number 594
15 cms
Marks: Impressed date code for 1855
Victoria & Albert Museum (3568 & a-1857)
Ill: No. 17, pl. 37
Ex: V & E, E26

F4. Marine Vase
Earthenware, amphora shape vase supported by three infant tritons with forked tails and moulded in relief with seaweed, the circular base decorated with sea-shells, modelled on a *vase aux tritons* made at Vincennes in 1754, richly painted with majolica colours, Minton ornament design number 526
41.5 cms
Date: c. 1853
Victoria & Albert Museum (505-1855)
Ill: No. 18, 1855, p. 91, one of the original exhibits at 'The Museum of Ornamental Art'

F5. Moorish Tray
Earthenware, circular shape, decorated with flowers outlined in relief around a central panel, a continuous chevron pattern round the border, painted with majolica glazes, Minton ornament design number 678
36 cms diam.
Marks: Impressed date code for 1858
City Museum & Art Gallery, Stoke (86 P 33)

F6. Holly Dish
Earthenware, the pierced rim moulded as holly branches and leaves, the centre with an impressed pattern of mistletoe, painted with majolica glazes, Minton ornament design number 726
38 cms diam.
Date: c. 1860
Royal Doulton Tableware Limited

Plate 29. Catalogue F8

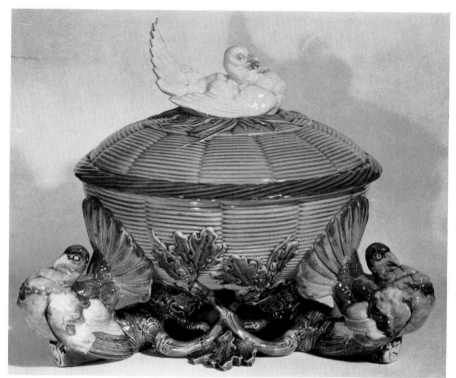

Plate 30. Catalogue F9

F7. Soulage Ewer and Stand
Earthenware, the oval shaped ewer decorated with applied panels of deities, moulded masks and arabesques, the oval stand with a central applied panel of a deity and a border of moulded arabesques, both richly painted with majolica glazes in imitation of Palissy ware, Minton ornament design number 732
Ewer 26.7 cms, stand 31 cms long
Modelled by Hamlet Bourne, after a Palissy ewer and stand in the Victoria & Albert Museum (7178-1860), from the Soulages Collection
Marks: Impressed date code for 1858
Victoria & Albert Museum (4730-1859)

Ill: No. 17, pl. 43
The Jacques Soulages Collection, displayed at Marlborough House in 1856, was subsequently bought for the nation by a public subscription, to which Herbert Minton donated £1000. The Collection was used extensively by Minton designers and decorators for sources

F8. Candlestick
Earthenware, Renaissance shape based freely on a Palissy model, moulded in relief with masks, grotesques, fruit and strapwork, and richly painted with majolica glazes, Minton ornament design number 765

40 cms
Date: c. 1858
Victoria & Albert Museum (5882-1859)

F9. Pigeon Pie
Earthenware, the moulded basket-work
body supported by three modelled pigeons
with fanned tails, resting on oak branches,
the cover surmounted with a seated pigeon,
naturalistically painted with majolica glazes,
Minton ornament design number 777
27.7 cms
Date: c. 1860
Victoria & Albert Museum (6930 & a-1860)

F10. Plaque
Earthenware, oval shape, the centre with a
figure of Una seated on a lion moulded in
relief, richly painted with majolica glazes,
Minton ornament design number 813
34.8 cms long
After the parian group by John Bell,
catalogue D9
Marks: Impressed M
Date: c. 1860
Royal Doulton Tableware Limited

F11. Jug
Earthenware, the cylinder body moulded
in relief with dancing figures in medieval
dress, the handle formed by a twisted ivy
stem, the metal-mounted cover surmounted
by a joker's head, richly painted with
majolica glazes, Minton ornament design
number 1231
33 cms
Marks: No. 7 impressed and date code
for 1865
Victoria & Albert Museum (C.91-1969)

F12. Jug
Earthenware, depressed ovoid shape
moulded in relief with cherubs, ivy, and a
horned mask, the handle modelled as a

mermaid, richly painted with majolica
glazes, Minton ornament design number
1420
20.5 cms
Marks: No. 7 impressed
Date: c. 1870
Royal Doulton Tableware Limited
Compare this jug with the parian version,
catalogue E17, taken from the same mould

F13. Teapot and Cover
Earthenware, modelled as a seated monkey
encircling a large fruit with its arms and
legs, its head forming the cover and its tail
the handle, painted with majolica glazes,
Minton ornament design number 1884
15 cms
Marks: No. 7 impressed and date code for
1874
Royal Doulton Tableware Limited

F14. Seahorse with Shell
Earthenware, modelled as a cupid holding
aloft a shell, riding on the back of a winged
seahorse, on an oval base, painted with
majolica glazes, Minton figure design
number 326
38.5 cms
Modelled by A. Carrier de Belleuse
Marks: No. 5 impressed and date code for
1858
Victoria & Albert Museum (5884-1860)
Ill: No. 17, pl. 35; No. 21, p. 54 (parian
version)
Ex: V & E, E25
A very similar seahorse figure was later
made in stoneware at the Doulton Lambeth
factory, probably modelled by Mark Marshall

F15. Bonbonnière
Earthenware, formed by three shells
supported by bearded masks and surmounted

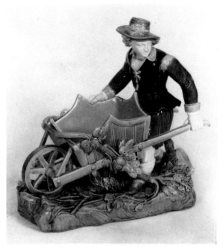

Plate 31. Catalogue F16

by a cherub representing Industry, richly
painted with majolica glazes, Minton
ornament design number 906
31 cms
Date: c. 1860
H. V. Levy
The cherub was also made without the
stand, as part of a set of three figures
representing Art, Science and Industry
(Minton figure designs number 367, 368,
& 369)

F16. Man with Wheelbarrow
Earthenware, modelled as a man in rustic
dress pushing a wheelbarrow over a rocky
base, the wheelbarrow entwined with a
moulded hop branch, richly painted with
majolica glazes, Minton figure design
number 413
35 cms
Marks: No. 7 impressed and date code for
1871
H. V. Levy

F17. Jug
Earthenware, modelled as a seated cat, the handle formed by its tail, its right paw resting firmly on a mouse, naturalistically painted with majolica glazes, Minton design number 1924
25 cms
Marks: No. 7 impressed and date code for 1874
W. Chappell
This cat jug was made in a variety of sizes, and is one of a great range of largely functional majolica pieces based on animal forms that were issued in the 1860s and 1870s

F18. Spill Vase
Earthenware, modelled as a cockerel, its head on one side and one leg raised, standing over a square rustic vase on an oval base ornamented with moulded foliage, richly decorated with naturalistic majolica glazes, Minton ornament design number 1982
36.5 cms
Designed by John Henk
Marks: Incised *J. Henk*, No. 7 impressed and date code for 1878
Royal Doulton Tableware Limited
Ill: No. 13, col. pl. VI; No. 14, pl. 68

F19. Plaque
Earthenware, freely painted with enamels in imitation of maiolica with a classical battle scene, a detail of the *Battle of the Milvian Bridge* by Raphael
59 cms diam.
Painted by Emile Lessore
Marks: Signed *E Lessore*, No. 6 printed in red
Date: c. 1860
Victoria & Albert Museum (547-1894)

F20. Tazza
Earthenware, circular shape on a low foot, painted in enamels in imitation of maiolica with an Aesop scene, the wolf in sheep's clothing
26.5 cms diam.
Painted by Edouard Rischgitz
Marks: Signed *Edouard Rischgitz*; painted on reverse, *Le 12 Juillet 1864* and *MINTON*
Victoria & Albert Museum (6-1865)
Ill: No. 17, pl. 79
For one piece from an Aesop porcelain service painted by Rischgitz see catalogue H27

F21 & 22. Negro Male and Negro Female
Earthenware, modelled as standing figures on square bases ornamented with moulded satyrs, both holding on their heads baskets adorned with garlands of fruit, the male wearing a lion's skin, the female holding a fan, both richly decorated and painted with majolica glazes, Minton ornament designs 1157 and 1158
186 cms
Design after A. Carrier de Belleuse
Marks: No. 7 impressed and date code for 1865
Gay Antiques Limited, London
Based on a pair of candelabra, in gilt bronze, modelled by Carrier de Belleuse for M. Denière of Paris and included in the 1862 Exhibition, which in turn were after designs by Jean le Pautre (1617–82)

Section G
Renaissance-influenced wares
c. 1855–80

Interest in the Renaissance was widespread among potters in the middle of the nineteenth century. The wares of Palissy were reproduced in France, Italian potters rediscovered maiolica and in Germany there was a stoneware revival. Mintons played a large part in this Neo-Renaissance, prompted by the personal interest and ceramic background of Léon Arnoux. Under his guidance Italian maiolica, Limoges enamel, St Porchaire inlaid earthenwares, French faience and the works of Palissy were reproduced, many of which posed considerable technical and design problems. Minton Renaissance wares range from precise copies of Museum objects to free interpretations and new designs in a generalised Renaissance style, and tend to be associated with particular designers and decorators. The Limoges enamels were painted by Lawton, Kirkby and Lockett, based freely on models by Pierre Reymond and Jean de Court. Arnoux and Kirkby were largely responsible for the maiolica, although a considerable contribution was also made by Alfred Stevens. Maiolica in the Victoria and Albert Museum was used in a general way for models, but was only rarely reproduced precisely. The St Porchaire inlaid earthenwares, then known as Henri II wares, represented the greatest technical challenge. Although C. Toft is most commonly associated with this ware, Arnoux produced the first examples in 1858, using a combination of painted and inlaid decoration that was not based on particular models. In 1861 C. Delange's book[1] was published, which illustrated all known examples of St Porchaire earthenware. Arnoux and Colin Minton Campbell were among the subscribers to this book, which became the standard source for Minton St Porchaire wares: it was also used by other potters, for example Avisseau of Tours, who showed St Porchaire wares in the 1862 Exhibition. Toft produced a series of replicas based on plates in Delange, several of which were made in small editions, despite the laborious nature of the technique.

(1) *Recueil de toutes les pièces de la faience française dite Henri II*, Paris, 1861

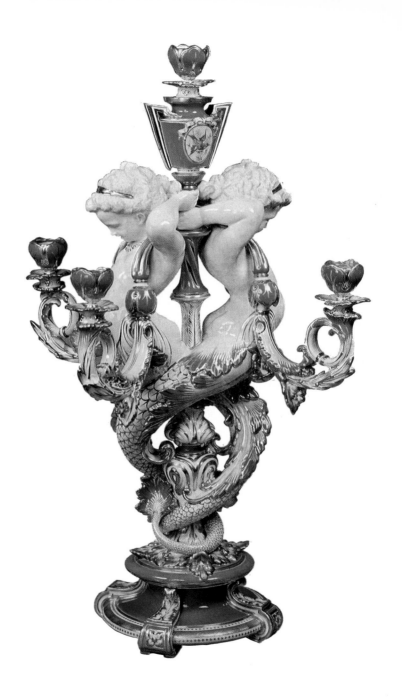

Colour Plate 3. Catalogue 114

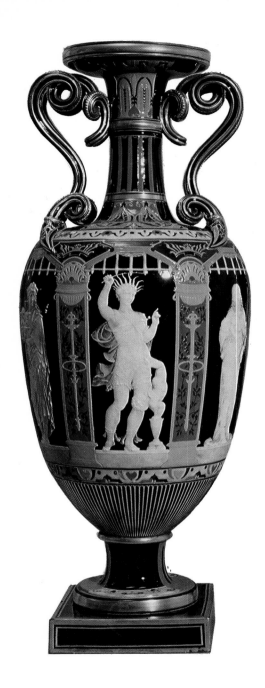

Colour Plate 4. Catalogue TG15

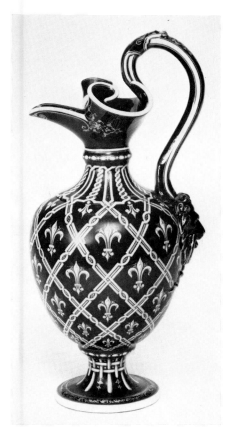

Plate 32. Catalogue G3

G1. Dish

Earthenware, circular shape with moulded bands, the blue ground painted with a central portrait panel and a frieze of arabesques and strapwork in imitation of Limoges enamel
53 cms diam.
Painted by Stephen Lawton
Marks: Inscribed in red, *Manufactured by Minton & Co Stoke upon Trent. Painted in imitation of Enamels by Stephen Lawton February 1856*

City Museum & Art Gallery, Stoke (176 P 34)

G2. Coupe Limoges and Cover

Bone china, tazza-shaped with tall foot and circular base, based on Limoges models by Pierre Reymond, the rich dark ground painted in colours in imitation of Limoges enamel, Minton ornament design number 692
25.5 cms
Painted by Stephen Lawton
Marks: Inscribed *MINTON & CO STOKE UPON TRENT* and signed *SL*
Date: c. 1858
Victoria & Albert Museum (4773-1859)
See also the related drawings. A tazza and cover in the Victoria and Albert Museum, 4756-1868, may have been used as a model

G3. Jug

Bone china, ovoid body with circular foot and tall neck, the raised handle jointed to the body by a moulded lion's mask, based on an Urbino maiolica shape, painted in imitation of Limoges enamel and enriched with gilding, Minton ornament design number 654
36.2 cms
Painted by Benjamin Lockett
Date: c. 1856
Victoria & Albert Museum (4731-1859)
Ex: V & E, E6

G4. Vase, Scroll Handle

Bone china, eighteenth century, ovoid shape with raised scroll handles supporting pendant foliate swags in imitation of ormolu, the dark blue ground painted with Renaissance motifs in the style of Faenza maiolica, Minton ornament design number 601
37.7 cms

Designed by Silas Rice, painted by Thomas Allen
Marks: No. 6 printed in red, also rubbed inscription in red giving details of manufacture
Date: c. 1858
Victoria & Albert Museum (4732-1859)
Several versions of this vase are known, with different ground colours but similar decoration, and all appear to have been produced by Rice and Allen

G5. Plate

Bone china, circular shape, the dark ground painted with strapwork and arabesques in imitation of Limoges enamel, with a profile portrait in the centre in the style of Jean de Court
23.5 cms diam.
Painted by G. W. Rhead
Marks: Signed *G. W. RHEAD 1874*, No. 7 impressed
City Museum & Art Gallery, Stoke (3839)

G6. Italian Vase

Earthenware, classical shape with raised handles modelled as coiled snakes, based on sixteenth century Italian maiolica models, the blue ground freely painted in white enamel with cherubs, festoons and arabesque panels, Minton ornament design number 658
29.2 cms
Designed by Alfred Stevens
Marks: No. 7 impressed
Date: c. 1864
Victoria & Albert Museum (185-1864)
Ill: No. 17, pl. 42; No. 21, p. 57
Ex: V & E, B9
Designs by Stevens for the decoration of this vase and for other pieces were included in the Alfred Stevens Centenary Exhibition held in the Victoria and Albert Museum

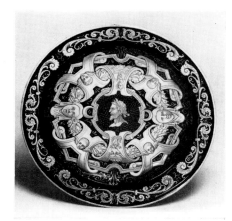

Plate 33. Catalogue G5

in 1975. Stevens worked for Mintons from
c. 1859 to c. 1861, his last involvement
with commercial manufacturers. Many
designs survive from this period, in the
Museum and in the Minton archives, but
few pieces seem actually to have been pro-
duced. This vase, probably based on Urbino
models, became a standard Minton shape. It
is unlikely that Stevens designed the shape
as its introduction would appear to predate
his involvement with Mintons. See also the
related drawing. An identical vase is in the
collections of the Conservatoire Nationale
des Arts et Métiers, Paris (no. 7191-1863)

G7. Plate
Earthenware, circular shape, painted in
enamels with medallions containing female
figures on a yellow ground, the rim with a
border of fruit
28 cms diam.
Designed by Alfred Stevens
Marks: Inscribed *MINTON February
1864*, date code for 1863
Victoria & Albert Museum (187-1864)
Ill: No. 17, pl. 42

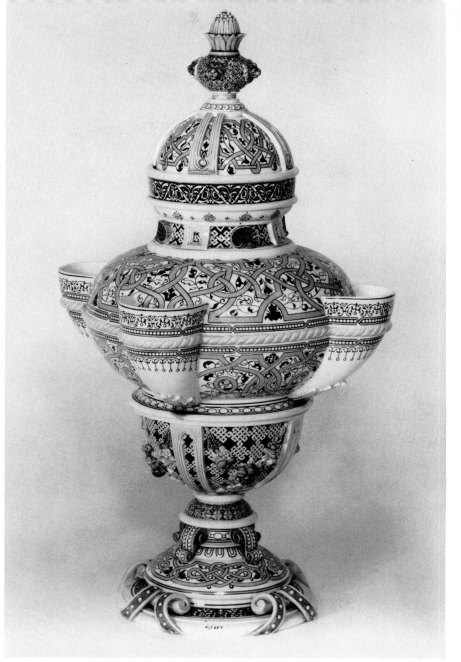

Plate 34. Catalogue G11

Ex: London 1862 (similar example),
V & E, B11
See also the related drawing

G8. Tazza

Earthenware, circular shape on a baluster
foot moulded with ram's heads, the cream-
coloured ground painted and inlaid with
coloured clays in imitation of St Porchaire
earthenware
10.6 cms
Decorated by Léon Arnoux
Marks: *MINTON 1859 L.A****X*
inlaid on the base
Victoria & Albert Museum (5883-1859)
Although Arnoux was a skilled designer and
technician in many fields, it is unusual to
find pieces actually signed by him; there are
two other examples in this exhibition,
catalogue G14 and L1. This tazza is one
of the first pieces of inlaid earthenware
produced by Minton

G9. Jug

Earthenware, conical shape on a circular
base, the spout moulded as a bearded mask,
the handle as a dragon, the cream-coloured
ground painted and inlaid with arabesques
in coloured clays in imitation of St
Porchaire earthenware, Minton ornament
design number 1058
26.7 cms
Decorated by Charles Toft
Date: c. 1873
Victoria & Albert Museum (1178-1864)
Ill: No. 4, pl. 34, for the original of this
design; No. 10, pl. 154
Ex: Vienna 1873

G10. Salt

Earthenware, triangular shape, the salt
cellar supported by columns and by seated
figures holding shields, the cream-coloured

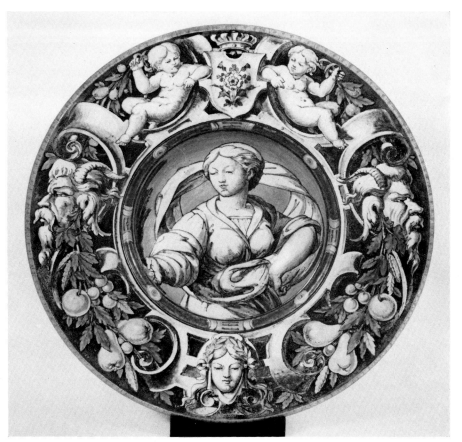

Plate 35. Catalogue G14

ground painted and inlaid with coloured
clays in imitation of St Porchaire earthen-
ware, Minton ornament design number
1747
17.8 cms
Decorated by Charles Toft
Marks: *C. TOFT MINTONS 1879* inlaid
on the base
Royal Doulton Tableware Limited
Ill: No. 4, pl. 49, for the original for this
design

G11. Vase and cover

Earthenware, graduated Renaissance shape
with four attached pockets, moulding in
relief and a domed cover, the cream-
coloured ground painted and inlaid with
coloured clays in imitation of St Porchaire
earthenware, Minton ornament design
number 2146
52.5 cms
Decorated by Charles Toft
Marks: *C. TOFT MINTONS 1877* inlaid

on the side of the base
City Museum & Art Gallery, Stoke (629)
Ill: No. 7, pl. 418; No. 13, pl. 71
Ex: Paris 1878

G12. Ewer

Earthenware, the ovoid body mounted on a
broad circular foot, the flared mouth
supporting a handle moulded as a snake,
decorated in relief with applied insects,
worms, frogs, and grotesques, the cream-
coloured ground painted and inlaid with
coloured clays in imitation of St Porchaire
earthenware, Minton ornament design
number 2348
23.5 cms
Decorated by Charles Toft
Marks: *C. TOFT MINTONS* inlaid on the
base
Date: c. 1878
Royal Doulton Tableware Limited
Ill: No. 4, pl. 51, for the original for this
design; No. 7, pl. 418; No. 13, pl. 71
See also the related drawing

G13. Wall Plaque

Earthenware, oval shape incorporating a
clock, barometer and thermometer with
moulded cherubs and Renaissance
ornamentation, the cream-coloured
ground painted and inlaid with coloured
clays in imitation of St Porchaire earthen-
ware, Minton ornament design number 1770
Size: 75 cms
Decorated by Charles Toft
Marks: *C. TOFT MINTON* inlaid below
the thermometer
Date: 1873
Royal Doulton Tableware Limited
Ill: No. 18, 1873, p. 155; No. 12, p. 209
Ex: Vienna 1873; Philadelphia 1876

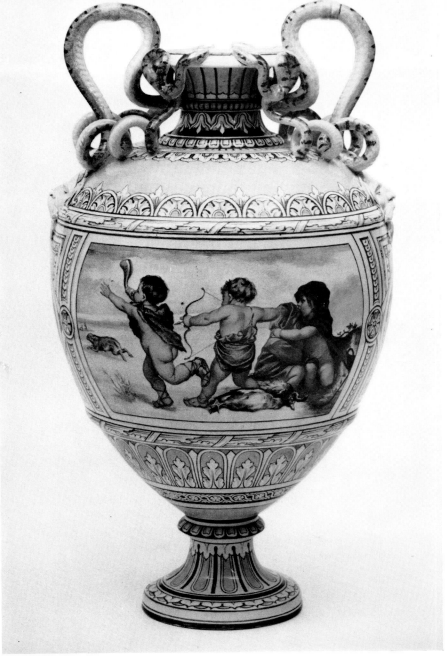

Plate 36. Catalogue G15

G14. Plaque
Earthenware, circular shape, painted in
enamels with a central female figure
holding a palm, after a design by Alfred
Stevens, surrounded by a border of
Renaissance strapwork, cherubs, masks
and fruit, the verso loosely painted with
foliate ornament
44 cms diam.
Painted by Léon Arnoux
Marks: Signed *L.A....x MINTON. 1859*
on verso
G. A. Godden
Ill: No. 9, pl. 363
The fairly accurate painting in the style
of Castelli maiolica and the use of
the tin glaze over a rather crude earthen-
ware suggest that this plaque was designed
to be an accurate representation of Italian
maiolica, although it does not appear to be
based on any particular piece. It is unusual
in carrying Arnoux's signature, one of only
three items in the exhibition to be signed,
and shows his interest in Renaissance
styles of decoration and manufacture.

G15. Vase Snake Handle Italian
Earthenware, the ovoid body mounted on a
narrow foot, the two handles formed by
complex writhing snakes, after a sixteenth
century Urbino model, the yellow ground
painted with bands of ornament containing
two panels, one a scene of cherubs hunting
game in the snow, the other of dancing
cherubs, Minton ornament design number
630
58 cms
Painted by William Wise
Date: 1878
Thomas Goode & Company Limited
Ex: Paris 1878

G16. Plaque
Earthenware, circular, painted in enamels
with a portrait bust of Queen Victoria
surrounded by scrollwork and grotesques in
imitation of Italian maiolica
64.5 cms diam.
Painted by Thomas Kirkby
Date: 1855
Victoria & Albert Museum (3340-1856)
Ill: No. 9, pl. 365
Ex: Paris 1855
Its pair, a portrait of the Empress Eugénie,
is now in the Swiss Cottage, Osborne,
Isle of Wight.

G17. Jewelled Ornamental Jug
Earthenware, bottle shape with moulded
flutes and a small loop handle, blue ground
painted with floral arabesques in white
enamel in imitation of Nevers faience,
Minton ornament design number 568
20.3 cms
Date: c. 1855
Victoria & Albert Museum (3569-1857)

G18. Plaque
Earthenware, circular shape, painted in
ruby lustre and gilt with a portrait of
Hadrian surrounded by a border of Renais-
sance arabesques and strapwork, inscribed
AELIVS.HADRIANVS:AVG, the verso
loosely painted in a similar style
44 cms diam.
Painted by F. W. Moody
Marks: Signed *FM* on the verso
Date: c. 1870
Victoria & Albert Museum (C.280-1921)

Section H

Tablewares
c. 1835–1910

Throughout the nineteenth century tableware was an essential part of Minton's production, and contributed significantly to their financial stability. Ironstones, semi-porcelains, bone chinas and earthenwares were produced in vast quantities, reflecting the various styles in current use in the factory. French-inspired designs by Jeannest, painted by Kirkby, Allen, Latham were produced side by side with transfer-printed earthenwares in oriental, Renaissance and Gothic styles. The process of acid gilding, developed in 1863, was used extensively to ornament services richly painted in enamels in the style of eighteenth century Sèvres, and with scenes after Watteau, Lancret, Angelica Kauffmann and Boucher. Antonin Boullemier added both humour and sentiment to tableware production with his freely painted cherubs and infants, creating wares that were highly prized throughout the world, and particularly in America. The popularity of *pâte-sur-pâte* ornamental wares led Minton's to develop a method of reproducing *pâte-sur-pâte* decoration on tablewares, using a combination of moulding and slip-painting techniques. At the same time, the essentially conservative nature of tableware production meant that many early patterns of the period c. 1800–10 were still in use a hundred years later.

In the 1870s and 1880s the influence of the Kensington Art Pottery Studio, and the development of methods of colour printing on ceramics brought about a revival of earthenware, decorated with fresh and lively designs by W. S. Coleman, H. Stacy Marks, J. Moyr Smith, G. Léonce and others, which reflected contemporary interests in medievalism and Japan. During this period Minton also established their reputation as suppliers of special services, to the Royal and aristocratic families of Europe, and to important retailers such as Tiffany and T. Goode & Company.

H1. Dish
Ironstone, square with moulded handles, transfer-printed in black with oriental flowers and vases contained within an irregular border, overpainted with enamels and enriched with gilding, Minton pattern number 4402
27 cms long
Marks: No. 3 printed
Date: c. 1838
Royal Doulton Tableware Limited

H2. Plate
Ironstone, circular with moulded lobed rim, transfer printed in blue with a passion flower pattern
26 cms diam.
Marks: No. 3 printed
Date: c. 1845
Victoria & Albert Museum (2722-1901)
Ill: No. 17, pl. 2

H3. Dish and cover
Earthenware, rectangular with moulded scroll borders and handles transfer-printed in blue with Italianate scenery, the *Dacca* pattern, and enriched with gilding
31 cms long
Marks: No. 3 printed
Date: c. 1838
Royal Doulton Tableware Limited

Plate 37. Catalogue H3

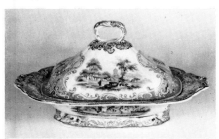

H4. Teapot and cover
Bone china, revived rococo shape, the flared foot and mouth decorated with scrolls, moulded spout and handle, the domed cover with a pine cone knop, the green and white ground painted with foliate scrolls in gold, Minton pattern number 7026
27 cms
Marks: Pattern number painted in gold
Date: c. 1840
G. A. Godden
Ill: No. 5, pl. 26

H5. Sèvres Ewer
Bone china, ovoid shape, after a Sèvres model, the tall handle and mouth and the gadrooned foot decorated with moulded scrolls, the white ground finely gilded, on the front a gold monogram and the date 1844, Minton ornament design number 38
24.5 cms
Date: 1844
G. A. Godden
Ill: No. 5, pl. 80

H6. Jug
Bone china, ovoid shape with a narrow neck, the white ground naturalistically painted in enamels with butterflies, wild flowers, grasses and insects, and enriched with gilding
23 cms
Marks: No. 5 printed in green
Date: c. 1850
Royal Doulton Tableware Limited

H7. Plate
Bone china, circular, the white ground painted in enamels with a central floral spray and the rim with a continuous border of floral swags hung from a purple ribbon, in turn suspended from the gilded edge
23.7 cms diam.
Marks: No. 5 in gold
Date: c. 1851
Victoria & Albert Museum (457-1852)

H8. Plate
Bone china, circular with lobed, pierced rim, painted in enamels with two rustic lovers after Boucher, the rim also painted and enriched with gilding
23.2 cms diam.
Marks: No. 5 painted in blue
Date: c. 1850
Royal Doulton Tableware Limited

H9. Plate
Bone china, circular, with lobed, pierced rim, painted in enamels with a seascape, the rim also painted and enriched with gilding
23.2 cms diam.
Marks: No. 5 painted in blue
Date: c. 1850
Royal Doulton Tableware Limited

H10. Plate
Bone china, with five pierced panels on the rim, the white ground painted in enamels with a central panel of a butterfly, grasses and a blackberry bush, and five panels of different butterflies and grasses round the rim, enriched with gilding
23.5 cms diam.
Painted by John Latham
Date: c. 1860
Victoria & Albert Museum (7344-1862)
Ex: V & E, E7

H11. Plate
Bone china, lobed circular shape with a complex pierced rim containing shaped panels, the centre painted in enamels with the interior of the 1851 Exhibition, the

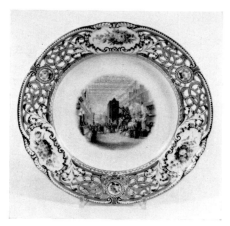

Plate 38. Catalogue H11

panels on the rim painted with flower
sprays, enriched with gilding
24.5 cms diam.
Marks: No. 5 in blue, printed garter
containing Minton & Co.
Date: 1851
G. A. Godden
Ill: No. 5, pl. 37

H12. Centrepiece
Parian and bone china, three tiers supported
by a central column which rises from a
complex base moulded with scrollwork
and seashells and decorated with three
seated girl figures in parian, the top tier a
pierced basket surmounted by a figure of a
kneeling water boy in parian, the whole
richly ornamented with moulding and
decorated with turquoise enamel, floral
garlands and rich gilding, Minton orna-
ment design number 947
69.5 cms
Designed by Emile Jeannest, painted by
Thomas Kirkby
Date: 1851
Victoria & Albert Museum (454-1854)

Ill: No. 18, 1851, p. 114; No. 6, pl. 38
Ex: London 1851, V & E, E17
This centrepiece, and the related cream
bowl and plate, catalogue H13 and
H14, were made as part of a duplicate
of a dinner service bought by Queen
Victoria at the 1851 exhibition and presented
to the Emperor of Austria

H13. Cream bowl and cover
Bone china and parian, the bowl supported
by three standing cherubs in parian and a
central foliate pillar rising from a trefoil
base, the pierced cover surmounted by a
seated cherub in parian, both pieces
moulded in relief with scrolls and painted
with floral and foliate sprays in enamels,
and enriched with turquoise and gilding
25.5 cms
Designed by Emile Jeannest, painted by
Thomas Kirkby
Date: 1851
Victoria & Albert Museum (455-1854)
Ill: No. 18, 1851, pl. 79; No. 12, p. 200;
No. 16, pl. 79
Ex: London 1851 & 1862

Plate 39. Catalogue H17

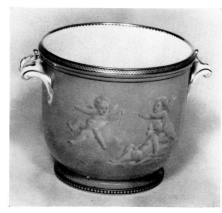

H14. Plate
Bone china, lobed circular shape with a
complex pierced rim containing shaped
panels, the centre painted in enamels with
playing cherubs, the panels on the rim
painted with entwined bands of flowers and
wreaths, enriched with gilding
24.5 cms diam.
Designed by Emile Jeannest, painted by
Thomas Kirkby
Date: 1851
Victoria & Albert Museum (456-1854)
Ill: No. 6, pl. 35; No. 12, p. 207

H15. Plate
Bone china, circular, painted in enamels
with a central flower and three floral
sprays in panels reserved out of the blue and
gold rim, enriched with gilding
23 cms diam.
Date: c. 1855
Victoria & Albert Museum (2719-1901)

H16. Seau
Bone china, Sèvres shape with two scroll
handles, the white ground painted in
enamels with a spray of flowers contained
by a trellis of roses and gilt leaves
10.4 cms
Date: 1851
Victoria & Albert Museum (639-1853)
This style of seau was also produced at
Derby

H17. Seau
Bone china, Sèvres shape with two scroll
handles, the puce ground painted *en
camaïeu* with cherubs hunting, black and
gilt borders around the foot and mouth
10 cms
Painted by Thomas Kirkby
Date: c. 1862
Victoria & Albert Museum (8093-1863)
Ex: London 1862

H18. Cup and saucer
Bone china, ovoid shape with twisted
handle, the white ground painted in
Sèvres style with garlands and swags of
flowers in monochrome blue enamel, and
enriched with gilding
Cup 6 cms, saucer 14.2 cms diam.
Marks: No. 5 painted in blue
Date: c. 1862
Victoria & Albert Museum (648 & a-1863)

H19. Cup and saucer
Bone china, low shape with raised loop
handle, decorated with a band of embossed
moulding, the rims painted with a border
of black, white and gold enamel, enriched
with gilding
Cup 4.5 cms, saucer 13.6 cms diam.
Marks: No. 7 impressed, and date code for
1862
Victoria & Albert Museum (8095 & a-1863)

H20. Cup and saucer
Eggshell bone china, painted in enamels
with an irregular band of floral wreaths,
swags and medallions reserved out of the
bleu céleste ground, enriched with gilding
Cup 6 cms, saucer, 13.2 cms diam.
Marks: No. 5 printed in green
Date: c. 1862
Victoria & Albert Museum (8102 & a-1863)

H21. Cup and saucer
Bone china, both pieces quatrefoil shape,
the cup handle moulded as a branch with
a floral terminal, painted in enamels with
floral sprays and trophies in panels reserved
out of the *bleu céleste* ground, enriched with
gilding
Cup 5.6 cms, saucer 15.2 cms long
Marks: No. 7 impressed, and date code for
1862
Victoria & Albert Museum (8104 & a-1863)

H22. Plate
Bone china, circular, the pale green ground
painted in enamels in oriental style with
an exotic bird standing on a flowering bush
24.6 cms diam.
Marks: No. 7 impressed, and date code for
1865
Royal Doulton Tableware Limited
See also the related drawing

H23. Plate
Bone china, circular, painted in enamels in
oriental style with an exotic bird seated
on a branch
24.6 cms diam.
Marks: No. 7 impressed
Date: c. 1870
Royal Doulton Tableware Limited

H24. Plate
Bone china, coupe shape, freely painted in
enamels with a blue bird sitting among
reeds
24.4 cms diam.
After designs by Gustav Léonce
Marks: No. 7 impressed, and date code for
1880
Royal Doulton Tableware Limited

H25 & H26. Pair of plates
Bone china, coupe shape, painted in enamels
in oriental style, one with flowers in a
German stoneware jug, the other with
flowers in a Venetian glass vase
24 cms diam.
Marks: No. 7 impressed, and date code for
1879
Royal Doulton Tableware Limited
The plates come from a set in which each
piece is painted with a vase or jug from a
different country, including China, Japan,
India, Austria, France

H27. Plate
Bone china, circular with pierced lattice-
work rim, freely painted in enamels with
an Aesop scene, the cat and the mice, the
rim enriched with gilding
25 cms diam.
Painted by Edouard Rischgitz
Marks: Signed *Edouard Rischgitz*, No. 7
impressed
Date: c. 1870
Royal Doulton Tableware Limited
See also the plaque painted by Rischgitz,
catalogue F20

H28. Plate
Bone china, coupe shape, the turquoise
border enriched with jewelling, gilding,
and flowers painted in enamels, the centre
freely painted with a seated Russian playing
a balalaika beside a river
24 cms diam.
Painted by Edouard Rischgitz
Marks: Signed *Edouard Rischgitz*, inscribed
in gold: *W.P.&G.Phillips. London*, and date
code for 1874, No. 7 impressed
G. A. Godden

H29. Plate
Bone china, lobed circular shape, the
turquoise rim decorated with raised gold
wreaths, the centre painted in enamels with
a group of people in eighteenth century
costume beside a river, with a distant
view of a town, after Joseph Vernet
25 cms diam.
Painted by Anton Boullemier
Marks: Signed *A. Boullemier*, No. 8
printed in gold
Thomas Goode & Company Limited
Ex: Paris 1878

H30 & H31. Tazza and Plate
Bone china, the plate circular with a pierced
chain rim enclosing medallions decorated
in raised gold, the tazza similarly shaped
with a tripod scroll support and a pierced
base, both pieces painted in enamels with
scenes from Lord Milton's adventures in
Canada
Plate 23.5 cms diam., tazza 14.3 cms
Decoration based on sketches by Lord
Milton made during a journey across
Canada
Marks: Plate inscribed in red: *One party
across the mountains*, tazza inscribed in red:
The Assiniboine rescues Bucephalus, both
pieces with Phillips mark printed in red
(retailer), No. 7 impressed
Date: c. 1876
Royal Doulton Tableware Limited
These pieces are from a dinner service
specially made for Lord Milton

H32. Plate
Bone china, coupe shape with a pierced
Greek key pattern around the rim, the
dark blue ground painted in white enamel
with a cherub standing before a monument,
enriched with gilding
24 cms diam.
Decorated by Anton Boullemier
Marks: Signed *A. Boullemier*, No. 10
printed in red
Date: c. 1880
Thomas Goode & Company Limited

H33 & H34. Tazza and Plate
Bone china, the plate circular with pierced
lattice-work panels on the rim, the tazza
similarly pierced and supported by three
moulded cherub caryatids with scroll
bases, linked by wreaths, both pieces

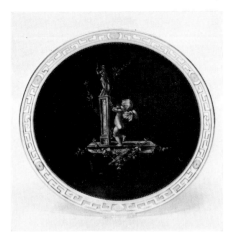

Plate 40. Catalogue H32

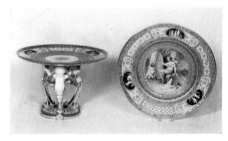

Plate 41. Catalogue H33 & H34

decorated with three classical medallions
on the rim surrounded by arabesques in
raised gilding and jewelling, the plate
painted in enamels with a classically dressed
girl decorating a plaque, assisted by two
cherubs, after Angelica Kauffmann, both
pieces enriched with gilding
Plate 25 cms diam., tazza 15 cms.
Painted by Anton Boullemier
Marks: Plate signed *A. Boullemier*, Goode
mark printed in gold (retailer), No. 7
impressed, and date code for 1888.
Thomas Goode & Company Limited

H35. Plate
Bone china, coupe shape, painted in
enamels with a cherub riding a seashell
drawn by a pair of fish, the rim enriched
with gilding
24.5 cms diam.
Painted by Anton Boullemier
Marks: Signed *A. Boullemier*, Goode
mark printed in red (retailer), and date code
for 1888
Royal Doulton Tableware Limited
Ex: Paris 1889

H36. Plate
Bone china, circular, the *bleu du roi* rim
decorated with gilding, in the centre a
panel painted in enamels with a scene from
Molière's *Le Bourgeois Gentilhomme*
24.6 cms diam.
Painted by Lucien Boullemier
Marks: Panel signed *L. Boullemier*, No. 8
printed in gold, No. 7 impressed, inscribed
in red: *Le Bougeois Gentilhomme*
Royal Doulton Tableware Limited
Ex: Paris 1878

H37. Plate
Bone china, circular with a complex
pierced lattice-work and floral rim, the
rose Pompadour centre painted in enamels
with a huntsman and lady, enriched with
gilding
26.5 cms diam.
Marks: No. 10 printed in gold, No. 7
impressed and date code for 1890
Royal Doulton Tableware Limited

H38. Tray
Bone china, quatrefoil shape, decorated with
five oval panels reserved out of the *rose
Pompadour* ground, painted in enamels
with views of Windsor, Balmoral, Dunrobin,

Cliveden and Trentham, enriched with gilding
42 cms long
Painted by H. L. Pratt
Marks: Inscribed in red on the verso;
Balmoral Castle, Windsor Castle, Dunrobin Castle, Cliveden House and *At the Bridge Trentham*, and signed, *H. L. Pratt, Penkhull Terrace Stoke-upon-Trent 1863*
By gracious permission of Her Majesty The Queen
This tray forms part of a déjeuner service bought by Queen Victoria in 1863 and still preserved at Osborne House

H39. Plate
Bone china, circular, the lattice-work pierced border enclosing floral panels, painted in enamels with a central floral spray reserved out of the *bleu céleste* ground, enriched with jewelling and gilding
25 cms diam.
Painted by Albert Gregory
Marks: Panel signed *A. Gregory*, no. 10 in gold, no. 7 impressed
Date: c. 1895
Royal Doulton Tableware Limited

H40. Plate
Bone china, coupe shape, painted in enamels with a central floral spray and three classical portrait medallions reserved out of the *bleu du roi* ground, around the rim garlands of flowers, additionally decorated with scrollwork and arabesques in raised gold
22.2 cms diam.
Marks: No. 10 printed in red
Date: c. 1900
Royal Doulton Tableware Limited

H41. Plate
Glazed parian, circular, the rim pierced and decorated with moulded scrolls, in the centre a round panel painted in white *pâte-sur-pâte* with a cherub kicking a heart, enriched with gilding
23 cms diam.
Decorated by Alboine Birks
Marks: Panel signed *A. Birks*, No. 10 printed in gold, No. 7 impressed
Date: c. 1890
Royal Doulton Tableware Limited

H42. Tray
Glazed parian, diamond shape, the white and gold *oeuil de perdrix* ground decorated with a dark blue oval panel painted with cherubs playing with a mask in white *pâte-sur-pâte*, further enriched with gilding
51.6 cms long
Decorated by Alboine Birks
Marks: Panel signed *AB*, No. 10 printed in gold, No. 7 impressed
Date: c. 1895
Royal Doulton Tableware Limited

H43. Plate
Glazed parian, coupe shape, the cream ground decorated in the centre and on the rim with pale blue panels painted in white *pâte-sur-pâte* with flowers and insects, and enriched with gilding
24 cms diam.
Marks: No. 10 printed in red
Date: c. 1900
Royal Doulton Tableware Limited

H44. Plate
Glazed parian, circular, the white ground decorated with three *pâte-sur-pâte* panels linked by a pale blue band and enclosed by raised foliate and jewelled gilding
26.6 cms diam.

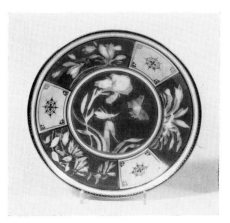

Plate 42. Catalogue H43

Marks: No. 10 printed in gold, No. 7 impressed
Date: c. 1900
Royal Doulton Tableware Limited
From incomplete plates preserved in the Minton Museum, it is apparent that some *pâte-sur-pâte* tablewares were moulded and not painted in slip

H45. Plate
Bone china, lobed circular shape, the white ground decorated with moulded scrolls painted in royal blue and gilt, in the centre with the Royal Garter
25.5 cms diam.
Marks: Buckingham Palace/Goode mark printed in red, No. 7 impressed
Date: c. 1870
Royal Doulton Tableware Limited
This design was in general use in many Royal residences for much of the nineteenth century, and can be found with Buckingham Palace, Balmoral, Royal Yacht and other backstamps. Identical services were also made by Copeland

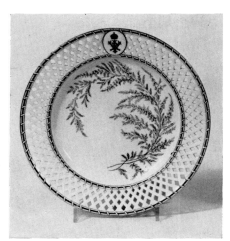

Plate 43. Catalogue H46

H46. Plate

Bone china, circular, with pierced lattice-work rim, the centre painted in enamels with a spray of heather, on the rim the monogram of Queen Victoria, enriched with gilding
27 cms diam.
Marks: Goode mark printed in red (retailer)
Date: c. 1895
Royal Doulton Tableware Limited
This plate was a replacement for a service originally made for Queen Victoria in 1879

H47. Plate

Bone china, circular, the rim decorated in raised enamels and gilding with chains, garters and Tudor roses, in the centre the insignia of the Order of the Garter
24 cms diam.
Marks: No. 10 printed in gold
Date: c. 1900
Royal Doulton Tableware Limited
A sample plate from a service made for use by the Order of the Garter

H48. Cup and Saucer

Bone china, printed in blue with a design of playing cards overpainted with enamels and enriched with gilding, Minton pattern number 1811
Cup 6.6 cms, saucer 14 cms diam.
Marks: No. 7 impressed and date code for 1873
Victoria & Albert Museum (692 & a-1935)
This style of decoration is probably taken from Paris porcelain, perhaps from the Nast factory

H49. Cup and Saucer

Bone china, the cup with a handle modelled as a butterfly, the white ground printed with naturalistic sprays of fruit, ferns and wild flowers overpainted with enamels and enriched with gilding
Cup 6.5 cms, saucer 14 cms diam.
Marks: No. 10 printed and registration mark for 7 April 1869, No. 7 impressed
Date: c. 1875
Victoria & Albert Museum (Circ.67-1970)

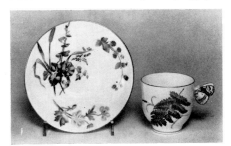

Plate 44. Catalogue H49

H50. Coffee cup and Saucer

Bone china, cylinder shape cup with steep walled saucer, painted in Sèvres style in enamels with roses contained by gilt wreaths reserved out of a spotted turquoise ground, further enriched with gilding
Cup 5.5 cms, saucer 12 cms diam.

Marks: No. 7 impressed and 1878
Royal Doulton Tableware Limited

H51. Cup and Saucer

Tinted and glazed parian, the gilded ground decorated with pale blue *pâte-sur-pâte* panels contained within a brown rococo border, enriched with gilding
Cup 7 cms, saucer 13.2 cms diam.
Decorated by Alboine Birks
Marks: Cup signed *AB*, No. 10 in gold
Date: c. 1880
Royal Doulton Tableware Limited

H52. Cup and Saucer

Bone china, fluted shape, the deep blue ground decorated with flowers and birds in white enamel, and enriched with gilding
Cup 6 cms, saucer 14.3 cms diam.
Marks: No. 10 printed in red, No. 7 impressed
Date: c. 1900
Royal Doulton Tableware Limited

H53. Cup and Saucer

Bone china, London shape, the inside of the cup and the rim of the saucer painted in enamels, with floral sprays reserved in rococo panels out of the deep blue ground, and enriched with gilding
Cup 5.8 cms, saucer 14 cms diam.
Marks: No. 10 printed in red
Date: c. 1900
Royal Doulton Tableware Limited

H54. Cup and Saucer

Bone china, Summerly shape, painted with flower sprays in red, blue and gold and enriched with gilding, Minton pattern number 101
Cup 6.1 cms, saucer 15.2 cms diam.
Marks: No. 10 printed in red, painted

pattern number, No. 7 impressed
Date: c. 1900
Royal Doulton Tableware Limited
This, and the following two cups and
saucers, are decorated with patterns intro-
duced before 1810, and still in use a century
later. The use of the Summerly shape,
designed by Sir Henry Cole in 1846,
also illustrates Minton's reliance on the
past designs during this period

H55. Cup and Saucer
Bone china, Summerly shape, painted
with bold floral arabesques in red, green
and gold, and enriched with gilding
Cup 6.1 cms, saucer 15.2 cms diam.
Marks: No. 10 printed in red, No. 7 im-
pressed
Date: c. 1900
Royal Doulton Tableware Limited

H56. Cup and Saucer
Bone china, Summerly shape, painted with
coastal landscapes in monochrome blue,
and enriched with gilding, Minton pattern
number 127
Cup 6.1 cms, saucer 15.2 cms diam.
Marks: No. 10 printed in red, painted
pattern number, No. 7 impressed
Date: c. 1900
Royal Doulton Tableware Limited

H57. Plate
Earthenware, octagonal, transfer-printed
in dark blue with Renaissance scrolls and
arabesques, the *Holland* pattern
24 cms diam.
Marks: No. 3, printed in blue, No. 7
impressed, and registration mark (illegible)
Date: c. 1870
Royal Doulton Tableware Limited

H58. Plate
Earthenware, circular, random decoration
of transfer-printed naturalist motifs,
overpainted with enamels
26.5 cms diam.
Designed by William Stephen Coleman
Marks: Printed W. S. Coleman scroll,
registration mark for 14 March 1870,
and date code for 1870, No. 7 impressed
Private Collection
Ill: Another plate from the service, No. 1,
pl. 92
W. S. Coleman was paid £200 in September
1869 for the designs for the Naturalist
series, which he undertook as a freelance
commission. Based on a similar service
designed by Felix Bracquemond in 1867,
after Japanese prints, the motifs were also
used on tiles

H59. Plate
Earthenware, coupe shape, transfer-printed
with Europa and the Bull, the emblem for
Taurus, within a square panel reserved
out of the mottled ground decorated with
foliage in oriental style, one of a series of
signs of the Zodiac
23 cms diam.
Marks: No. 7 impressed and date code for
1872
Victoria & Albert Museum (Circ.473-1970)

H60. Plate
Earthenware, circular, the celadon ground
transfer-printed in black with a duckling
seated on the handle of a Japanese fan,
from a service called *Gustave Doré*, because
the original was bought by Doré from
the 1878 Exhibition
24 cms diam.
Probably from designs by Gustav Léonce
Marks: No. 7 impressed and date code for
1878

Private Collection
Ex: Paris 1878

H61. Plate
Earthenware, octagonal, transfer-printed
in Japanese style with birds and flowers
and overprinted with enamels, the *Essex
Birds* pattern
22.5 cms diam.
Marks: No. 10 incorporating pattern name,
No. 7 impressed, registration mark for 10
April 1878, and date code for 1880
Private Collection

H62. Plate
Earthenware, octagonal, the cream ground
printed with the *Bamboo and Fan* pattern
and overpainted with enamels
25.5 cms diam.
Marks: No. 7 impressed, registration mark
for December 1875 and date code for 1880
Private Collection
Ill: No. 1, pl. 79

H63. Plate
Earthenware, circular, transfer-printed with
a central panel of birds and flowers in

Plate 45. Catalogue H57

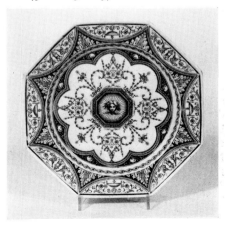

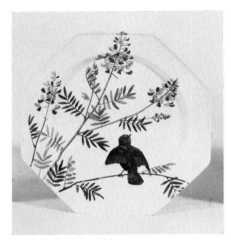

Plate 46. Catalogue H61

Japanese style, a fretwork and blossom border, overpainted with enamels, the *Faisan* pattern
25 cms diam.
Marks: No. 10 incorporating pattern name and registration mark for 14 September] 1880, No. 7 impressed and date code for 1881
Private Collection

H64. Plate
Earthenware, circular, the cream ground painted in brown with a Greek man seated at a table, *The Grace* from the *Anacreon* series and overpainted with enamels, the rim decorated with a fretwork and blossom border
25.5 cms diam.
Marks: No. 7 impressed, registration mark for January 1880, and date code for 1881
Private Collection
This series was originally designed for use on tiles. See the related drawing

H65. Plate
Bone china, coupe shape, printed with a knight in armour holding a hollyhock overpainted with enamels and enriched with gilding
24.5 cms diam.
From a design by Walter Crane
Marks: Printed on the verso, *The Hollyhock his Standard high Rears proudly to the Autumn Sky*, No. 10 printed, No. 7 impressed
Date: c. 1895
Victoria & Albert Museum (C.85-1967)
The plate is one of a series of designs borrowed by Mintons from *Flora's Feast, A Masque of Flowers* by Walter Crane, published in 1889. It is not likely that Crane adapted the designs himself, which were also used on tiles

Section I
Ornamental porcelains
c. 1850–80

Throughout the nineteenth century the influence of eighteenth century Sèvres on Minton was considerable, but is to be seen at its most dominant on the ornamental porcelains of the 1850–80 period. While these wares were never produced with any intention to deceive, their closeness to the original models is often remarkable. Of course, they were made in bone china, not in soft paste porcelain. Minton both owned and used original eighteenth century Sèvres moulds,[1] and had casts taken from objects in the Sèvres Museum; also, Arnoux regarded the successful reproduction of the turquoise, dark, blue, pink, apple green and yellow Sèvres ground colours as a rewarding technical challenge. In fact the technical control of ground colours, enamel painting, gilding and the bone china body meant that Mintons were often able to improve on the quality of the eighteenth century originals. The Minton designers and decorators also had access to a variety of Sèvres pieces, in both public and private collection; the most significant of these was owned by W. J. Goode, and included examples from the services made for Louis XVI, Madame du Barry and Catherine II of Russia, and the garniture known as the *Coventry Vases*, which W. J. Goode had bought from Lord Dudley in 1874. The Minton reproduction of these three vases was commissioned directly by W. J. Goode.

Sèvres styles and techniques were often blended and incorporated with other influences, for example the oriental, producing the splendidly catholic pieces that characterise Victorian ornamental porcelain. Elaborate moulding, fine enamel painting and rich gilding, combined with a free and inventive use of sources, gave these wares a popularity that was both immediate and lasting.

(1) Included in his evidence to the *Government Enquiry into the Arts*, 1862, by Michael Daintry Hollins, then in partnership with Colin Minton Campbell

63

I1. Harewood Bottle

Bone china, ovoid shape with moulded lobes and a narrow foot, after a Sèvres *bouteille à rubans*, the tall incurved neck tied with a moulded ribbon and surmounted by a small cover, the *bleu du roi* ground decorated with restained enamel jewelling and enriched with gilding, Minton ornament design number 299
37.5 cms
Date: c. 1851
Victoria & Albert Museum (2774 & a-1901)
Ex: London 1851, V & E, E5

I2. Sèvres Vase with Ropes

Bone china, ovoid shape on a narrow square base, after a Sèvres *vase antique ferré*, the body with four oval panels attached by moulded ropes, the broad cover surmounted with a pineapple knop, the four panels painted in enamels with dancing girls representing the four seasons reserved on white out of an apple green ground, and enriched with gilding, Minton ornament design number 450
50.8 cms
Painted by Thomas Allen
Date: 1851
Royal Doulton Tableware Limited
Ill: No. 6, pl. 35
Ex: London 1851

I3. Vase with Perforated Chain Handles

Bone china, classical shape with narrow square base with two extended pierced handles, after a Sèvres model, the cover with a tall knop, with two panels painted in enamels with an English landscape and a shipwreck reserved out of the *rose Pompadour* ground and surrounded by fruit, floral swags and ram's heads, and enriched with gilding, Minton ornament design number 469
37.5 cms

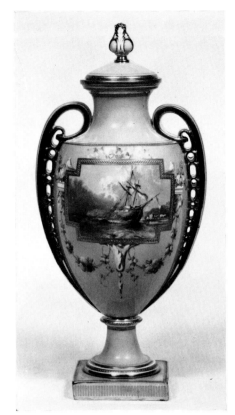

Plate 47. Catalogue I3

Marks: No. 6 printed in red
Date: c. 1869
Royal Doulton Tableware Limited

I4. Indian Bottle or Jar

Bone china, Chinese shape with two moulded ring handles, painted in enamels and gold with encircling foliage against a celadon ground, and enriched with gilding, Minton ornament design number 487
24.5 cms
Painted by Thomas Allen while a student at Marlborough House

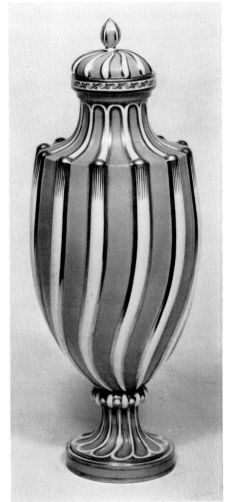

Plate 48. Catalogue I5

Marks: Inscribed in red on the base: *Painted by Thomas Allen. Student . . .* (remainder indecipherable)
Date: c. 1853
Victoria & Albert Museum (3562-1857)
Ex: Paris 1855

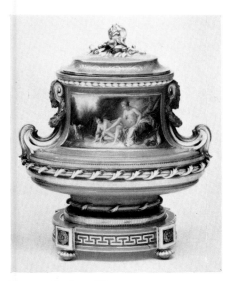

Plate 49. Catalogue I6

I5. Sèvres Vase, Twisted Flute
Bone china, classical shape with pronounced shoulder and narrow foot after a Sèvres *vase à côtes torses de côté*, by Duplessis, the foot, body and cover moulded in relief with raised spiral ribs, reserved in white out of the *rose Pompadour* ground and enriched with gilding, Minton ornament design number 449
40.7 cms
Date: c. 1855
Royal Doulton Tableware Limited

I6. Oval Queen's Vase
Bone china, depressed oval shape with broad neck and two scroll and wreath handles, after a Sèvres *vase éscritoire*, the stand with four feet, the cover surmounted with a moulded seed pod, painted in enamels on the front with a pastoral scene after Boucher and on the verso with musical instruments and trophies in rectangular panels reserved out of a *bleu céleste* ground, and enriched with gilding, Minton ornament design number 626
38 cms
Marks: No. 5 in green, No. 6 printed in red
Date: c. 1860
City Museum & Art Gallery, Stoke (1101)
Ill: No. 7, pl. 416 (similar vase)

I7. Vase Snake Handles Italian
Bone china, ovoid shaped on a narrow foot, the handles modelled as coiled snakes with mask terminals, painted in enamels with a portrait of a young girl in an oval panel reserved out of the *bleu du roi* ground, and enriched with gilding, Minton ornament design number 630
50 cms
Painted by E. Broughton, after Romney
Marks: Signed *E. Broughton 1876*, No. 7 impressed, T. Goode mark printed in gold (retailer), paper 1878 Exhibition label
Thomas Goode & Company Limited
Ex: Paris 1878
This vase makes an interesting contrast with the majolica version, catalogue G15, showing how similar shapes were frequently used in both earthenware and porcelain.

I8. Vase Rothschilds Perforated
Bone china, triangular shape with three bulbous vases attached to the moulded scroll base, after a Sèvres *vase triangulaire*, a tall pierced neck with a moulded scroll cover, the three vases painted in enamels with cherubs reserved out of a *bleu céleste* ground, enriched with gilding, Minton ornament design number 662
38 cms
Painting attributed to Thomas Allen
Marks: No. 5 printed in green
Date: c. 1855
Victoria & Albert Museum (4322-1857)

I9. Vase with Chains
Bone china, classical shape, based on a Sèvres *vase ferré à bandeaux*, on narrow foot with strap handles and two rectangular panels attached by moulded chains, moulded acanthus leaves and wreaths in imitation of ormolu, the pierced cover dome-shaped, the attached panel painted in enamels with a scene of cherubs playing, the *bleu du roi* ground enriched with gilding, Minton ornament design number 865
33 cms
Painting attributed to Christian Henk
Date: c. 1860
City Museum & Art Gallery, Stoke (3836)

I10. Flower Basket
Bone china, circular shape on three feet with a pierced, domed cover, painted in enamels with garden flowers, blackberries and snails reserved out of a gold ground, Minton ornament design number 1004
16 cms
Marks: No. 6 printed in red
Date: c. 1860
Victoria & Albert Museum (884-1863)

I11. Seau
Bone china, oriental cylinder shape with two pierced horizontal handles and four scroll feet, the rim and foot pierced with a Greek key pattern, painted in white enamel with birds, wild flowers and butterflies on a turquoise ground and enriched with gilding, Minton ornament design number 1994
23.5 cms
Painted by Désiré Leroy
Marks: Signed *Leroy*, No. 10 in gold, No. 7 impressed and registration mark for 15 June 1874 (refers to shape)
Date: c. 1878
D. Harrison
Ill: No. 6, pl. 45 (similar seau)
It is unusual to find Minton pieces bearing

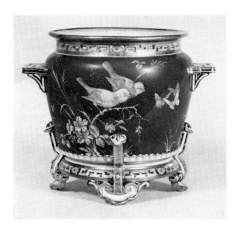

Plate 50. Catalogue 111

Leroy's signature, for his stay at Stoke was short, and he is much more famous for his subsequent work at Derby. At least four of these seaux are known, but only two are signed

112. Vase and Cover
Bone china, ovoid shape on a narrow foot decorated with moulded scrolls, after a Sèvres *vase fil et ruban*, two applied scroll handles, the cover decorated with moulded acanthus leaves and a pineapple knop, the body painted overall in enamels with a Harlequin scene after Watteau, the foot, handles and cover enriched with gilding
49 cms
Painted by Louis Jahn
Marks: No. 6 printed in red, No. 7 impressed, and date code for 1865
Royal Doulton Tableware Limited
Ill: No. 6, pl. 40

113. Elephant Vase
Bone china, a replica of a Sèvres *vase Duplessis à têtes d'éléphant* with two elephant head handles, painted in enamels on the front with a pastoral scene of a boy sending a love letter after Boucher and on the verso with a spray of flowers reserved out of a *rose Pompadour* and gilt vermiculated ground, enriched with gilding
29.5 cms
Marks: No. 7 impressed, Mortlock mark printed in gold (retailer), date code for 1876
City Museum & Art Gallery, Stoke (3459)
Ill: Similar vase No. 8, pl. 396; No. 6, pl. 48
Apart from the body, many Minton ornamental wares are virtually indistinguishable from their eighteenth century Sèvres counterparts. The elephant vase is probably the best-known example, and was produced in a variety of styles and colours throughout the latter part of the nineteenth century and well into the twentieth.

114. Candelabrum
Bone china, the four scroll branches supported by two tritons, standing back to back with their tails linked round the central column, on a circular base, the white ground picked out with *bleu céleste* and enriched with gilding, Minton ornament design number 2089
67 cms
Marks: No. 10 printed and Phillips mark (retailer)
Date: c. 1870
Victoria & Albert Museum (C.1236-1917)
Ill: No. 11, p. XXIIII (a)

115. Vase
Bone china, modelled as three straining cherubs pushing a falling ovoid bowl onto a square plinth, on an irregular round base, the bowl and plinth painted with turquoise enamel and enriched with gilding, Minton ornament design number 2342
32 cms
Designed and modelled by A. Carrier de Belleuse
Marks: Incised *CARRIER BELLEUSE*, No. 10 in red, No. 7 impressed, and date code for 1872
D.Harrison

116. Plate
Bone china, coupe shape, decorated with an etched design of bulls in sepia after K. Du Jadin, enriched with a gilt and jewelled border
27.5 cms diam.
Etched by William James Goode
Marks: Inscribed on the verso, *Etching on Porcelain by W. J. Goode. Finished for and presented to the South Kensington Museum. January 1867.*
Victoria & Albert Museum (307-1867)
William James Goode developed the technique of etching on porcelain in close

Plate 51. Catalogue 115

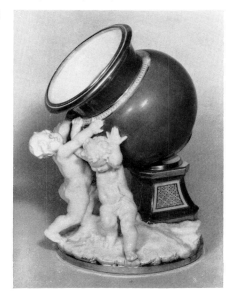

co-operation with Colin Minton Campbell. The technique is identical to etching except that porcelain replaces the copper, and the finished design, filled with pigment, is fired in the enamel kiln. By the nature of the process, each piece is unique. Several examples are known, including a plaque in the Victoria & Albert Museum dated October 1865, and the process aroused considerable interest at the Paris Exhibition of 1878

Section J

The Kensington Art Pottery Studio and its influence
c. 1870–90

In 1871 the Minton Art Pottery Studio was opened in South Kensington. Ground was leased from Her Majesty's Commissioners for the Exhibition of 1851 and Minton's built a studio, and a kiln 'so arranged as to consume its own smoke' with the intention of persuading eminent artists, 'especially ladies', to paint on porcelain and earthenware. The enterprise grew from the work of the South Kensington Museum porcelain painting class, where between 1867 and 1870 the female students painted Minton tile blanks for the decoration of the Grill Room at the Victoria and Albert Museum. It was later recorded that 'Messrs Minton were the first firm who fully broke down the barriers prejudice had erected in the way of women sharing in the higher branches of keramic art, by availing themselves of the assistance of some of the most talented of the students trained at South Kensington'. The nucleus of the Art Studio was a group of male professional artists from the factory in Stoke where the biscuit pottery was made. In this state it was transported to London for decoration and final firing. In addition to its technical equipment, every amenity was provided at the Studio to attract and encourage decorative artists. William Stephen Coleman was appointed Studio Manager, but the lack of documentary evidence makes it difficult to identify many of the other artists who worked in the Studio, in both professional and freelance capacities, The Studio became a a popular show place, but the venture was short-lived.

Coleman resigned in 1873, and was succeeded by Matthew Elder, the first of a series of erratic and inefficient managers, and then, in 1875, the premises were destroyed by fire. A variety of plaques, tiles and ornamental wares were produced, normally marked with the special printed backstamp (mark No. 9)

Plate 52. Catalogue J1 & J2

J1 & J2. Pair of Plaques
Earthenware, rectangular, freely painted in enamels with classical scenes, one with a girl considering a goldfish bowl, the other with a loosely draped girl testing the water of a swimming pool with her right toe
31 cms
Painted by William Stephen Coleman, in the style of Albert Moore
Marks: One signed *W. S. COLEMAN*
Date: c. 1870
Royal Doulton Tableware Limited

J3. Plaque
Earthenware, circular, freely painted in enamels with two dancing cherubs on a blue ground contained within a border of flowers and birds
51.5 cms diam.

Painted by W. J. Goode
Marks: Painter's monogram on the front, inscribed on the back; *Painted by W. J. Goode after W. S. Coleman October 1870*, No. 7 impressed, and date code for 1870
Thomas Goode & Company Limited
This plate illustrates the close relationship between Goode's and Minton's during this period.

J4. Plaque
Earthenware, circular, freely painted with a naked girl and child by a river bank, the child offering a swan a cherry, in a central panel contained by a border of flowers and a kingfisher
42.5 cms diam.
Painted by William Stephen Coleman

Marks: Signed *W. S. Coleman*, No. 7 impressed
Date: c. 1872
G. A. Godden
Ill: No. 7, pl. 413

J5. Plaque
Earthenware, circular shape, painted in enamels with a portrait of a girl with long hair wearing a flowered hat, holding a bunch of flowers in her left hand
57.5 cms diam.
Painted by E. J. S. (Unidentified)
Marks: Painter's monogram, No. 9 in black, No. 7 impressed, and date code for 1873
Private collection
Ill: no. 1, pl. 104

J6–J12. Set of Seven Plaques
Earthenware, circular shape, each plaque freely painted in enamels in the aesthetic style with a scene from the Seven Ages of Man, against a gold ground
1. A baby in the nurse's arm, a gardener and a maid looking on
2. A schoolboy being directed unwillingly to school by a maid drawing water from a well
3. A lover, writing a poem in a garden, two storks standing by a pond
4. A soldier in dispute over a gaming table, drawing his sword while his opponent is restrained by a girl
5. A justice, standing by a wall, receiving a petition from two peasants
6. An old man in a garden, flirting with a young girl
7. An aged pantaloon seated in a garden, a nurse standing by, a baby playing on the grass and a dog asleep at his feet
49.5 cms diam.
Painted by L. H. (unidentified), after H. Stacy Marks

Plate 53. Catalogue J3

Marks: Each plaque inscribed *H. S. MARKS* on the front. On the verso, each signed *L. H.*, printed Mortlock mark (retailer), No. 7 impressed, and various date codes between 1872 and 1874
Royal Doulton Tableware Limited
Ex: Vienna 1873
Although designed originally by Stacy Marks, the Seven Ages set was reproduced many times, both on circular and rectangular plaques. Tiles were also issued, painted with a reduced version. There are many designs for the set preserved in the Minton archives, and so it is clear that many painters were involved in their production. There are also pulls from copper plates of the outlines of the designs, an obvious indication of relatively large-scale production. A set, which may have been the original, featured in the interior of Eaton Hall, Cheshire.

J13. Plaque
Earthenware, circular shape, freely painted in enamels in a mixture of Islamic and Staffordshire slipware styles with heraldic figures contained within a border of animals and birds

Plate 54. Catalogue J11

34.3 diam
Marks: No. 9 in black, No. 7 impressed and date code for 1870
M. Whiteway

J14. Pilgrim Bottle
Earthenware, flat circular shape with two ring handles and a rectangular base, freely painted in enamels with two figures in medieval dress, the verso in monochrome blue with a Germanic castle, the whole additionally decorated with foliate ornament,

Minton ornament design number 1498
36 cms
Decoration after H. Stacy Marks
Marks: No. 7 impressed, and date code for 1877, painter's monogram
Victoria & Albert Museum (C.55-1915)
Ill: no. 1, pl. 102; No. 10, pl. 172; No. 17, pl. 83
See also the related design. This bottle and its pair (C.54-1915) were bought from Thomas Goode & Company by the donor to the Museum, Lady Constance Stern

Plate 55. Catalogue J14

J15. Plaque
Earthenware, circular shape, freely painted
in enamels with a portrait of a girl in a red
floppy hat holding a corn sheaf, against a
background of blackberry branches
51.5 cms diam.
Painted by William Wise
Marks: Signed *W. WISE 1877*, No. 7
impressed, and date code for 1876
Royal Doulton Tableware Limited

J16. Plaque
Earthenware, painted in enamels with a girl
in a yellow dress reclining on a bed sur-
rounded by rich blue drapes, an empty
decanter on a table beside her
30.2 cms diam.
Painted by H. W. Foster
Marks: Signed *H. W. F. MINTON*, No. 7
impressed, and date code for 1879
Royal Doulton Tableware Limited

Plate 56. Catalogue J17

J17. Plaque
Porcelain, rectangular shape, freely painted
in enamels with a scene of children and a
donkey on a beach
25.3 cms long
Painted by Anton Boullemier
Marks: Signed *A. Boullemier*
Date: c. 1875
City Museum & Art Gallery, Stoke (394
P 50)
One of a pair, this plaque with its loose
brush strokes and impasto technique shows
the influence of Emile Lessore on Boullemier
during his early years at the factory

J18. Vase
Earthenware, cylinder shape, the brown
body decorated in enamels with a frieze of
skeletal insects holding banners and enriched
with gilding
26.5 cms
Designed by Christopher Dresser
Marks: No. 7 impressed and date code for
1869
I. Bennett
See also the related drawing. This design is
illustrated in Dresser's *Principles of
Decorative Design* (Fig. 22), where he refers
to it as 'Old Bogey'. See also the note to
catalogue M1

J19. Flower Stand
Earthenware, cylinder shape on three bun
feet, freely painted in enamels with a pair of
jays fighting on an oak branch and bunch
of plums, the colours built up with an
impasto technique on the brown ground,
Minton ornament design number 1601
24.5 cms
Painted by William Mussill
Marks: Signed *W. Mussill*, No. 7 impressed,
and date code for 1870
Royal Doulton Tableware Limited

J20. Plaque
Earthenware, circular shape, painted in
enamels with a pair of pheasants flying
in a landscape with pines
30 cms diam.
Painted by J. Edward Dean
Marks: Signed *J. E. Dean*, No. 7 impressed
Date: c. 1890
Royal Doulton Tableware Limited

Section K

Pâte–sur–pâte wares and work of
Louis Marc Solon
c. 1858–1905

While it is generally accepted that Mintons
began to produce *pâte-sur-pâte* decorated
wares in 1870, following the arrival of
Louis Marc Solon in Stoke, they had
certainly been aware of the technique and
styles since the 1850s. In addition, Colin
Minton Campbell had been buying
French hard-paste *pâte-sur-pâte* plaques
decorated by Solon since 1867. The tech-
nique of *pâte-sur-pâte*, the building up of an
image in relief in successive layers of liquid
slip, is laborious, time-consuming and
expensive, and so it is remarkable that
Solon was able to devote all his energies to
this style of decoration over a long period of
time. An important part of his success was
due to the Minton tinted parian porcelain
body, a material much more responsive to
the *pâte-sur-pâte* technique than the French
hard-paste porcelains. At first he worked
alone, but he soon built up a small studio
where he trained a number of apprentices.
Rhead, Mellor, Sanders and Birks were
working with him by 1872 and his notebooks
reveal that he ran the studio along
Renaissance lines: the apprentices were
responsible for the mundane, repetitive or
purely ornamental work, while Solon
painted the figures. He continued to produce
pâte-sur-pâte for Mintons until his unwilling
retirement in 1904, and even after that
he continued to work in a freelance capacity
until his death in 1913. Greatly respected as
an artist, collector and ceramic historian, he
married Léon Arnoux's daughter and
played a considerable part in the well-
established French community in Stoke.

Solon was a skilled draughtsman and
prepared meticulous drawings of each design
before he began to paint on the unfired ware
with the liquid clay. Each layer of clay had
to dry before the next could be applied,
and so pieces could take many days to
complete. Each piece was biscuit fired, and
then fired again with a clear glaze. Every
design produced by Solon appears to be
original, and most were used only once.
However, in his designs he was able to
draw upon a great variety of sources and so
his cherubs, cupids and diaphanously
dressed girls reflect a familiarity with the
Renaissance, the engravings of the School
of Fontainebleau, Rubens and Raphael,
Boucher, Fragonard, Watteau and the
engravings of Bartolozzi, the Neo-classicism
of Ingres and Flaxman, and contemporary
material such as Valentines and Christmas
cards. He was also influenced by other
French designers working at Mintons,
especially Anton Boullemier. *Pâte-sur-pâte*
is probably Minton's best-known
contribution to Victorian ceramics, and is
certainly the most original. Although it was
extensively copied, both in England and
abroad, the originality and decorative skill
of Solon's *pâte-sur-pâte* makes it quite
distinct from his rivals.
Although in his books and articles he
referred to himself as Marc Louis Solon,
and frequently used the initials MLS,
this catalogue uses the form of his name
that occurs on his marriage certificate,
namely Louis Marc Solon.

K1. Vase

Tinted and glazed parian, oriental shape
with flared mouth, the celadon ground
decorated with flowers, leaves, grasses and
wheat naturalistically painted in raised
white slip, a border of foliate ornament
around the foot
25.5 cms
Marks: No. 6 printed in blue
Date: c. 1858
Victoria & Albert Museum (4735-1859)
This vase, and the more familiar Cordage
Vase displayed in the Victorian Primary
Gallery (8090-1863), indicate that the
Minton factory was accustomed to the *pâte-
sur-pâte* process long before Solon's arrival
in 1870

K2. Vase and Cover

Tinted and glazed parian, ovoid classical
shape on a narrow foot, the two upright
handles moulded with medallions and
bosses, two dark blue panels decorated in
white *pâte-sur-pâte* with a half naked girl sur-
rounded by tumbling cherubs deeply inset
into the pale green ground, the whole en-
enriched with gilding, Minton ornament
design number 1322
52 cms
Decorated by Louis Marc Solon
Marks: Signed *L. Solon 72*, No. 7 impressed
and date code for 1871
Royal Doulton Tableware Limited
This large vase is one of the early examples
of Minton *pâte-sur-pâte*. In style it is close
to Solon's work in France, especially in the
use of the pale green ground which was
soon abandoned because of the difficulty in
in maintaining an even colour on the tinted
parian body

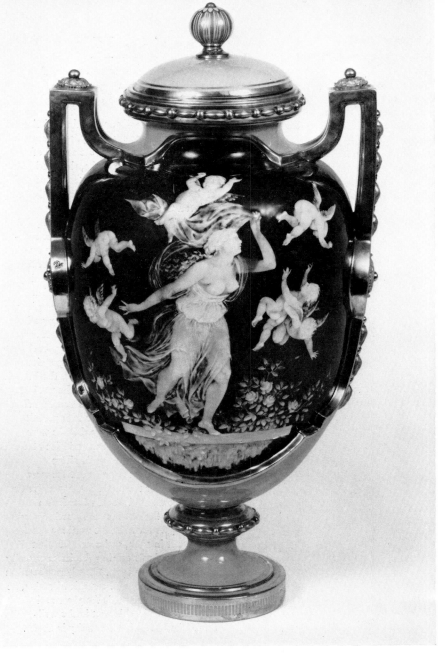

Plate 57. Catalogue K2

K3. Vase

Tinted and glazed parian, ovoid classical shape with narrow foot and neck, and two twisted handles, decorated with an architectural frieze and rich Pompeian ornamentation in polychrome *pâte-sur-pâte*, and enriched with gilding, Minton ornament design number 1937
41 cms
Decorated by Louis Marc Solon
Marks: Signed *L. Solon*, printed Daniell mark (retailer), No. 7 impressed
Date: 1876
Victoria & Albert Museum (572-1877)
Ex: Philadelphia 1876 by A. B. Daniell
Other examples of this polychrome vase are in the Thomas Goode Collection (catalogue TG17 & 18), and the Minton Museum, Stoke

K4. Tray

Tinted and glazed parian, rectangular shape with moulded scroll handles, the brown ground decorated in polychrome *pâte-sur-pâte* with a girl skipping over ropes held by four cherubs standing among foliage, enriched with silver and gilding
33.2 cms long
Decorated by Louis Marc Solon
Marks: Signed *L. Solon 78*, No. 8 printed in gold, No. 7 impressed, and date code for 1878
G. A. Godden
Ex: Paris 1878

K5. Bottle

Tinted and glazed parian, pilgrim flask shape with two applied handles, the ruby ground decorated in white *pâte-sur-pâte* with a girl sweeping away a cherub with a broom, the neck, foot and handles enriched with gilding, Minton ornament design number 1348
25.2 cms

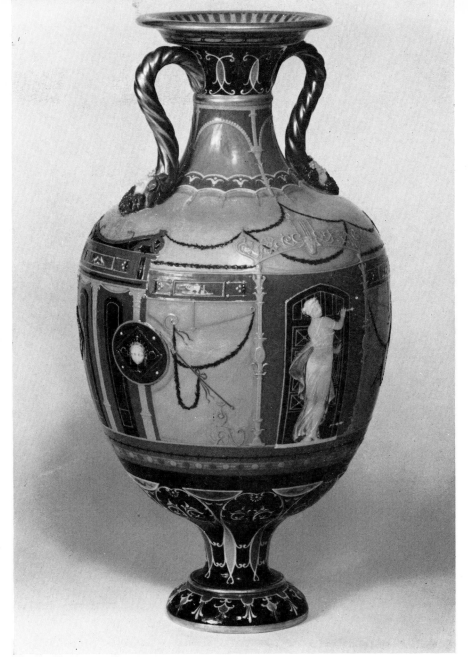

Plate 58. Catalogue K3

Decorated by Louis Marc Solon
Marks: Signed *L. Solon 78*, No. 8 printed
in gold, No. 7 impressed
Royal Doulton Tableware Limited
Ex: Paris 1878
This rare ruby ground was particularly
liked by Solon for its quality of changing
colour in different conditions of light; the
mushroom-pink colour in daylight inten-
sifies to a ruby-crimson under artificial
light

K6. Vase
Tinted and glazed parian, amphora shape
on a square base, with a flared mouth and
two knotted handles, the dark blue ground
decorated in white *pâte-sur-pâte* with a half
naked demonic girl holding a torch sur-
rounded by timorous cherubs in a rocky
landscape, on the verso a crouching sphinx
also surrounded by cherubs, the neck, base
and handles enriched with gilding, Minton
ornament design number
57.5 cms
Decorated by Louis Marc Solon
Marks: Signed *L. Solon*, No. 10 printed in
gold
Date: c. 1895
Royal Doulton Tableware Limited

K7. Vase
Tinted and glazed parian, tapering cylinder
shape with sharply waisted shoulder, the
brown ground decorated in white *pâte-sur-
pâte* with a continuous scene of naked
cherubs diving, swimming and playing
under water among reeds and fish, the neck
enriched with gilding
22 cms
Decorated by Louis Marc Solon
Marks: Signed *L. Solon*, No. 7 impressed
and dated 10.1.95
Royal Doulton Tableware Limited

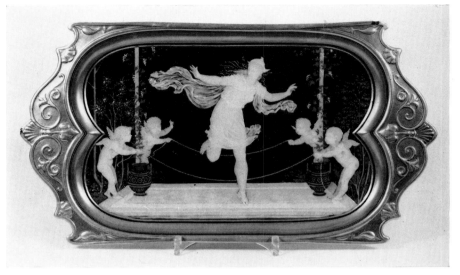

Plate 59. Catalogue K4

K8. Vase
Tinted and glazed parian, oriental shape
with flared mouth and foot, the shoulder
adorned with two applied looped handles,
the brown ground decorated in white *pâte-
sur-pâte* with naked cherubs flying on the
backs of butterflies and moths, the neck and
foot enriched with gilding, Minton orna-
ment design number 3355
32.5 cms
Decorated by Louis Marc Solon
Marks: Signed L. *Solon*, No. 10 printed in
gold
Date: c. 1900
Royal Doulton Tableware Limited

K9. Vase and Cover
Tinted and glazed parian, classical shape
with sharply waisted foot, two twisted scroll
handles, the cover with moulded leaves and
and an acorn knop, the dark green ground
decorated in white *pâte-sur-pâte* with a
diaphanously veiled girl being struck by
arrows, on the verso a cupid firing arrows,
the foot, neck, cover and handles enriched
with gilding
34.7 cms
Decorated by Louis Marc Solon
Marks: Signed *L. Solon*, No. 10 printed in
gold, dated 4.2.05
Royal Doulton Tableware Limited

K10. Plaque
Tinted and glazed parian, rectangular shape,
the brown ground decorated in white *pâte-
sur-pâte* with a half-naked sculptress
chiselling a giant head, lying on a rock at
her feet
24.2 cms
Decorated by Louis Marc Solon
Marks: Monogrammed *LMS*
Date: c. 1875
Royal Doulton Tableware Limited

K11. Plaque

Tinted parian, rectangular shape, the un-glazed but polished olive ground decorated in white *pâte-sur-pâte* with a scene of girls jumping through hoops held by winged cherubs, each carrying on her back a cherub rider who wields a whip
40 cms long
Decorated by Louis Marc Solon
Marks: Signed *L. Solon*. Inscribed in red on the verso: *First trial of unglazed polished parian at Mintons June 1881. L. Solon*
Royal Doulton Tableware Limited

K12. Set of Mounted and Framed Plaques

Tinted and glazed parian, six square plaques and the central rectangular plaque made to commemorate Queen Victoria's Jubilee of 1897, the blue ground decorated with white *pâte-sur-pâte*, the six plaques con-taining cherubs holding books representing the decades of Victoria's reign, the central plaque a formal portrait of Victoria seated on a throne at a writing desk, inscribed *VICTORIA RI*
Central panel 39 cms
Decorated by Louis Marc Solon
Marks: Central plaque signed *L. Solon*, the frame bearing two inscribed brass plates:
Executed by MINTONS in commemoration of Queen Victoria's Jubilee 1897, Pate sur Pate Plaques by L. Solon
City Museum & Art Gallery, Stoke
The existence in the Minton Museum of a cast, unglazed blank in white parian of the central panel suggests that these panels may have been made by a combination of moulding and *pâte-sur-pâte* techniques

K13. Plaque

Tinted and glazed parian, circular shape, the pink ground decorated in white *pâte-sur-*

pâte with a seated girl in classical costume about to place a collar and chain on a weeping cherub
18 cms diam,
Decorated by Alboine Birks
Marks: Signed *A. Birks*
Date: c. 1890
Royal Doulton Tableware Limited
The close similarity between this plaque and one in the Thomas Goode Collection (catalogue TG59) suggests that they may have been made by a combination of moulding and *pâte-sur-pâte* techniques

K14. Inkstand

Tinted parian, L shaped, the upright back supporting a pen tray, the base with two covered inkwells, the sides elaborately pierced, the brown ground decorated with white *pâte-sur-pâte*, a panel of cupids at archery practice on the back, floral garlands and a shell-shaped monogrammed escutcheon on the front, the whole enriched with gilding, Minton ornament design number 2850
23.5 cms long
Decorated by AL (unidentified)
Marks: Signed *AL*, No. 10 printed in gold, No. 7 impressed
Date: c. 1900
City Museum & Art Gallery, Stoke (84 P 33)
Ill: no. 2, pl. 85B

K15. Vase and Cover

Tinted and glazed parian, bottle shape, the tall swelled neck surmounted with a small cover, mounted on a complex rococo base from which are drawn two scroll handles, the the dark blue ground decorated with two oval green panels painted with cupids resting in a landscape in white *pâte-sur-pâte*, additionally decorated with raised gold wreaths and enriched with gilding

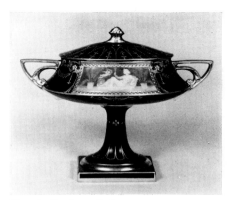

Plate 60. Catalogue K16

34.5 cms
Decorated by Alboine Birks
Marks: Signed *AB*, No. 10 printed in gold, No. 7 impressed
Date: c. 1900
Royal Doulton Tableware Limited

K16. Vase and Cover

Tinted and glazed parian, Art Nouveau shape with tall foot and square base, extended handles, the dark blue ground decorated with a rectangular panel in white *pâte-sur-pâte* of Juno reclining on a day bed accompanied by a winged cherub and a peacock on a grey-green ground, enriched with gilding, Minton ornament design number 3817
17.5 cms
Decorated by Alboine Birks
Marks: Panel signed *A. Birks*, No. 10 printed in gold
Date: c. 1908
Royal Doulton Tableware Limited

K17. Vase

Tinted and glazed parian, oriental shape, the yellow ground decorated in white *pâte-sur-pâte* with a continuous frieze of cherubs

and birds on a blue grey band, and enriched with jewelled gilding
18 cms
Decorated by Lawrence Birks
Marks: Signed *LB*, No. 10 printed in gold, No. 7 impressed
Date: c. 1900
Royal Doulton Tableware Limited
See also the related drawing

Plate 61. Catalogue K18

K18. Plaque
Earthenware, square, decorated in sgraffito technique with a scene of two cherubs potting, their wheel turned by five other cherubs within a rococo border containing pots and potters tools carved from a layer of beige slip over the terracotta ground
33 cms
Decorated by Louis Marc Solon
Marks: Inscribed *L. Solon 1877*
City Museum & Art Gallery, Stoke (444)
The pair to this plaque, decorated with a similar scene of cherubs firing their wares, is on display at the Gladstone Pottery Museum, Longton.

K19. & K20. Pair of figures, *A Good Bag*, and *Ill-licked Cub*
Glazed terracotta, both freely modelled as women in classical style standing on round bases, the one emptying a sack full of baby cherubs onto the ground at her feet, the other with her back turned imperiously away from a small winged cherub kneeling at her feet
21.2 cms and 22.2 cms
Modelled by Louis Marc Solon
Marks: Both incised *L. M. Solon*
Date 1898
City Museum and Art Gallery, Stoke (1199 and 1200)
Ill: No. 2, pl. 92B (one only)
Although closely related in style to Solon's *pâte-sur-pâte* decoration, it is very rare to find three-dimensional models by him. Only one other such figure is recorded, in the Minton Museum. The surviving *Pâte-sur-Pâte* Record Book, lists six figures in red clay, and it is not likely that any others were produced

K21. Plate
Earthenware, circular shape, freely painted in enamels with a portrait of a baby, above his head a pennant inscribed: 1817 (sic)
PETIT LEON AVRIL 72
29.5 cms
Decorated by Louis Marc Solon
Marks: Inscribed on the verso: *a mes cheres soeurs LMS 1872*, No 7 impressed, and date code for 1872
City Museum & Art Gallery, Stoke (28 P 51)
This early portrait of Léon, Solon's son and the future Art Director, is a rare example of painting by Solon

K22–29 Eight tiles
Earthenware, decorated in sgraffito technique, the three large tiles with standing figures holding pots representative of countries renowned for ceramic production, the small tiles with cherubs, vases and foliate ornament, one with the date 1883, all carved from a layer of beige slip over the terracotta ground
Size: large tiles 41 cms, small tiles 20.5 cms
Decorated by Louis Marc Solon
W. L. Solon
Ex: Paris 1878
These tiles were originally incorporated in a fireplace designed by the architect Norman Shaw as part of the Minton stand at the Paris 1878 Exhibition, and later moved to Solon's house, No. 1 The Villas, Stoke (see the related photograph). This fireplace, 18 ft 6 ins high and 6 ft 6 ins wide and including 34 tiles decorated by Solon, was sold in November 1913 for £27 in the dispersal sale following Solon's death

Section L

Oriental influenced wares

c. 1860–90

From the late 1850s until the end of the century, the most important outside influence on European design was the art of the Middle and Far East. Minton were in the forefront of this movement. Colin Minton Campbell purchased Persian tiles in Paris and Constantinople in 1858, the year in which he became managing director, and the Design Studio reference library included books of Japanese prints of flowers and birds from around 1860, when such things were first available in Europe. Oriental motifs were used in the decoration of wares of all types, and there were serious attempts to reproduce the forms and colours of available models. Léon Arnoux made a considerable contribution in his capacity as an experimental ceramic chemist and through his interest in Chinese ceramic technology.

It was at the Paris Exhibition of 1867 that both French and English manufacturers showed the results of their work in quantity, and from contemporary comment it would appear that the French were less successful than Mintons, who were commended by the International Jury for the eveness and brilliance of their transparent enamel colours. Technical experiments continued for some years, as it is recorded, for example, that Minton only achieved the exact reproduction 'of the red pigment so conspicuous on Rhodian pottery' for their display at the London International Exhibition of 1871. A range of wares in porcelain and earthenware was produced, based on such diverse sources as Chinese cloisonné, Japanese lacquer, Islamic metalwork, Isnik pottery, Japanese ivories, oriental bronzes and jades and Chinese monochrome glazed wares. On the evidence of the Patent Office Design Register, the arts of China and Japan in one form or another were the predominant influence on the cheaper wares as well as on tile decoration from the mid 1870s.

L1. Bottle

Hard paste porcelain, moon flask shape
with two handles, crackle glazed overall in
Chinese style, Minton ornament design
number 1348
19.8 cms
Designed by Léon Arnoux
Marks: *L. Arnoux Minton & Co* incised
into the footrim
Date: c. 1862
Victoria & Albert Museum (281-1864)
Ill: Similar crackle glazed vase, No. 6,
pl. 42
This bottle illustrates Arnoux's interest in
Chinese ceramic technology, and indicates
that the interest in China during this period
was far more than simply stylistic, antici-
pating the work of many of the studio
potters in both France and England.

L2. Vase

Earthenware, ovoid shape with waisted neck
and foot, two moulded dragon ring handles,
decorated with a turquoise majolica glaze, a
moulded band of oriental ornament painted
in brown and gold around the shoulder and
foot, and enriched with gilding, Minton
ornament design number 1720
23 cms
Marks: No. 7 impressed and date code for
1872
Royal Doulton Tableware Limited

L3. Vase

Earthenware, fluted oriental shape mounted
on a four-footed stand in imitation of carved
wood, decorated with a brilliant lime green
majolica glaze, the stand aubergine, Minton
ornament design number 1554
33 cms
Marks: No. 7 impressed and date code for
1873
City Museum & Art Gallery, Stoke (10 P 68)

L4. Vase

Earthenware, oriental inverted pear shape
with two applied lion's mask ring handles,
decorated with a brilliant yellow majolica
glaze
22 cms
Marks: No. 7 impressed and date code for
1873, paper label for 1874 Exhibition
City Museum & Art Gallery, Stoke
(14 P 68)
Ex: London 1874

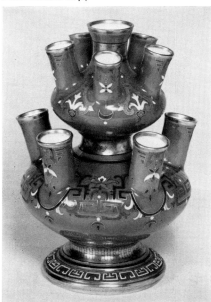

Plate 62. Catalogue L6

L5. Vase

Earthenware, bottle shape with flared
mouth and two handles applied to the neck,
decorated with a lustrous green glaze,
Minton ornament design number 1719
25.5 cms
Marks: No. 7 impressed, and date code for
1874
City Museum & Art Gallery, Stoke (4068)

L6. Vase

Bone china, the double gourd shape
adorned with eleven upright cylinder shape
necks, after Dutch delftware models, the
turquoise ground painted with coloured
enamels and gilding in imitation of Chinese
cloisonné, Minton ornament design number
1593
25.5 cms
Marks: No. 7 impressed, and date code for
1871
Date:
City Museum & Art Gallery, Stoke (3403)
See also the related drawing

L7. Vase

Bone china, fluted oriental shape mounted
on a four-footed stand in imitation of
carved wood, the turquoise ground richly
decorated with enamels and gilding in
imitation of Chinese cloisonné, the stand
painted brown, Minton ornament design
number 1554
33 cms

Plate 63. Catalogue L11

Marks: No. 10 printed, No. 7 impressed
Date: c. 1874
J. M. Scott
Ill: No. 22, p. 27
Ex: Fine Art 1972, No. 150
See also the related design

L8. Bottle
Bone china, moon flask shape with two
applied handles, the dark blue ground
decorated on both sides with oriental vases
and flowers moulded in relief in white,
additionally painted with white slip and
enriched with gilding, Minton ornament
design number 1820
28 cms
Marks: No. 10 printed, No. 7 impressed,
and date code for 1873
Royal Doulton Tableware Limited

Plate 64. Catalogue L12

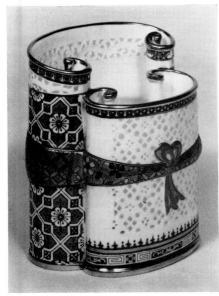

L9. Vase
Bone china, moon flask shape with two
applied handles, the dark green ground
moulded in relief with exotic fish in gold,
silver and pink, amid strands of seaweed,
in the style of oriental lacquer, and enriched
with gilding, Minton ornament design
number 1348
31.5 cms
Marks: No. 10 printed in gold, No. 7
impressed, and date code for 1881
Royal Doulton Tableware Limited

L10. Vase
Bone china, triangular shape, the three
panels separated by moulding in the
Chinese style and mounted on a pierced
oriental stand in imitation of carved wood,
the pink ground decorated with narcissi and
prunus drawn in white slip and enriched
with gilding, Minton ornament design
number 1865
31 cms
Marks: No. 10 printed, No. 7 impressed
Date: c. 1885
City Museum & Art Gallery, Stoke (6 P 68)

L11. Plate
Bone china, circular shape, the blue ground
decorated with concentric patterns in white
slip in the style of Staffordshire slipware
and painted with butterflies and a blackberry
branch in raised gold
20.5 cms diam.
Decorated by Charles Toft
Marks: *C. Toft 1878* incised on the verso
City Museum & Art Gallery, Stoke

L12. Spill Vase
Bone china, formed by two scrolls held
together by a moulded ribbon and bow,
pierced with geometric and foliate patterns
filled with translucent glaze in rice-grain

style, the white ground transfer-printed in
blue with an oriental pattern, the ribbon
painted with enamels and gilding, Minton
ornament design number 2263
15 cms
Marks: No. 7 impressed
Date: c. 1880
Royal Doulton Tableware Limited

L13. Match Pot
Tinted and glazed parian, modelled as a
bamboo stalk from which hangs a dead bird
with outstretched wings, its body being
investigated by a mouse, Minton ornament
design number 1915
14.8 cms
Marks: No. 7 impressed and date code
Victoria & Albert Museum (Circ. 407-1970)

L14. Japanese Boat
Earthenware, modelled as a boat formed
from a tree-trunk containing a seated man
holding a fan and a standing woman holding
a tiller, both in Japanese costume, the raised
bow and stern modelled as flowering prunus
branches, after a Japanese ivory, painted
with majolica glazes, Minton ornament
design number 1926
35 cms long
Designed by John Henk
Marks: *J.Henk* incised
Date: c. 1875
Royal Doulton Tableware Limited

L15. Indian Bottle
Bone china, pear shaped with a sharply
waisted foot, the tall neck surmounted with
a flared stopper, the white ground decorated
with Persian foliate patterns in raised blue
and green enamel, and enriched with gilding,
Minton ornament design number 688
20.5 cms
Date: 1862
Victoria & Albert Museum (7896-1863)

Ill: No. 18, 1862, p. 126
Ex: London 1862

L16. Bottle
Earthenware, pear shape with waisted foot,
a collar round the mouth, and two applied
handles, the white ground printed in green
with floral patterns in Persian style, addition-
ally painted with green and red enamels
52.2 cms
Marks: No. 7 impressed, and date code for
1874
Royal Doulton Tableware Limited
See also the related drawing. The decoration
of this bottle was based on a Persian model
in the Victoria & Albert Museum, but it is
not a copy

L17. Dish
Earthenware, freely painted in red, green
and blue enamels with flowers in imitation
of Isnik pottery, the white ground in the
style of tin glaze
29 cms diam.
Date: 1862
Victoria & Albert Museum (8100-1863)
Ex: London 1862

L18 & L19. Bottle and Stand
Bone china, the stand circular, the bottle
with a tapering neck and moulded ridged
collar, the white ground painted with
coloured enamels and gilding in imitation
of Islamic inlaid metalwork, Minton
ornament design number 2138
Bottle 25.6 cms, stand 24 cms diam.
Marks: Goode mark printed in gold
(retailer), No. 7 impressed, and date code for
1877
Private Collecton
See also the related drawing

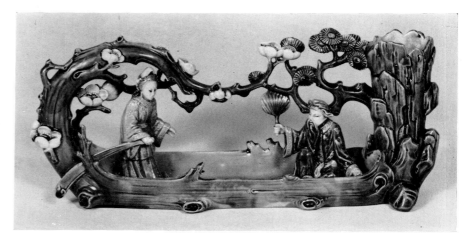

Plate 65. Catalogue L14

Plate 66. Catalogue L18 & L19

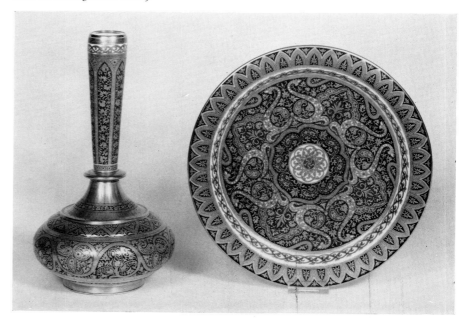

L20. Vase
Bone china, conical shape with a narrow
foot and six loop handles around the waisted
neck, the olive green ground decorated in
Persian style with alternate spiral panels of
pinks and forget-me-knots in polychrome
pâte-sur-pâte and painted dark clouds and
gilt stars, the whole enriched with gilding,
Minton ornament design number 2139
58 cms
Decorated by Charles Toft
Marks: Signed *C. Toft*, No. 10 printed in
gold, No. 7 impressed, and date code for
1880
Royal Doulton Tableware Limited
Ill: *L'Art*, 1878, p. 53

L21. Umbrella Stand
Bone china, cylinder shape with embossed
medallions around the mouth and foot, two
handles modelled as elephant's heads
holding rings in their trunks, the maroon
ground decorated with flowering branches
painted in Japanese style in enamels
interspersed with swasticas, and enriched
with gilding, Minton ornament design
number 1697
43.3 cms
Marks: Goode label (retailer), No. 7
impressed, and date code for 1878
Thomas Goode & Company Limited
Ex: Paris 1878

L22. Vase
Bone china, cylinder shape with tapering
neck and foot, two applied handles
modelled as prunus branches and a flared
mouth, the stippled gold ground decorated
with flying cranes modelled in relief in
white slip and with oriental emblems in red,
and further enriched with gilding, Minton
ornament design number 1947
57.5 cms

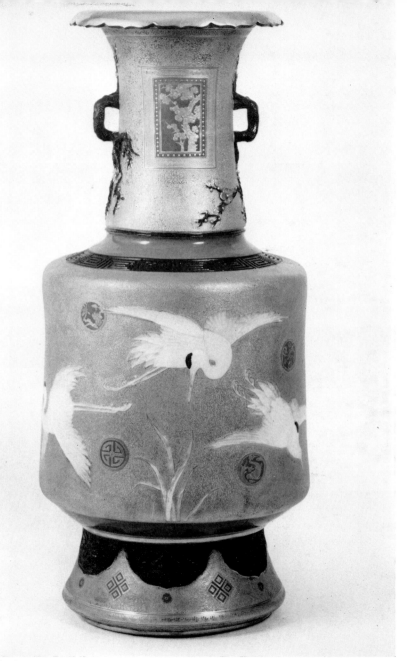

Plate 67. Catalogue L22

Marks: No. 7 impressed
Date: c. 1880
Thomas Goode & Company Limited

L23. Vase and Stand
Bone china, oriental shape with two handles
formed as elephant's heads holding rings in
their trunks, mounted on a four-footed
oriental base modelled as a carved wood
stand, the blue ground richly painted with a
bird and a dragon surrounded by clouds
in enamels and gilding in imitation of
Chinese cloisonné, the handles in imitation
of bronze, Minton ornament design number
1776
59 cms
Marks: Goode printed label (retailer)
Date: c. 1888
Thomas Goode & Company Limited
See also the relating drawing

L24. Vase and Cover
Bone china, oriental shape, the body pierced
in imitation of basketwork surrounding
three heart-shaped panels decorated with
flowers painted with enamels within a
raised gilt outline on a cream ground, a dark
blue band decorated with gilt foliage around
the foot and shoulder, the domed and
pierced cover surmounted by an orange
Dog of Fo, the whole enriched with gilding,
Minton ornament design number 2856
71 cms
Marks: No. 7 impressed and date code for
1888
Thomas Goode & Company Limited
Ex: Paris 1889
See also the related drawing

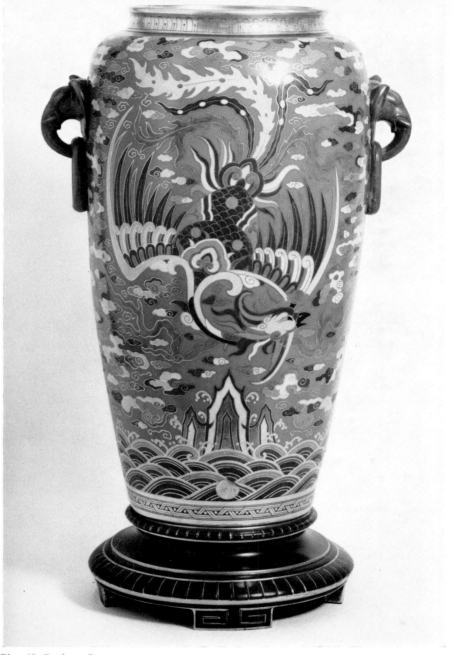

Plate 68. Catalogue L23

Section M
Ornamental porcelains
c.1880–1910

M1. Drum Vase
Bone china, cylinder shape richly painted in
enamels in Chinese cloisonné style, with
butterflies, beetles and geometric plants on a
turquoise ground and enriched with gilding,
mounted on a rococo metal stand modelled
as a vine, Minton ornament design number
1342
36.8 cms
After a design by Dr Christopher Dresser
Date: c. 1879
Private Collection
Ex: Fine Art, 1972, No. 176
Although a large number of signed designs
by Dresser are preserved in the Minton
archives, it is rare to find these designs
actually applied to pieces. This vase was
originally made with a circular ceramic base,
and the factory design books illustrate a
complete version, with another Dresser
design. These books contain photographs of
a variety of pieces with Dresser-based
decoration, and there are also a series of
shapes, numbers 2693–2698 and 2763,
which correspond exactly with Dresser
designs
See also the related drawings

M2. Bottle and Stand
Bone china, flask shape with two small
handles on the shoulder, mounted on a
pierced oriental base, painted in enamels
with sprays of roses and cornflowers, a
crowned floral monogram and scrolls bearing
the legends: *Dieu et Mon Droit* and
Gott Mit Uns and the date *January 25th*

1883, reserved against the matt silver
ground, and the whole enriched with
gilding, Minton ornament design number
2421
33.5 cms
Designed by W. J. Goode
Marks: Inscribed on the base: *Presented by
the Countess Bernstorff. Designed by W. J.
Goode London 1883*. Goode mark in gold
(retailer) and date code for 1883
G. A. Godden
Ill: No. 8, pl. 397
Made as a Silver Wedding present for the
Crown Prince and Princess of Germany, the

Plate 69. Catalogue M1

bottle was modelled on a Chinese turquoise glazed Chien-Lung bottle with Louis XVI ormulu mounts in the Victoria & Albert Museum. Countess Bernstorff was the widow of the Prussian Ambassador to Britain

M3. Writing Set
Bone china, comprising a rococo shape tray with two scroll handles, two covered ink stands with knops formed by gilt flowers and a small Sèvres eared vase, all after Sèvres models, painted in enamels with sprays of fruit and flowers in panels with looped green borders reserved out of the *rose Pompadour* ground, all pieces further decorated with green bands and enriched with gilding
Tray 32.5 cms diam.
Marks: All pieces with Mortlock mark printed in gold (retailer), and date 1884
Royal Doulton Tableware Limited

Plate 70. Catalogue M4

M4. Perforated Bottle
Bone china, pear shape, with moulded scroll foot and two twisted rococo handles, in the Chelsea gold anchor style of the 1760s, the neck and domed cover pierced with graduated holes, the *bleu du roi* ground decorated with birds seated on a bush in raised gold, the whole enriched with gilding, Minton ornament design number 158
32.3 cms
Marks: No. 10 printed in red
Date: c. 1885
Royal Doulton Tableware Limited
The introduction of this shape dates back to the 1830s, indicating the length of time that some of the ornamental porcelains remained in production

M5. Vase
Bone china, bottle shape, mounted on an oriental base with four feet, two pierced dragon handles after Persian models, the cream ground decorated with floral panels in 'Persian' style in raised enamels and gilding, around the neck a pierced band filled with translucent glaze, enriched with gilding, Minton ornament design number 2975
32 cms
Marks: No. 10 printed in red, No. 7 impressed
Date: c. 1890
Royal Doulton Tableware Limited

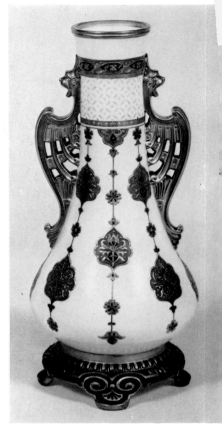

Plate 71. Catalogue M5

M6. Vase
Bone china, ovoid shape with narrow neck and foot, in the style of nineteenth century Sèvres decoration by M. Roussel, two handles below the flared mouth, mounted on a square stepped base, painted in monochrome purple enamel with a central frieze of agricultural scenes separating the turquoise and white neck and foot, enriched with gilding
59 cms

Painted by M. Dudley
Marks: Frieze signed *M. Dudley*, No. 7
impressed
Date: c. 1885
Royal Doulton Tableware Limited

M7. Vase with Embossed Ornaments and Festoons

Bone china, classical shape, after a Sèvres *vase Duplessis grec rectifié*, the facetted body moulded with panels and flutes and a central band of embossed medallions, the neck with a deep Greek key pattern and with pendant foliate swags, the foot with additional classical ornaments, the two angular fluted handles linking the band of medallions to the neck, the conical cover also deeply moulded, the *bleu du roi* and white ground also richly decorated with gilding, Minton ornament design number 470
45.5 cms
Marks: No. 10 printed in gold, No. 7 impressed
Date: c. 1890
Royal Doulton Tableware Limited

M8. Vase Hollandais

Bone china, fan shape after a Sèvres model, the base pierced, painted in enamels with two circular panels containing scenes of sailors after Morin and two oval floral panels reserved out of the *rose Pompadour* ground, the base painted with flower sprays, and enriched with gilding, Minton ornament design number 2185
21 cms
Painting attributed to Lucien Boullemier
Marks: No. 10 printed in gold
Date: c. 1900
Royal Doulton Tableware Limited
Ill: No. 2, pl. 67 (similar vase)

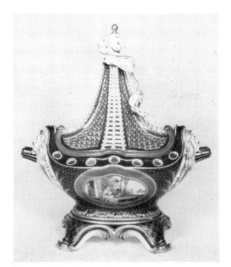

Plate 72. Catalogue M9

M9. Vaisseau à Mât

Bone china, the base modelled freely as a ship after a Sèvres model, the two handles moulded as lion's masks framing cannons, the tall cover elaborately pierced in the style of rigging, surmounted by a fluttering pennant, mounted on a scroll base with four feet, painted in enamels with a rustic scene, and on the verso a floral spray in oval panels with broad green borders reserved out of the *bleu du roi* and gold ground, additionally decorated with garlands of flowers on bow and stern and the whole richly gilded
43.5 cms
Painted by J. E. Dean
Marks: One panel signed *J. E. Dean*, No. 10 printed in gold
Date: c. 1900
Royal Doulton Tableware Limited
Ill: No. 8, pl. 394 (similar vase)
The design for the original Sèvres *vaisseau à mât* was drawn from the arms of the city of Paris. Like the elephant head vase, the

ship was closely copied by Minton who had some of the Sèvres moulds to work from. This vase remained in production until well into this century

M10. Monteith, or Flower Holder

Bone china, oval shape with two scroll handles after a Sèvres model, painted in enamels with exotic birds in a landscape in two oval panels reserved out of the *bleu céleste* ground, and enriched with gold swags and gilding
30 cms long
Painted by J. E. Dean
Marks: One panel signed *J. E. Dean*, No 10 printed in gold
Date c. 1900
Royal Doulton Tableware Limited

M11. Cabinet cup and saucer

Bone china, the cup cylindrical, the saucer steep-sided with no footrim, after a Sèvres model, painted in enamels with rustic scenes from engravings by R. Gaillard after Boucher, reserved out of the *bleu céleste* ground, both pieces additionally decorated with gilded lattice-work and wreaths
Cup 8 cms, saucer 15.2 cms diam.
Painted by H. P. Boullemier
Marks: Both pieces signed *H. P. Boullemier*, No. 10 printed in gold
Date: c. 1905
Royal Doulton Tableware Limited

M12. Seau

Bone china, circular shape with two scroll handles after a Sèvres model, a frieze of moulded acanthus leaves around the foot, the *bleu céleste* ground interrupted by bands containing continuous garlands of flowers in enamels and classical medallions painted *en camaïeu* on a brown ground, and enriched

with gilding, Minton ornament design
number 2264
19 cms
Painted by H. P. Boullemier
Marks: One medallion signed *H. Boullemier*,
No. 10 printed, No. 7 impressed
Date: c. 1905
Royal Doulton Tableware Limited
This seau is one of a range of pieces made
as copies of the Sèvres service produced for
Catherine II of Russia in 1779, and may
have been modelled on examples of the
Catherine service in the collection of
W. J. Goode.

M13. Spill Vase
Bone china, the ovoid rococo vase on a
rectangular base beside a standing figure of
a girl holding a distaff in her right hand,
lightly painted with enamels and enriched
with gilding, an adaptation of Minton figure
design number 503, which does not include
the vase
25.5 cms
Marks: No. 10 printed in black
Date: c. 1905
City Museum & Art Gallery, Stoke (3399)
Early in this century Mintons reintroduced
a range of their earlier figures, adapted to
suit the fashion of the period. Painted in
washed-out pastel colours, these revived
figures do not seem to have been very
successful

Section N
Secessionist wares
c. 1902–12

Judging by advertisements in the *Studio*
and by the first dated price list issued in
August 1902, Secessionist Ware was first
produced in that year. From the start the
design of the range was attributed to Léon
V. Solon and John W. Wadsworth. As its
name suggests the design of the range was
based on the Viennese Secession move-
ment and reveals both the surprising impact
of Vienna in North Staffordshire early in
this century and the continuity of the inter-
national tradition that had characterised
Minton's output during the nineteenth
century.
The range included ornaments and table-
wares in continental Art Nouveau shapes,
decorated with largely abstract floral motifs
with slip-trailed or moulded raised outlines
and painted with majolica glazes in a free
way that allowed the colours to flow into
each other. As such, Secessionist Ware
represents a development of the majolica
ranges produced by Minton since 1850.
Despite its Austrian pretensions, much
Secessionist Ware was probably based on
sources close at hand in the Potteries. Since
1898 James Macintyre & Co. of Cobridge
had been producing the very similar slip-
trailed Florian Wares and tableware
designed by William Moorcroft, while G.
Cartlidge was working for S. Hancock & Co.
in a closely related style. However, the
Secessionist range differed in that it was
produced in large quantities by industrial
methods rather than by a small studio or

Art pottery; also the ware was cheaply
priced and only indirectly marketed as Art
pottery.
A special printed mark was used (No. 11).
Secessionist Wares remained in production
until c. 1914.

N1 & N2. Comport and Plate
Earthenware, the plate circular, the comport
an irregular oval shape on an inverted
trumpet base, the mottled turquoise ground
decorated with Art Nouveau floral patterns
moulded in relief painted in green and
yellow ochre, Minton ornament design
numbers 3520 and 3515
Comport 12 cms, plate 23 cms diam.
Designed by Léon V. Solon and John W.
Wadsworth
Marks: No. 7 impressed
Date: c. 1905
Royal Doulton Tableware Limited

N3. Candlestick
Earthenware, inverted trumpet shape,
mottled green and yellow ground freely
decorated with slip-trailed foliage in ochre
and brown, Minton ornament design
number 3465
15.6 cms
Designed by Léon V. Solon and John W.
Wadsworth
Marks: No. 11 in black, No. 7 impressed
Date: c. 1904
Royal Doulton Tableware Limited

N4. Vase
Earthenware, gourd shape with tall neck,
the mottled red ground decorated with
slip-trailed foliate patterns in green and
white, Minton ornament design number
3547
12.7 cms
Designed by Léon V. Solon and John W.
Wadsworth
Marks: No. 11 in black, No. 7 impressed
Date: c. 1904
Victoria & Albert Museum (Circ.28-1970)

N5. Jug, Cavendish shape
Earthenware, cylinder shape with low-set

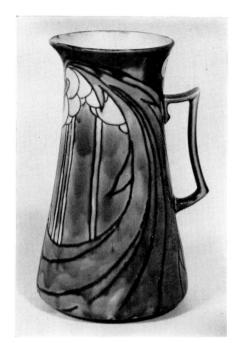

Plate 73. Catalogue N5

rectangular handle, the mottled blue ground
decorated with slip-trailed foliate patterns
in blue and green
30 cms
Designed by Léon V. Solon and John W.
Wadsworth
Marks: No. 11 in black, No. 7 impressed,
and date code for 1908
R. & I. Smythe
This jug, a well-known Minton shape, was
originally part of a wash stand set. It is
unusual to find Secessionist patterns applied
to functional wares

N6. Vase
Earthenware, crocus shape with applied loop
handles, the pink and green mottled ground
decorated with slip-trailed floral patterns in

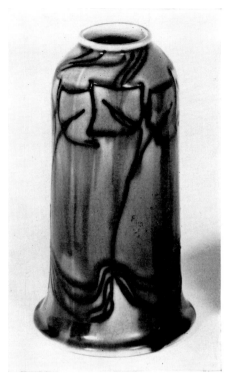

Plate 74A. Catalogue N8

dark green and yellow, Minton ornament
design number 3551
18.3 cms
Designed by Léon V. Solon and John W.
Wadsworth
Marks: No. 11 in black, No. 7 impressed
Date: c. 1904
R. & I. Smythe

N7. Vase
Earthenware, crocus shape with applied
loop handles, the yellow and blue mottled
ground decorated with slip-trailed floral
patterns in blue and white, Minton
ornament design number 3551

18.3 cms
Designed by Léon V. Solon and John W. Wadsworth
Marks: No. 11 in black, No. 7 impressed
Date: c. 1904
R. & I. Smythe

N8. Vase
Earthenware, cylinder shape with incurved neck, the green and yellow mottled ground decorated with slip-trailed floral patterns in dark green and pink, Minton ornament design number 3548
15.5 cms
Designed by Léon V. Solon and John W. Wadsworth.
Marks: No. 11 in black, No. 7 impressed
Date: c. 1904
R. & I. Smythe

N9. Vase
Earthenware, bottle shaped, the mottled blue and green ground decorated with white flowers outlines in green slip
12 cms
Designed by Léon V. Solon and John W. Wadsworth
Marks: No. 11 in black
Date: c. 1904
R. & I. Smythe

N10. Vase
Earthenware, conical shape, the mottled red and green ground decorated with white flowers outlined in green slip
12.5 cms
Designed by Léon V. Solon and John W. Wadsworth
Marks: No. 11 printed in black
Date: c. 1904
R. & I. Smythe

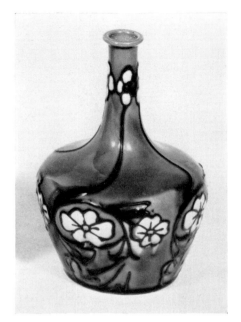

Plate 74B. Catalogue N9

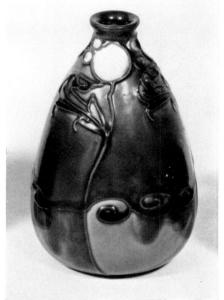

Plate 74C. Catalogue N10

N11. Vase
Earthenware, tapering cylinder shape with flared mouth and foot, two applied strap handles, the dark blue ground decorated with yellow and red flowers and green leaves outlined in slip, Minton ornament design number 3371
29.6 cms
Designed by Léon V. Solon and John W. Wadsworth
Marks: No. 11 in black
Date: c. 1904
R. & I. Smythe

N12. Vase
Earthenware, tapering cylinder shape with narrow neck and irregular flared foot, two divided strap handles attached to the shoulder, the green ground printed with

foliage in dark green and decorated with a peacock outlined in relief and painted with turquoise, yellow and purple enamels
28.7 cms
Designed by Léon V. Solon and John W. Wadsworth
Marks: No. 7 impressed
Date: c. 1906
R. & I. Smythe

N13. Vase
Earthenware, tapering cylinder shape with flared mouth and foot, two applied strap handles, the olive green ground printed with foliage in brown, additionally painted in blue, and with a painted brown and yellow band below the neck, Minton ornament design number 3371
29.6 cms

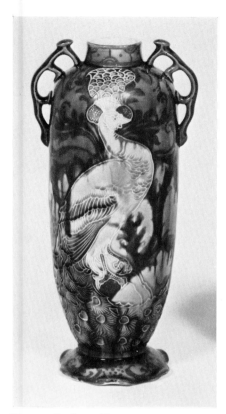

Plate 75. Catalogue N12

Designed by Léon V. Solon and John W. Wadsworth
Marks: No. 10 in black, No. 7 impressed
Date: c. 1906
R. & I. Smythe

N14. Vase
Earthenware, tall ovoid shape with narrow neck, the turquoise ground decorated with ochre Adamesque swags outlined in slip, an ochre band on the shoulder and foot
31.7 cms

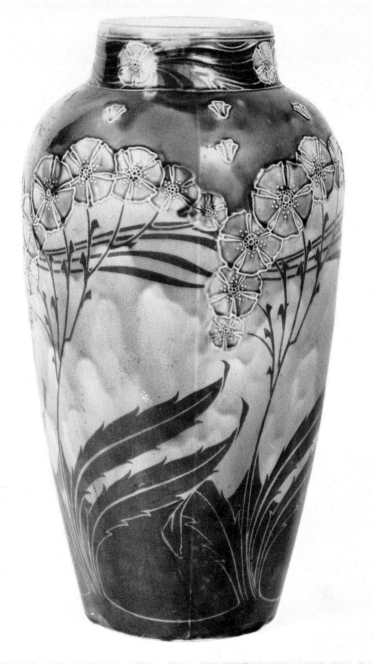

Plate 76. Catalogue N16

Designed by Léon V. Solon and John W.
Wadsworth
Marks: No. 11 in black, No. 7 impressed
Date: c. 1906
R. & I. Smythe

N15. Jardinière
Earthenware, depressed ovoid shape, the
pale green ground decorated with foliate
patterns printed in dark green and a band of
red, blue and yellow chrysanthemums
outlined in relief around the shoulder
18.5 cms
Designed by Léon V. Solon and John W.
Wadsworth
Marks: No. 7 impressed
Date: c. 1906
R. & I. Smythe

N16. Large Vase
Earthenware, tapering cylinder shape with
narrow neck, the pale green ground printed
with foliage patterns in dark green, with
garlands of blue flowers outlined in relief
around the shoulder
45 cms
Designed by Léon V. Solon and John W.
Wadsworth
Marks: No. 7 impressed, and date code for
1912
R. & I. Smythe
See also the related drawing

N17. Plate
Earthenware, circular shape, the mottled
blue ground decorated with Art Nouveau
flowers in green and ochre outlined in relief,
Minton ornament design number 3514
23 cms diam.
Designed by Léon V. Solon and John W.
Wadsworth
Marks: No. 7 impressed, and date code for
1910

R. & I. Smythe
Ill: No. 9, pl. 479

N18. Jardinière and Stand
Earthenware, the pale green ground
decorated with stylised Art Nouveau
flowers in turquoise outlined in relief
89.3 cms
Designed by Léon V. Solon and John W.
Wadsworth
Date: c. 1906
R. & I. Smythe
See also the related printed catalogue for
this and the other secessionist jardinière, No.
N19

N19. Jardinière and Stand
Earthenware, decorated with a printed
yellow ground and green foliage, and with
flowers painted in red and yellow, outlines in
relief
93 cms
Designed by Léon V. Solon and John W.
Wadsworth
Date: c. 1906
R. & I. Smythe

Section O

Encaustic tiles
c. 1840-70
Printed and painted tiles
c. 1850-1910
Moulded tiles
c. 1860-1910

A large display of individual tiles shows the range of Minton tile production in the various fields, and the variety of styles, patterns and techniques; also included are relevant drawings and designs.

The slide carrousel includes examples of architectural tile schemes that are still in existence.

Encaustic tiles c. 1840–70
In 1830 Samuel Wright of Shelton took out a patent for 'a manufacture of ornament tiles' which caught the attention of Herbert Minton. Already interested in medieval encaustic tiles, Minton bought Wright's patent, and by dint of lengthy and expensive experiments he was eventually able to produce encaustic tiles in commercial quantities. The process of inlaying clays of one colour into another colour is technically complicated because of the varying contraction rates of the different clays during firing. However, by using brass moulds, presses and chemically balanced clays Minton was able to re-establish the encaustic tile as a standard part of English floor decoration. His first commissions, many of which were for Trentham Hall, were carried out during the 1830s.

However, the subsequent success of the encaustic tile was due in part to Minton's successful reproduction of the medieval tiles on the floor of the Chapter House, Westminster, in the early 1840s which led to the production, in 1842, of the catalogue entitled *Old English Tile Patterns*. A great range of encaustic tiles was introduced, some based on existing medieval examples, and some on new designs drawn from the works of A. W. N. Pugin. Because of his commissions at Alton Towers and Cheadle, Pugin was a frequent visitor to Staffordshire; he also knew Mintons well because of their work for the Palace of Westminster. Although there are signed designs by Pugin for printed tiles in the Minton archives, it is not possible to say that Pugin designed encaustic tiles directly for Minton. The relationship seems to have been that of architect and supplier, rather than designer and manufacturer.

By the 1850s encaustic tiles had become very colourful, and many manufacturers were producing a great variety of designs. Churches, commercial and civic buildings, hotels and private houses throughout the world boasted encaustic tile floors. Examples still intact today include Osborne House, Isle of Wight, the Capitol, Washington and the Senate House, Melbourne

Printed and painted tiles c. 1850–1910
Herbert Minton's personal interest in tiles played a large part in the Victorian revival of tile production. As with the encaustics, he actively involved himself in every new development that could contribute to the

improvement of the manufacture of tiles.

In June 1840 Richard Prosser took out his patent for making articles from powdered clay by pressure, and Minton immediately bought a half share in this patent. By August of the same year tiles, buttons and tesserae for mosaics were being produced in Stoke by Prosser dust-presses, and by March 1844 ninety presses were at work. The dust press was the key to the revival of the tile industry, for it imposed a consistency, regularity and speed that were unobtainable by hand methods.

In 1848 Minton took an interest in the Collins and Reynolds lithographic printing process, patented on 14 March of that year, and he developed this as a method of printing areas of flat colour in one operation. The first tiles decorated by this process were for the Smoking Room of the Palace of Westminster, from designs by A. W. N. Pugin. Tiles of this type were shown in London in 1851 and in Paris in 1855, when Alfred Reynolds, one of the patentees and Minton's tile manager gained a First Class Certificate.

By the 1860s a wide range of printed tiles was being produced in many styles, despite the l1wsuit in 1868 following the dissolution of the partnership between Minton and Michael Hollins that attempted to prevent Minton from continuing in the manufacture of tiles. Production received a new impetus from the Kensington Art Pottery Studio, which was established in the wake of tile commissions received during the construction and decoration of the South Kensington Museum. During its short life the Studio produced a vast number of designs for tiles and panels reflecting current interest in medievalism and the arts of Japan and Persia, many of which were subsequently produced in Stoke.

In about 1874 the first of the now familiar sets of printed tiles was issued, and other sets quickly followed. Many designers were used, but J. Moyr Smith and William Wise are probably the most well known. Moyr Smith was the most prolific, and his sets, *Shakespeare*, *Old Testament*, *New Testament*, *Old English History*, *Tennyson*, *Waverley*, *Industrial*, *Thompson's Seasons*, etc., were produced in a variety of colours, styles and sizes.

Production of these tiles continued throughout the century, and their subject matter covered an extraordinarily wide field. Designs adapted from Christopher Dresser and Walter Crane were produced side by side with humorous and grotesque sets, while the influence of Japan vied with revivals of delftware and Sadler & Green printed patterns. Hand-colouring was combined with printing, and there were experiments with etching, block-printing, lithography and photo-reproduction.

Moulded tiles c. 1860–1910

From the early 1860s Mintons were producing pressed tiles decorated with moulding and ornamentation in sharp relief, and painted with bright majolica glazes. Tiles of this type were not designed as individual units, but were seen as part of large-scale decorative schemes. Styles were drawn from Renaissance and medieval sources predominantly, although the naturalism that characterises much of the majolica ware can also be seen in the tiles. The Old Refreshment Room, and the staircase to the old Ceramic Gallery at the Victoria & Albert Museum, and the Royal Dairy at Frogmore are examples of such schemes that still survive intact. Majolica decorated moulded tiles remained in production throughout the nineteenth century, and were only replaced in about 1900 by the Art Nouveau inspired slip-trailed tiles, where a raised outline was used to separate the colours. For these tiles both slip-trailing and press-moulding techniques were used, and like the similarly inspired Secessionist wares, they were painted with majolica glazes. All these moulded tiles were fired in a horizontal position in order that the colours should not flow beyond their designed limits.

A selection of Minton tiles is illustrated on the endpapers.

Section P

Large exhibition pieces displayed in the Old Refreshment Room

The Old Refreshment Rooms

The three refreshment rooms for the Museum were planned in 1860 by its architect, Captain Francis Fowke. Work was sufficiently advanced by November 1865 for Fowke and the Director, Sir Henry Cole, to consider the decoration of these rooms, which comprise one of the government's most striking decorative schemes surviving from the second half of the nineteenth century.

Cole commissioned the newly formed firm of Morris, Marshall & Faulkner for the West Room, Edward Pointer for the East Room and the Museum's own staff designer, Godfrey Sykes (a pupil of Alfred Stevens, from Sheffield) for the large central room. Fowke died in 1865 and Cole secured Major-General Henry Scott to supervise the completion of the building. Three months later Sykes also died, and his designs were taken over by his two assistants, Reuben Townroe and James Gamble (also pupils of Alfred Stevens, from Sheffield). However, Gamble was in fact responsible for most of the work on the central room.

The Gamble Room

Sykes and Cole decided that the walls of the Central and East Rooms should be clad in majolica tiles, no doubt inspired by John Thomas's dairy at Frogmore, and also for ease in cleaning. Minton, Hollins & Co., already involved in the manufacture of the Ceramic staircase, received the commission for this work. Gamble's four majolica columns were ordered in 1867 for £257, and in the same year Minton's estimated £983 for the majolica on the walls. Two years later, they rendered a further invoice for £465 for tiles. Other manufacturers, for example Maw & Co., were also involved in the decoration of this room.

The inscription in the frieze is based on an ornamental alphabet designed by Sykes for the Museum in 1863 (the letter I is a self-portrait), and reads, *There is nothing better for a man than that he should eat and drink, and that he should make his soul enjoy good in his labour XYZ* (*Ecclesiastes* II, 24).

The Poynter Room

Poynter was well advanced on his design for what became known as the Dutch Kitchen, or Grill Room, by November 1866 when he asked for payment of £150 for the lower tile panels, decorated with representations of Andromeda, Venus, Sappho, Proserpine, Eurydice and other classical ladies. The large upper panels represent the Seasons and the Months in contemporary dress, for the designs of which Poynter wanted £415. Plain white tiles were supplied by Mintons and these were painted by ladies of the South Kensington Museum Porcelain Class, at the rate of 6d per hour. Work was still continuing in 1870.

In 1899 Major-General Sir John Donnelly, Secretary to the Department of Science and Art, stated that the cost of this room, excluding the Grill designed by Poynter, was £1,345 16s, which compares with the reported cost of £1,127 for the Morris Room.

P1. Captain Fowke

Large parian bust on a rectangular plinth, the head modelled with considerable freedom, *CAPTAIN FOWKE* impressed in a panel on the base

53 cms

Designed and modelled by Thomas Woolner

Marks: Impressed on the verso, *Captain Fowke RE Born 1823 Died 1865*, Signed, *T. Woolner Sc*. No. 7 impressed

Victoria & Albert Museum (C.9-1976)

Captain Fowke of the Royal Engineers was the architect responsible for the design and construction of the Victoria & Albert Museum. This bust appears to have been made to special order as the design does not appear in the Minton figure books; it also represents the only known example of the Pre-Raphaelite sculptor Woolner's work for Minton

P2. Wine Cooler, Victoria

Earthenware, the bowl decorated in relief with scenes of bear hunting, vine swags and trophies, the lid with two modelled children seated beside a barrel surmounted by a basket containing grapes and vine leaves, the base ornamented by young huntsmen with animals, the whole richly painted with majolica glazes, Minton ornament design number 631

64 cms

Date: c. 1851

Victoria & Albert Museum (7261-1861)

Ill: No. 18, p. 116

Ex: London 1851

The huntsmen mounted on the base were also made separately, as figure models

P3. Monkey Garden Seat

Earthenware, modelled as a monkey crouching on a woven rush mat, holding a coconut in its left hand and supporting on

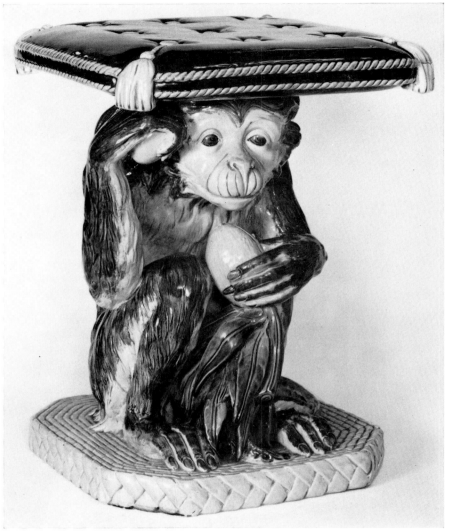

Plate 77. Catalogue P3

its head a buttoned and tasselled cushion, richly painted with majolica glazes, Minton ornament design number 589

47 cms

Marks: No. 7 impressed

Date: c. 1860

City Museum & Art Gallery, Stoke (46 P 72)

There are a great number of unusual garden

seats produced by Mintons in the middle of
the 19th century, mostly designed for
majolica decoration. Two other examples,
the seats supported by deer heads, can be
seen in the 19th century Primary Gallery in
the Victoria & Albert Museum (1308-1870)

P4. Peacock
Earthenware, modelled as a life-size peacock
with a flowing tail standing on a tall rock,
naturalistically painted with majolica glazes,
Minton ornament design number 2045
160 cms
Designed by Paul Comolera
Marks: Moulded signature, *P. Comolera*
Date: c. 1875
Royal Doulton Tableware Limited
Perhaps the best-known example of
Victorian majolica, the peacock was only one
of a range of life-size models of birds and
animals produced by Minton, several of
which were designed by Comolera. It is
commonly known as the Loch Ard Peacock
because one was shipped to Australia for
exhibition in Melbourne in 1880;
unfortunately the ship, the *Loch Ard* was
wrecked fourteen miles from the Australian
coast, but the packing case containing the
peacock was salvaged and the bird was
found to be intact. Since then at least nine
examples of the peacock have been traced
and others may well exist, as the factory
records do not reveal how many were
made. A pair were exhibited in London in
1894, priced at 90 gns.

P5. Flower Stand, or Jardinière
Earthenware, formed by two tiers of basins,
the upper of which is circular, the lower
tripartite supported by three female
caryatid figures standing on lion's feet on a
circular base; the upper basin is flanked by

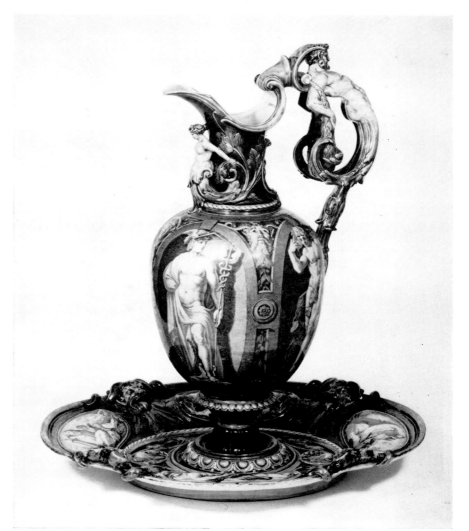

Plate 78. Catalogue P7

modelled cherubs and the whole is decorated
with swags and ornament moulded in relief
and painted with enamels in imitation of
Urbino maiolica on a turquoise ground
207 cms
Possibly designed by Emile Jeannest

Marks: *MINTON & CO STOKE UPON
TRENT* painted on the base
Date: 1855
City Museum & Art Gallery, Stoke (179 P
35)
Ill: No. 18, 1855, p. 14

Ex: Paris 1855; Ceramic Court, Crystal Palace 1856

Although this particular flower stand does not appear to be included in the factory design books, it is only one of a series of large ornaments that Mintons produced. Many of its component parts can be seen in other designs, for example numbers 934 and 1025, and it is possible that many of these large items were made with interchangeable parts

P6. Prometheus Vase, or Captive Vase

Earthenware, the classical vase with a narrow foot painted in imitation of maiolica with the Rape of the Sabines, four realistically moulded warriors bound head and foot to the two tall handles, the cover surmounted with a model of Prometheus and the eagle, the whole additionally decorated with majolica glazes, Minton ornament design number 1328

124 cms

Designed by Victor Simeon

Date: 1867

Victoria & Albert Museum (1048-1871)

Ill: No. 18, catalogue 1867, p. 93

Ex: Paris 1867; London 1871

Several versions of this vase are known, including one with monochrome painting in the Minton Museum, Stoke. A simplified version was also made in porcelain, see catalogue P8

P7. Ewer and Stand

Earthenware, the ewer a classical shape with a moulded mermaid below the spout, the handle modelled as a merman bending backwards and clutching his divided foliate tail, the body of the ewer naturalistically painted with deities standing in niches, the stand with four panels painted with the labours of Hercules contained by

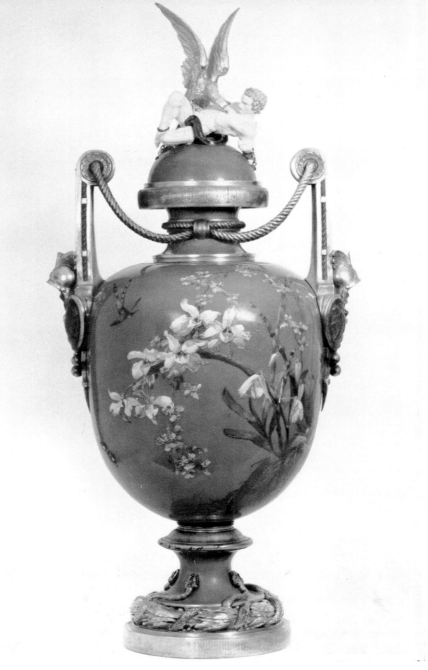

96

Plate 79. Catalogue P8

moulded masks and foliage, both pieces additionally decorated with majolica glazes, Minton ornament design number 616
Ewer 72.5 cms, stand 62 cms long
Designed by Emile Jeannest
Painted by Thomas Allen, the ewer from engravings by Raffaello Guidi after Polidoro da Caravaggio, the stand after Lebrun
Date: 1862
Victoria & Albert Museum (8107 & a-1863)
Ill: No. 18, 1862, p. 126; No. 12, p. 204; No. 21, p. 48 (similar example)
Ex: London 1862, V & E, E18
See also the related drawing

P8. Prometheus Vase and Cover

Bone china, ovoid shape on a circular base decorated with moulded snakes and tall handles linked to the neck of the vase with moulded ropes, their terminals ornamented with trophies, the domed cover surmounted by a figure of Prometheus and the eagle, the *bleu celéste* ground painted with flowers and birds in thick impasto, and enriched with gilding
100.9 cms
Designed by Victor Simeon
Marks: No. 10 printed, No. 7 impressed, and date code for 1876
Thomas Goode & Company Limited
Ex: Paris 1878

P9. Fountain

Earthenware, the large circular basin supported by moulded grotesques, the cream-coloured ground painted and inlaid with coloured clays in imitation of St Porchaire faience
153 cms (in its original state)
Decorated by Charles Toft
Date: 1878
Thomas Goode & Company Limited
Ref: *Pottery & Glass Trades Review*, 1878, p. 184
Ex: Paris 1878
Although now incomplete (the central portion is missing) this is still the largest and most impressive Minton example of the St Porchaire style of inlaid earthenware in existence. Unlike most of Toft's work in the St Porchaire style, this fountain is not based on a sixteenth century model

P10. Elephant

Earthenware, modelled as an elephant with trunk extended and two long tusks, standing on a carved wooden base inset with green glazed tiles, surmounted by a howdah richly decorated with moulded tassels and Indian ornamentation and painted with coloured enamels and gilding in imitation of Islamic tapestry, Minton ornament design number 2907
208 cms
Date: 1889
Thomas Goode & Company Limited
Ex: Paris 1889
Perhaps the best-known Victorian ceramic objects in Britain, this elephant and its pair have graced the windows of Thomas Goode & Company in South Audley Street since 1889, when they were made for the Paris Exhibition. When new, they cost Goode's £84 12s the pair, without bases. They were made of a new material, described as 'une nouvelle espèce de faience, sorte intermédiare entre la porcelaine tendre et la faience ordinaire'. Their size caused many production problems for, apart from the howdah, they were made and fired in one piece. Each was placed in a saggar in the tile oven, after the doorway had been greatly widened. Their subsequent appearance in the Minton photographic order books suggest that others may have been made to special order, but no other examples appear to be known

Section TG

Pâte-sur-pâte by Marc Louis Solon
and other Minton artists c. 1865–1910
displayed by Thomas Goode & Company at
19 South Audley Street, London W1

Thomas Goode set up in business as a china retailer in 1827, in premises in Mill Street, Hanover Square. The business was successful, and in 1844 he was able to move to larger premises in South Audley Street, the site of the present offices and show-rooms.

Thomas Goode's son, William James, was born in January 1831, and from an early age worked with his father gaining practical experience of the business. In 1857 he became a partner and then spent much of his time visiting suppliers and manufacturers in Britain and Europe. Thomas Goode retired in 1867, leaving his son in control of the business.

W. J. Goode was a virtuoso with many talents—manager, salesman, designer and collector, all of which helped to establish the company's international reputation during the Victorian period.

He was an inventive designer of both shapes and decoration, and was able to work in a variety of techniques; he painted majolica plates after the style of W. S. Coleman, and developed the technique of etching on porcelain which aroused con-siderable acclaim at the Paris Exhibition of 1878.

In the year 1879 he designed the Golden Wedding plaque given to the Emperor and Empress of Germany by Queen Victoria, and was responsible for a number of State services, including those made for the Viceroy of India and for the British Embassy in St Petersburg. All of these items were manufactured by Minton, with whom Goode's had a particularly close relationship. From the early years of the company Goode's had been buying from Minton, and after 1840 Minton became their major supplier. Between 1857 and 1867 the purchases from Minton totalled £106,469. This relationship developed throughout the 19th century, on both a business and personal level and W. J. Goode's eldest son, born in 1857, was christened Minton.

In 1878 Goode's bought the entire Minton stand at the Paris Exhibition, and put it on display in their showrooms. In the 1889 Paris Exhibition Minton wares were exhibited on both their own and on Goode's stand.

W. J. Goode also built up a famous collection of eighteenth century porcelain, specialising in Sèvres. He commissioned Minton to make copies from pieces in his collection, including the *Vaisseau à mât* and the *vase à têtes d'éléphant*. The collection was displayed in a specially built Sèvres Room at South Audley Street until his death in 1892, when the collection was sold.

Perhaps W. J. Goode's greatest achievement was the reconstruction of his premises in South Audley Street which started in 1875, and was completed in 1876. The

present building was designed in a contemporary style by Ernest George and Peto, with extensive use made of moulded and carved brickwork, and colourful tiles designed at the Minton Art Pottery Studio in South Kensington. The centenary of this building has prompted Thomas Goode & Company to mount an extensive exhibition of their collection of Minton *pâte-sur-pâte* wares, designed to be seen as a part of, and a complement to, the main Minton exhibition at the Victoria & Albert Museum.

This collection, which shows the development of *pâte-sur-pâte* from c. 1860 to 1910, features the work of Marc Louis Solon and his apprentices. Also included in the collection are pieces from the Paris Exhibitions of 1878 and 1889. Unless stated otherwise, all pieces on display are the property of Thomas Goode & Company.

TG1. Flask

Tinted and glazed parian, flat-sided flask shape on four square feet, the blue ground decorated in white *pâte-sur-pâte* with a cupid crouching in a spider's web, on the verso the monogram MG, enriched with gilding
14.7 cms
Decorated by Marc Louis Solon
Marks: Signed *L. Solon*, Goode mark in gold (retailer), No. 7 impressed
Dated: c. 1880
The MG monogram is generally accepted to be representative of the close relationship between Minton and Thomas Goode & Company. This spider's web design appears to have been a favourite of Solon's, for he made many versions of it, generally applied to flasks of this shape.

TG2. Vase and cover

Hard paste porcelain, classical shape with ormolu mounts and handles, the celadon ground decorated in white *pâte-sur-pâte* with a diaphanously dressed girl carrying cherubs in two baskets, enriched with gilding
Decorated by Louis Marc Solon
Marks: Signed *LMS*
Date: c. 1865
Royal Doulton Tableware Limited
The French elegance and the use of colour make this vase typical of Solon's work for the Sèvres factory, where he learnt the *pâte-sur-pâte* process before coming to England in 1870

TG3. Plaque

Hard paste porcelain, oval shape, the mottled pale blue ground decorated in white *pâte-sur-pâte* with a girl being tripped by a winged cherub
22 cms

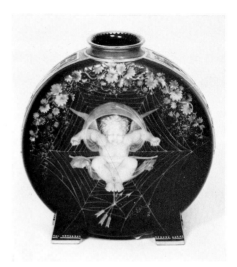

Plate 80. Catalogue TG1

Decorated by Louis Marc Solon
Marks: Signed *Miles*
Date: c. 1865
This plaque is an example of the *pâte-sur-pâte* decoration produced by Solon in France where he frequently used the signature *Miles*, an anagram of his initials

TG4. Vase

Hard paste porcelain, five-sided oriental shape, the chocolate-coloured panels decorated in polychrome *pâte-sur-pâte* with a seated girl and two cherubs holding nets, surrounded by foliage, enriched with gilding
21.2 cms
Decorated by Louis Marc Solon
Marks: Signed *Miles*, inscribed on the base: *Rousseau, rue Coquillière 41*
Date: c. 1865
This vase is an example of the work of Solon when he was in partnership with Rousseau, after leaving Sèvres. Pieces of

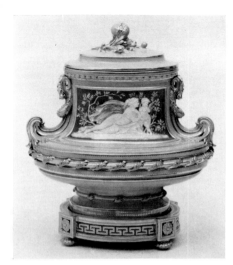

Plate 81. Catalogue TG8 & 9

this period are generally rather uneven in quality, and the painting is sometimes crude. This indicates how much harder it was to work in hard paste porcelain, with its higher firing temperature

TG5. Vase and cover
Tinted parian porcelain, Sèvres shape with four applied medallions and narrow foot, the pale green ground decorated with coloured *pâte-sur-pâte* and enriched with gilding, the blue medallions with cherubs in white *pâte-sur-pâte* and coloured flowers
35 cms
Decorated by Louis Marc Solon
Marks: No. 7 impressed
Date: 1872
This vase is an early example of *pâte-sur-pâte*. Although the shape was frequently used by Mintons for ornamental porcelain, the colour and style of decoration clearly shows the dependence on France

TG6 & 7. Pair of vases and covers
Tinted and glazed parian, ovoid Etruscan shape with two tall handles, the cover placed low on the shoulder, the white ground decorated with two brown rectangular *pâte-sur-pâte* panels surrounded by Renaissance and eighteenth century arabesques and scrolls in *pâte-sur-pâte* in Etruscan colours, the covers and feet predominantly pink, enriched with gilding
31 cms
Marks: No. 10 printed in gold, No. 7 impressed and date code for 1869
These Etruscan vases pose several problems. First, the decorator is unknown, despite the high quality of the *pâte-sur-pâte*. Second, they appear to have been made before L. M. Solon came to Stoke. According to the surviving wages book, Solon started working for Mintons in October 1870. The long-standing assumption that Solon introduced *pâte-sur-pâte* to England in 1870 seems to be based only on his own written statements, and may be thrown into doubt by these vases. Certainly Mintons were familiar with both tinted parian and a form of *pâte-sur-pâte* decoration long before Solon's arrival (see catalogue K1), and the possibility that Sèvres-type *pâte-sur-pâte* was being produced before 1870 is intriguing. Third, the style of these vases is quite unlike work produced by Solon, and is untypical of Minton *pâte-sur-pâte* as a whole

TG8 & 9. Pair of Oval Queen's Vases, with covers and stands
Tinted and glazed parian, depressed ovoid shape with broad necks, scroll handles, extensive moulded ornaments, after an eighteenth century Sèvres model, the celadon ground decorated with olive panels painted in white *pâte-sur-pâte* with reclining naked girls and cherubs, on the verso classical emblems, enriched with gilding
38.4 cms
Decorated by Louis Marc Solon
Marks: Signed *LMS*, No. 7 impressed and date code for 1872

TG10 & 11. Pair of vases
Tinted and glazed parian, classical shape with narrow feet, after an eighteenth century Sèvres model, flared mouths and twisted handles with moulded terminals, the *bleu du roi* ground decorated overall with gilded foliage surrounding oval brown panels painted in white *pâte-sur-pâte* with seated girls and cherubs adorned with foliate swags
41 cms
Marks: One signed *M*, No. 10 printed, No. 7 impressed
Date: c. 1873
Like the Etruscan vases, TG6 & 7, this pair are also by an unknown decorator and are in a style untypical of both Solon and Minton

TG12 & 13. Pair of vases
Tinted and glazed parian, classical shape with handles, the brown ground decorated in white *pâte-sur-pâte*, one with a standing girl holding a tray, surrounded by cherubs engaged in domestic pursuits, the other with a figure of Mercury being invited by cherubs to take part in a feast, the feet and neck additionally decorated with polychrome *pâte-sur-pâte* and enriched with gilding
44 cms
Decorated by Louis Marc Solon
Marks: Both signed *L. Solon 76*. Other marks obscured

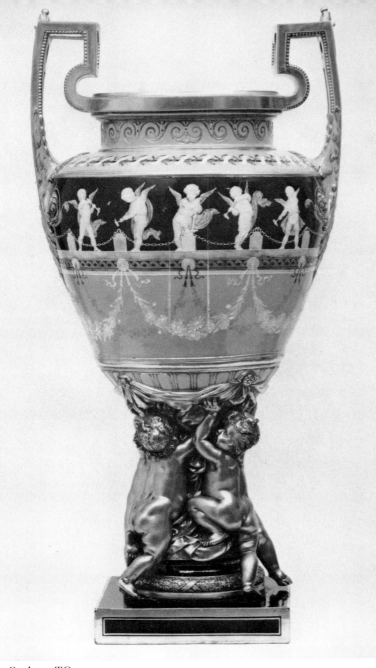

TG14. Vase
Tinted and glazed parian, amphora shape
with two tall rectangular handles, supported
by three naked straining cherubs standing
on a square base, the pale green ground
decorated with a blue band painted with a
frieze of cherubs hammering chains in
white *pâte-sur-pâte*, additionally decorated
with swags and ornamentation, enriched
with gilding, the supporting cherubs
finished in matt silver
95.5 cms
Decorated by L. M. Solon, the cherub base
designed by A. Carrier de Belleuse
Marks: Signed *L. Solon*, No. 8 in gold,
No. 7 impressed and date code for 1877
Ill: G. A. Sala, *Paris Herself Again*, 1878,
p. 199, no. 15, facing p. 318
Ex: Paris 1878

TG15 & 16. Pair of vases
Tinted and glazed parian, amphora shape
with square bases and snake handles, the
brown ground decorated with standing
classical figures in white *pâte-sur-pâte* set in
a polychrome arcade ornamented with
arabesques and enriched with gilding
59 cms
Decorated by Louis Marc Solon and H.
Hollins
Marks: Signed *L. Solon*, No. 8 in gold,
No. 7 impressed
Date: 1876
Ex: Paris 1878

TG17 & 18. Pair of vases
Tinted and glazed parian, classical shape
with square bases, flared mouths and
twisted handles with moulded finials, the
ochre ground decorated in polychrome
pâte-sur-pâte with classical scrolls,
arabesques and architectural motifs
surrounding diamond shaped panels

Plate 82. Catalogue TG14

101

painted in white with deities, enriched with gilding

41.5 cms

Panels decorated by Louis Marc Solon, with ornaments by T. Mellor

Marks: One signed *LS*, the other signed *L. Solon*, No. 8 printed in gold

Ex: Paris 1878

TG19 & 20. Pair of vases

Tinted and glazed parian, classical shape with handles, the blue ground decorated in white *pâte-sur-pâte* with a continuous frieze of girl miners excavating cherubs from rocks, the feet and neck additionally decorated with polychrome *pâte-sur-pâte* and enriched with gilding

44 cms

Decorated by Louis Marc Solon

Marks: One signed *L. Solon*, the other signed *L. Solon 81*, No. 10 printed

Date: 1881

TG21. Vase

Tinted and glazed parian, classical shape with two handles, the brown ground decorated in white *pâte-sur-pâte*, with a central frieze of cherubs carrying water from a stream to a bucket, the neck and foot additionally decorated with polychrome *pâte-sur-pâte* and enriched with gilding

40 cms

Decorated by Louis Marc Solon

Marks: Signed *L. Solon*, No. 10 in gold, No. 7 impressed and date code for 1885

TG22. Vase

Tinted and glazed parian, ovoid classical shape, flared mouth, two low-set moulded handles with mask terminals, the olive ground decorated in white *pâte-sur-pâte* with a circle of cherubs fishing in a giant vase, on the verso a scene of water nymphs

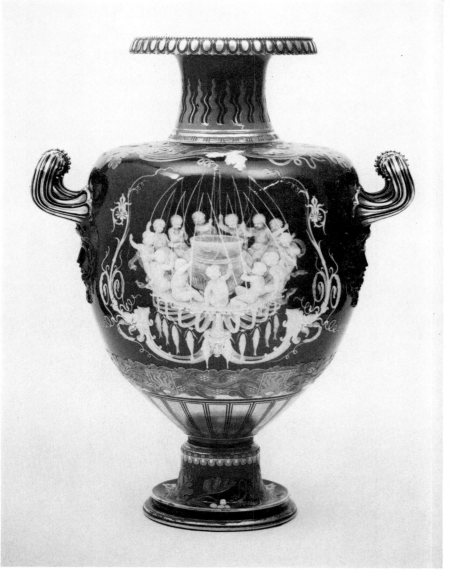

Plate 83. Catalogue TG22

fishing from a boat and from a wooded shore, the neck and foot additionally decorated with vines in polychrome *pâte-sur-*

pâte, and enriched with gilding

65 cms

Decorated by Louis Marc Solon

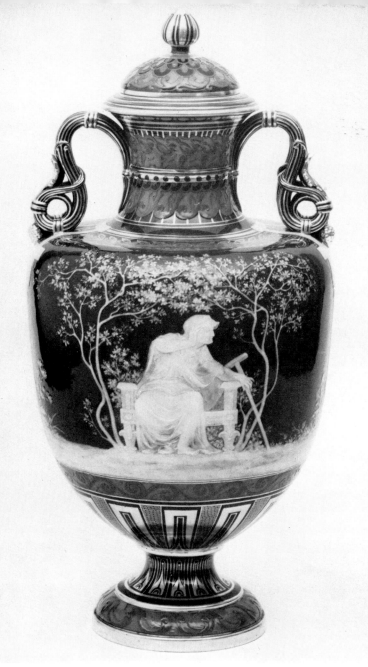

Plate 84. Catalogue TG28

Marks: Signed *L. Solon*, Goode mark in gold (retailer), No. 7 impressed and date code for 1887
Ill: *Queen*, vol. LXXXV, p. 788
Ex: Paris 1889

TG23. Vase and cover
Tinted and glazed parian, classical shape with two raised handles moulded as foliate wreaths attached by ribbons, the blue ground decorated in white *pâte-sur-pâte* with a winged cherub drawing a veil over a statue, enriched with gilding
30 cms
Decorated by Louis Marc Solon
Marks: Signed *L. Solon*, No. 10 in gold, No. 7 impressed
Date: c. 1885

TG24 & 25. Pair of flasks
Tinted and glazed parian, flat-sided flask shape with four square feet, the pink ground decorated in white *pâte-sur-pâte*, one with cherubs cooking a heart, the other with the cherubs preparing to eat the heart, enriched with gilding
15 cms
Decorated by Louis Marc Solon
Marks: Both signed *L. Solon*, No. 10 printed in gold, No. 7 impressed
Date: 1879

TG26 & 27. Pair of vases
Tinted and glazed parian, amphora shape with narrow foot and two knotted handles, the blue ground decorated in white *pâte-sur-pâte*, one with a winged nymph picking grapes, the other with a sea nymph rising from the waves, the versos with cherubs with fishing nets and rods, the neck, foot and handles enriched with gilding
53.5 cms
Decorated by Louis Marc Solon
Marks: Both signed *L. Solon*, Phillips mark

printed in gold (retailer), No. 7 impressed
and date code for 1890

TG28. Vase and cover
Tinted and glazed parian, classical shape
with two complex scroll handles, the dark
olive ground decorated in white *pâte-sur-pâte* with newly born infants and, on the
verso, a seated figure depicting old age, the
neck and foot additionally decorated with
polychrome *pâte-sur-pâte* and enriched with
gilding
53.6 cms
Decorated by Louis Marc Solon
Marks: Signed *L. Solon*, No. 10 printed,
No. 7 impressed
Date: c. 1890

TG29. Vase and cover
Tinted and glazed parian, classical shape
with two complex scroll handles, the dark
olive ground decorated in white *pâte-sur-pâte* with a central frieze of winged cherubs
catching doves, the neck and foot
additionally decorated with polychrome
pâte-sur-pâte and enriched with gilding
53.6 cms
Decorated by Louis Marc Solon
Marks: Signed *L. Solon*, No. 10 printed in
gold, No. 7 impressed
Date: c. 1890

TG30 & 31. Pair of vases
Tinted and glazed parian, amphora shape
with handles, the brown ground decorated
in white *pâte-sur-pâte*, one with three
girls with lyres reclining in an oak tree,
the other with girls standing in a pine tree,
both surrounded by cherubs, the feet and
necks additionally decorated with poly-
chrome *pâte-sur-pâte* and enriched with
gilding
47 cms

Decorated by Louis Marc Solon
Marks: one signed *L. Solon*, No. 10
printed in gold
Date: c. 1890

TG32 & 33. Pair of vases and covers
Tinted and glazed parian, classical shape
with pronounced shoulders and foliate ring
handles, the brown ground decorated in
white *pâte-sur-pâte* with winged female
figures scattering seed and watering the
ground, the versos with agricultural motifs,
and enriched with gilding
41 cms
Decorated by Louis Marc Solon
Marks: Both signed *L. Solon*, No. 10
printed in gold, No. 7 impressed and date
code for 1892 or 1893

TG34. Flask and stand
Tinted and glazed parian, pilgrim flask
shape with two moulded handles, mounted
on a pierced and gilded oriental stand, the
white and gold *oeuil de perdrix* ground
decorated with circular brown panels
painted in white *pâte-sur-pâte* with three
cherubs holding pigeons, on the verso
flowers and a tambourine, enriched with
gilding
33 cms
Decorated by Alboine Birks
Marks: Signed *AB*, No. 10 in gold, No. 7
impressed
Date: c. 1880

TG35 & 36. Pair of vases
Tinted and glazed parian, classical shape
with narrow feet and necks, and
twisted handles with mask terminals, the
black ground decorated with a central frieze
of cherubs in white *pâte-sur-pâte* carrying
musical instruments, flowers, fruit and
wreaths, the necks and feet additionally

decorated with arabesques in polychrome
pâte-sur-pâte and enriched with gilding
40 cms
Decorated by Alboine Birks
Marks: Signed *AB*, No. 10 printed in gold,
No. 7 impressed and date code for 1888

TG37. Vase
Tinted and glazed parian, ovoid shape on
narrow foot, the dark blue ground decorated
in white *pâte-sur-pâte* with two winged
cherubs seated either side of a steaming
cooking pot, enriched with gilding
18.5 cms
Decorated by Alboine Birks
Marks: Signed *AB*, No. 10 printed, No. 7
impressed
Date: c. 1890

TG38 & 39. Pair of vases and covers
Tinted and glazed parian, classical shape
with pronounced shoulders and foliate ring
handles, the brown ground decorated in
white *pâte-sur-pâte* with seated female
figures creating flying cherubs out of a fire
and a tambourine, enriched with gilding
35 cms
Decorated by Alboine Birks
Marks: Signed, *A. Birks*, No. 7 impressed
and date code for 1910
Several versions of this design are known on
similar vases

TG40. Vase
Tinted and glazed parian, classical shape
with two handles, the brown ground
decorated in white *pâte-sur-pâte* with a
diaphanously veiled girl seated in a tree
flanked by two cherubs with musical
instruments, the neck additionally decorated
with polychrome *pâte-sur-pâte*, enriched
with gilding
40 cms
Decorated by Lawrence Birks

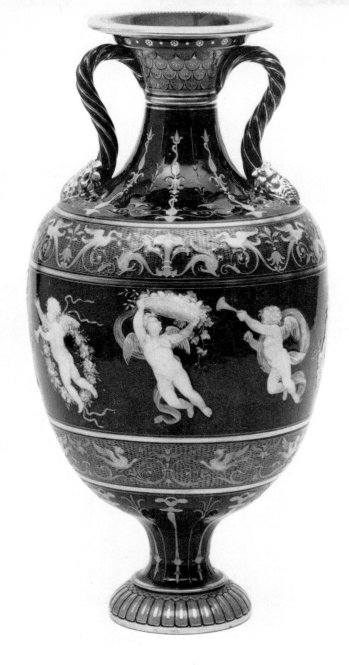

Marks: Signed *LB*, No. 10 printed in gold, No. 7 impressed and date code for 1890

TG41. Vase and cover

Tinted and glazed parian, oriental shape with two moulded elephant head handles holding rings in their trunks, the olive ground decorated with a Japanese carp in white and coloured *pâte-sur-pâte*, and enriched with gilding
33.5 cms
Decorated by H. Hollins
Marks: Signed *HH*, No. 10 printed, No. 7 impressed and date code for 1873

TG42. Flask

Tinted and glazed parian, pilgrim flask shape, swelled neck with two loop handles, the pink ground decorated with circular brown panels moulded in white relief with oriental scenes, additionally decorated with white *pâte-sur-pâte* and enriched with gilding
31.5 cms
Marks: Mortlock mark printed in gold (retailer), No. 7 impressed and date code for 1873

TG43. Barleycorn jug

Tinted and glazed parian, ovoid shape with tall neck, waisted foot, and moulded handle, the brown ground decorated in white *pâte-sur-pâte* with a naked cherub holding an ear of barley, additionally decorated with barley stalks, on the verso a scroll, inscribed in gold: *This is the gist of Barleykorn, Glad am I that the Cild is born* (sic), enriched with gilding
18.4 cms
Marks: No. 10 in gold, No. 7 impressed and date code for 1885

Plate 85. Catalogue TG35 & 36

105

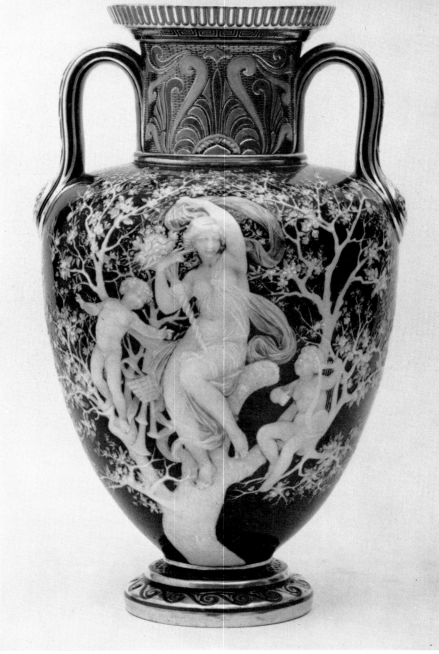

Plate 86. Catalogue TG40

TG44. Vase
Tinted and glazed parian, classical shape with two raised handles moulded as foliate wreathes attached by ribbons, the brown ground decorated with pink panels painted in white *pâte-sur-pâte* with eighteenth century arabesques, additionally decorated in a similar style with polychrome *pâte-sur-pâte* and enriched with gilding
33.5 cms
Decorated by T. Mellor
Marks: Signed *T. Mellor*, No. 10 printed in gold, No. 7 impressed
Date: c. 1885

TG45. Bowl
Tinted and glazed parian, the brown ground decorated with a frieze of classical figures in combat in white *pâte-sur-pâte* and enriched with gilding, modelled on Greek vase painting
8.5 cms
Marks: No. 10 printed
Date: c. 1880

TG46 & 47. Pair of flasks
Tinted and glazed parian, pilgrim flask shape with loop handles, the olive ground decorated in polychrome *pâte-sur-pâte* in oriental style with flowers and insects, the necks and feet additionally decorated with asymmetrical bands of colour, enriched with gilding
19 cms
Marks: No. 7 impressed
Date: c. 1880

TG48. Vase
Tinted and glazed parian, hexagonal oriental shape, the green ground decorated in white *pâte-sur-pâte* with Japanese flowers and enriched with gilding
16.6 cms
Marks: No. 7 impressed

Plate 87. Catalogue TG41

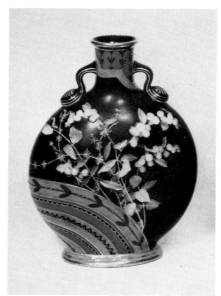

Plate 88. Catalogue TG46

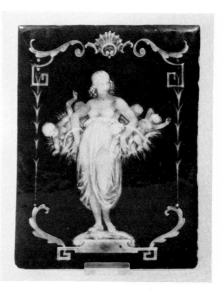

Plate 89. Catalogue TG49

Date: c. 1890
Ill: No. 2, pl. 84B

TG49. Plaque
Tinted and glazed parian, rectangular shape,
the blue ground decorated in white *pâte-sur-pâte* with a half naked girl holding a harvest
of cherubs in two baskets, framed by a
scrollwork border
23.4 cms
Decorated by Louis Marc Solon
Marks: Signed *LMS*
Date: c. 1870

TG50 & 51. Pair of plaques
Tinted and glazed parian, rectangular shape,
the black ground decorated in white *pâte-sur-pâte*, one entitled *histoire ancienne* with a
girl asleep in a chair, a cherub asleep across

the book on her lap, the other entitled
Roman nouveau with a girl in a chair
reading a book, her words eagerly followed
by a cherub on her lap
18.7 cms
Decorated by Louis Marc Solon
Marks: Both signed *L. Solon*, No. 7
impressed
Date: 1871

TG52. Plaque
Tinted and glazed parian, rectangular shape,
the black ground decorated in white *pâte-sur-pâte* with a girl dressed as a classical
warrior guarding a captive cherub in a cage,
while two other cherubs look on
19 cms
Decorated by Louis Marc Solon
Marks: *L. Solon*
Date: c. 1875

TG53. Plaque
Tinted and glazed parian, rectangular shape,
the olive ground decorated in white *pâte-sur-pâte* with a sculptor carving a statue of a
girl holding a lamp, aided by a cherub
holding a mirror
29 cms long
Decorated by Louis Marc Solon
Marks: Signed *L. Solon*
Date: c. 1880

TG54. Plaque
Tinted and polished parian, rectangular
shape, the brown ground decorated in white
pâte-sur-pâte with a kneeling girl burying a
cherub while others, grieving and cheerful,
look on
20 cms long
Decorated by Louis Marc Solon
Marks: Signed *L. Solon*
Date: c. 1890

TG55. Plaque
Tinted and glazed parian, oversquare shape, the brown ground decorated in white *pâte-sur-pâte* with two lovers being crowned by a cherub, while a cherub orchestra plays in the background
22.5 cms
Decorated by Louis Marc Solon
Marks: Signed *L. Solon*
Date: c. 1890

TG56. Plaque
Tinted and glazed parian, rectangular shape, the brown ground decorated in white *pâte-sur-pâte* with a girl driving a cluster of cherubs before her with a whip
27.1 cms
Decorated by Louis Marc Solon
Marks: Signed *L. Solon*
Date: c. 1890

TG57. Plaque
Tinted and polished parian, rectangular shape, the brown ground decorated in white *pâte-sur-pâte* with two girls trying to pull a winged cherub in two different directions, flanked by conflicting signposts
29.6 cms long
Decorated by Louis Marc Solon
Marks: Signed *L. Solon*
Date: c. 1900

TG58. Plaque
Tinted and glazed parian, a long rectangle in three sections, the olive ground decorated in white *pâte-sur-pâte* with cherubs in a tug-of-war, the cherub in the centre trapped by the rope
55.6 cms long
Decorated by Louis Marc Solon
Marks: Signed *L. Solon*
Date: c. 1900

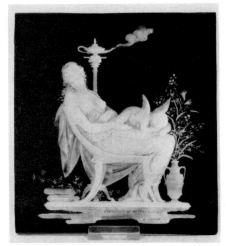

Plate 90. Catalogue TG50

TG59. Plaque
Tinted and glazed parian, rectangular shape, the brown ground decorated in white *pâte-sur-pâte* with the distribution of wisdom, an old man in a central bower handing out owls to eager girls with cages
37 cms long
Decorated by Louis Marc Solon
Marks: Signed *L. Solon 1906*

TG60. Plaque
Tinted and polished parian, square shape, the blue ground decorated in white *pâte-sur-pâte* with a girl striking a cherub in a fountain while three other cherubs look on
16 cms
Decorated by Louis Marc Solon
Marks: Signed *L. Solon 09*
Date: 1909

TG61. Plaque
Tinted and glazed parian, circular shape, the brown ground decorated in white *pâte-sur-pâte* with a seated girl placing a collar and chain on a weeping cherub

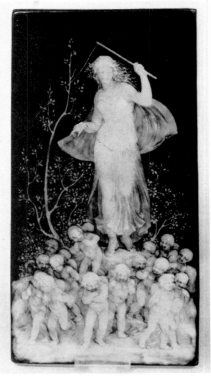

Plate 91. Catalogue TG56

15 cms diam.
Decorated by Alboine Birks
Marks: Signed *A. Birks*
Date: c. 1885

TG62–70. Part Dessert Service
Tinted and glazed parian, comprising a centrepiece and stand, an oval comport, a round comport and six plates, the centrepiece an elaborate shape with moulded scroll handles and feet and a pierced rim, the stand with four scroll and medallion feet, the round comport similarly shaped, the oval comport on four moulded scroll feet linked by foliate swags, the foot

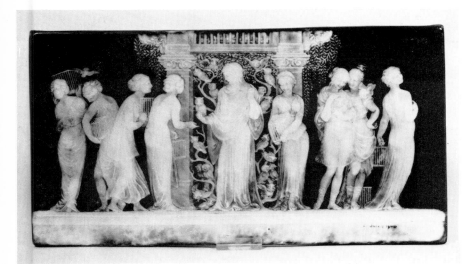

Plate 92. Catalogue TG59

central panels in various shapes and colours painted with cherubs in white *pâte-sur-pâte*, enriched with gilding
24 cms diam.
Various decorators (unidentified)
Marks: All panels initialled, No. 10 in red, No. 7 impressed
Date: c. 1890

TG74. Plate
Tinted and glazed parian, the cream ground decorated with swags and festoons in pink and green *pâte-sur-pâte*, in the centre a blue panel painted in white *pâte-sur-pâte* with a cupid juggling with hearts, enriched with gilding
23.5 cms diam.
Decorated by Louis Marc Solon
Marks: Signed *L. Solon*, No. 10 in gold, No. 7 impressed
Date: c. 1880

and rim pierced, the plates coupe shape, the centrepiece and comports decorated with brown panels painted with cherubs, arabesques and trophies in white *pâte-sur-pâte*, the plates coupe shape with panels in various colours painted with cherubs in white *pâte-sur-pâte*, all pieces richly gilded
Centrepiece 41 cms long, oval comport 28 cms long, round comport 25 cms long, plates 24.3 cms diam.
Centrepiece and comports decorated by Lawrence Birks, the plates by various decorators (unidentified)
Marks: Centrepiece and comports signed *LB*, plates variously initialled, No. 10 printed in gold, No. 7 impressed
Date: c. 1889
Ex: Paris 1889

TG71, 72 & 73. Three plates
Tinted and glazed parian, coupe shape, the claret and gold ground decorated with

Plate 93. Catalogue TG62

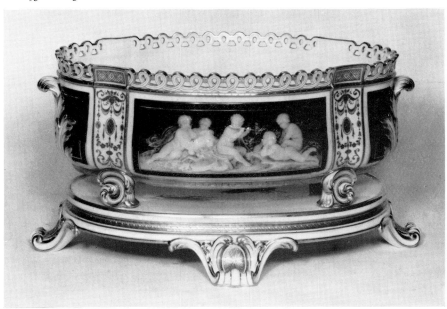

TG75. Plate
Tinted and glazed parian, the white ground decorated with scrolls and arabesques in raised gilding, on the rim three light blue circular medallions moulded with classical heads in white *pâte-sur-pâte*
22.5 cms diam.
Decorated by Alboine Birks
Marks: One medallion signed *A. Birks*, No. 10 in gold, No. 7 impressed
Date: c. 1890
Although signed, tablewares in *pâte-sur-pâte* of this type were cast from moulds. A minimal amount of work was added by hand, to conceal the moulding and to enable the pieces to be signed. The use of moulding is quite apparent on incomplete plates preserved at the Minton Museum and some of the moulds used are known to exist. See also catalogue TG76

TG76. Plate
Tinted and glazed parian, the blue and gold *oeuil de perdrix* ground decorated with a central blue panel painted in white *pâte-sur-pâte* with a half naked girl surrounded by cherubs and foliage, enriched with gilding
24.3 cms diam.
Decorated by Lawrence Birks
Marks: Signed *LB*, printed Phillips mark (retailer)
Date: c. 1900

TG77. Plate
Tinted and glazed parian, the black ground decorated in white *pâte-sur-pâte* with a winged cherub slotting an arrow into a giant bow suspended from the clouds
24 cms diam.
Decorated by Louis Marc Solon
Marks: Signed *L. Solon*
Date: c. 1890
Royal Doulton Tableware Limited

TG78. Plate
Parian, the white ground decorated with moulded *pâte-sur-pâte* panels
24 cms diam.
Marks: No. 7 impressed
Date: c. 1900
Royal Doulton Tableware Limited
This incomplete plate shows the moulded *pâte-sur-pâte* panels with additional work by the decorator, before the glazing and the raised gilding which would complete the design. Tableware of this type was in production until 1939

TG79–84. Déjeuner set
Tinted and glazed parian, comprising a diamond shape tray, teapot and cover, creamer, sucrier and two cups and saucers, the green ground decorated with brown and white panels surrounded by arabesques in polychrome *pâte-sur-pâte*, enriched with gilding
Tray 52.5 cms long, teapot 10 cms
Various decorators (unidentified)
Marks: Several pieces initialled, No. 7 impressed
Date: c. 1880

TG85–90. Six buttons
Tinted and glazed parian, decorated with flowers in polychrome *pâte-sur-pâte* and enriched with gilding
3 cms diam.
Marks: *Minton* painted in gold
Date: c. 1890
Royal Doulton Tableware Limited

TG91. Plaque
Tinted parian, circular shape, the blue ground decorated with a profile bust of L. M. Solon in white *pâte-sur-pâte*
9.7 cms

Marks: Engraved round the bust, *L. M. Solon MDCCCXV*
Date: 1890
A number of these plaques are known, and so it is likely that they were made by a combination of moulding and *pâte-sur-pâte* techniques

List of Lenders

Her Majesty The Queen
D22, E6, H38

I. Bennett, Esq.
J18

W. Chappell, Esq.
F17

City Museum and Art Gallery, Stoke-on-Trent
A3, A4, A6, A9, A10, A13, A14, D3, E3,
E5, F5, G1, G5, G11, I6, I9, I13, J17,
K12, K14, K18, K19, K20, K21, L3, L4,
L5, L6, L10, L11, M13, P3, P5

Gay Antiques Ltd
F21, F22

G. A. Godden, Esq.
A7, A12, A21, B9, C3, C4, C5, C7, C8,
C10, C11, C12, C13, C14, D1, G14, H4,
H5, H11, H28, J4, K4, M2

T. Goode & Company Ltd
G15, H29, H32, H33, H34, I7, J3, L21,
L22, L23, L24, P8, P9, P10, TG1,
TG3–TG76, TG79–TG84, TG91

F. Halliwell, Esq.
B19, F2

D. Harrison, Esq.
I11, I15

R. Hildyard, Esq.
D5

H. V. Levy, Esq.
B1–B8, B10–B18, B20–B25, B27, B28, D8,
E2, E4, E9, E10, E11, F15, F16

Mrs I. Lockett
A collection of tiles

Private Collection
H58, H60–H64, J5, L18, L19, M1

Royal Doulton Tableware Limited
A2, A5, A11, A15, A16, A19, C1, D2, D4,
E7, E15, E16, F6, F10, F12, F13,
F18, G10, G12, G13, H1, H3, H6, H8, H9,
H22–H27, H30, H31, H35, H36, H37,
H39–H47, H50–H57, I2, I3, I5, I12, J1, J2,
J6–J12, J15, J16, J19, J20, K2, K5–K11,
K13, K15, K16, K17, L2, L8, L9, L12,
L14, L16, L20, M3–M12, N1, N2, N3, P4,
TG2, TG77, TG78, TG85–TG90

J. M. Scott, Esq.
L7, and a collection of tiles

R. & I. Smythe
N5–N19

W. L. Solon, Esq.
K22–29

M. Whiteway, Esq.
J13